ARTS CENTRES

Every town should have one

ARTS CENTRES

Every town should have one

JOHN LANE

With contributions by Robert Atkins, Alec Davison, Denys Hodson, Catherine Mackerras, Peter Stark, Harland Walshaw, Dave Ward and Graham Woodruff

Paul Elek London
and New Hampshire USA

First published in 1978 by
Paul Elek Ltd
54–58 Caledonian Road, London N1 9RN
and Paul Elek Inc
10 South Broadway, Salem, New Hampshire 03079, USA

ISBN 0 236 40069 X

Typeset by Computacomp (UK) Ltd.,
Fort William, Scotland
and printed in Great Britain by
Unwin Brothers Limited,
The Gresham Press, Old Woking, Surrey

CONTENTS

vi

LIST OF PLATES

ACKNOWLEDGEMENTS

This book owes much to many friends who have helped in its making. I am grateful to all those, too numerous to mention, who sent useful information and to Robert Atkins, Chris Butchers, Chris Carrell, Alec Davison, John English, Bill and Wendy Harpe, Jeremy Rees, Peter Stark and Harland Walshaw with whom I had long and valuable conversations on the subject of arts centres. Their words make up a substantial part of this book. I must also thank Chris Cooper and David Pease for their suggestions and Robert Hutchison and Harland Walshaw for reading the book in manuscript. My final debt of gratitude is to my wife, Truda, who tolerated my withdrawal from family life with considerable forbearance. Without the assistance and encouragement of all these people this book would not have been written.

The author and publishers wish to acknowledge permission for quotations as follows: from Erich Fromm, *The Sane Society* (Routledge & Kegan Paul and Holt Rinehart); from Lord Redcliffe-Maud, *Future Support for the Arts in England and Wales* (Calouste Gulbenkian Foundation); from Ivan Illich, *Tools for Conviviality* (Calder & Boyars and Harper & Row); from Charles A. Reich, *The Greening of America* (Allen Lane The Penguin Press, 1971, reprinted by permission of Penguin Books Ltd, and Random House Inc.); from Polly Toynbee, *A Working Life* (published by Hodder & Stoughton and reprinted by permission of A. D. Peters & Co. Ltd); from Huw Beynon, *Working for Ford* (published by Allen Lane, reprinted by permission of EP Publishing Ltd); and from John English, *Place for the Arts* (North West Arts Association); from Okat p'Bitek, *Song of Lawino* (Third World Publications).

PREFACE

By the end of the century every town in Britain will have its own arts centre. The idea, unthinkable as it would have been only one generation ago, quietly, almost inexorably gathers force. At a recent count there were some 150 different centres, and of these half are less than five years old.[1]

The term 'arts centre' has come into common use only in recent years. Originally it was used to describe a building under the roof of which activities in more than one art-form took place and people of different interests and backgrounds came into social contact with one another.[2] At the time of writing there are numerous projects, some housed in specially purpose-built facilities, which can be described in this manner. But if a building and a policy for more than one art-form remain important concepts, the term can also be used to describe projects which make use of existing community facilities, which travel to the places where people live and work. Indeed many such ventures, strongly influenced by a desire to widen public participation, would prefer to send teams of '*animateurs*' into their neighbourhood than make use of an elaborate and expensive facility which constrains the creative power and initiative latent in every human being. This emphasis in itself marks a change in how we think. Thus the term 'arts centre' now embraces a wide variety of forms of which it sometimes seems the only common factors are people and the place of the imagination in their lives. As a description it is, of course, inadequate.[3] The term implies confinement to a building whereas today we need to liberate the imagination: to have art without walls. And yet it is the best we have.

Much of this activity stems from the Education Act of 1944. Schooling in Britain still officially seeks the arts of literacy and numeracy but, as Lord Redcliffe-Maud has pointed out, 'the other arts have been creeping in from the curricular periphery, infiltrating the barbed wire of examinations and seeking to give

our children experience of *creating* something, as well as of accurate numbering and clear thought'.[4] Thus if the educational system in the past effectively disabled the majority from entering into an appreciation of the arts, a large territory of imaginative experience is also opening up to a vast new public. More and more people – at least more and more of those who live in cities and suburbs, who are young and fairly affluent – now have the training and the inclination to explore the world of books, museums, country houses and the arts. Interestingly a recent American enquiry revealed a surprisingly high number interested in the arts: 64% of the adult population – 93 million Americans – would be prepared to pay an additional 'five dollars a year in taxes if the money were directed towards support of the arts and cultural facilities'.[5]

Something of this lies behind the attention being given now at national and international levels to the question of cultural provision, the steady growth of public spending on the arts and the rise of numerous official and semi-official public bodies with a responsibility to spread artistic experience and enjoyment throughout society at national, regional and local levels. During the 1950s and 1960s Britain saw a spate of theatre building unequalled in its history and, at much the same time, the provision of numerous, purpose-built arts centres established under the aegis of official bodies. At Sussex, Stirling and Aberystwyth the universities created fine buildings while others, for example, were built by the College of Adult Education at Harlech, the Inner London Education Authority in Marylebone and, more recently, by the governors of Christ's Hospital School, Horsham. Since 1948, and still more since 1974, local government has had the legal power, and therefore some responsibility, for seeing that opportunities for enjoyment of the arts are available to every citizen. The Wyvern in Swindon, Basildon Arts Centre and the Adam Smith Centre in Kirkcaldy are notable examples of their growing patronage. Although different public bodies approach the arts in a wide variety of ways, most of the facilities for which they are responsible are characterised by large buildings governed by a council of management who have appointed a director to manage their affairs. The centres present a mixed programme of professional artistic events usually limited to travelling opera and ballet,

orchestral and chamber music, brass bands, jazz, folk music and so forth, with a smattering of local amateur work. In their programming alone it is easy enough to recognise the basic values and assumptions of those who dominate our cultural affairs.

It is perhaps understandable that those in touch with the contemporary development of ideas have found such endeavour almost pitifully inadequate in scope. The arts for many have ceased to be a field of living experience, and those who are now trying by their own effort to put this to rights have been concerned only to make them real again for modern man. But rather than present professionally provided performances for a static audience in special buildings, they are seeking to reduce the mind-boggling separation of the arts from everyday reality by *involving* people in activities which have some meaning for their lives. Thus the 'voluntary' centres − and the majority of those established in recent years are most adequately described by that term − are people-based. They are caring projects where person speaks to person in a language both can understand. In this, as in so much else, the voluntary centres constitute much more than a very minor footnote in the margin of our cultural history; they are significant in that they constitute an index of a whole new cultural style.

On the face of it the arts centres may appear irrelevant to the true needs of our time. They may seem, in fact, utterly peripheral to the business of existence which moment by moment, day by day, consumes the lives of multiples of thousands for whom the arts, let alone the arts centres, may seem as distant as the nearest star. Yet to observe the centres is to see, as in a mirror, the face of our society. To see the freedom and individuality, the new layers of expressive needs − self-discovery and self-fulfilment − which the technology of abundance has brought within reach of all. To see, too, the reverse side of this golden coin: the shadow of alienation, the destruction of community, the almost total loss of meaning which characterises the modern western world. In the voluntary arts centres these factors have been converted into a contemporary currency which is capable of renewing both those who choose to make use of them, their communities and the ailing spirit of the day. As nodes of the creative life of their own neighbourhoods they remain amongst the most comprehensive, if least acknowledged, animators of personal and community

renewal as we are beginning to understand them in our time. This book has been written because we need them, and shall continue to need them in the years ahead.

1 HISTORY

The idea of a place in which arts activities in the community could find a focal point did not exist before the Second World War. There were (as there still are) the great urban institutions – theatres, galleries and concert halls – in which, like Victorian conservatories, the most magisterial, the rarest hybrid blooms could be cultivated and enjoyed. But the gardeners were professional; the culture hot-house; the visitors a small minority of the population as a whole.

There were also, it is true, a small number of enterprises, like Black Mountain College in North Carolina (founded in 1933) and the Dartington Hall Trust in Devonshire (1925) which attempted to bridge the gap between creative artists and the community in which they lived. Indeed, when the potter Bernard Leach, the painter Mark Tobey and the Ballets Joos lived and worked there, Dartington was a kind of forerunner, an inspired model of the arts-centre idea. But its concern for the arts and their application to the needs of society owed much to the influence of an Indian, the poet and philosopher, Rabindranath Tagore, for whom they were a natural part of life:

> In your Devonshire enterprise do try to attract some budding poets, some scapegraces whom no one else dares to acknowledge ... Get some artists, too, to lend energy to your work. Never mind how small the flame may be, provided they have enough of a gift to light the lamp, and let yours be a league of vagabonds ... If only in Devon you could have a Goethe with his Weimar attached to your enterprise. He would write songs for you. Then your whole place would be humming with music.[1]

Such aspirations and their practical realisation in a country which continued to regard 'culture' in Henry James's words as 'a sort of silly dawdling ... a proceeding properly confined to women,

foreigners and other unpractical persons', were years, even decades, ahead of their time.[2]

Post-war idealism
After the war, in a climate much changed, the moment came. The first tremor of the new trend was a modest booklet, *Plans for an Arts Centre*[3] published for the Arts Council of Great Britain in 1945 as a practical contribution to the study of the problem of housing the arts:

> The arts should be honourably housed; but their accommodation must be properly related to the size of the community they serve. One will look to metropolitan centres for a wide range of specialist buildings. At the other end of the scale, the village is never likely to be able to provide anything more ambitious than a modest multi-purpose hall as part of a social centre. But between these extremes come numbers of medium-sized industrial, county and market towns, some at present with partial provision for the arts and some with nothing at all.
>
> This book ... is designed to show how the arts can be accommodated in a medium-sized town with a population between 15,000 and 30,000 – a town where it is not economically possible to run a separate theatre, art gallery and hall for concerts, but where occasional visiting companies, touring exhibitions, orchestras and concert artists have to be housed in a single multi-purpose hall.
>
> Such an arts centre can and should play a vitally important part in the life of the community it serves ... for ... an arts centre, if it is to be of full value, must be designed to accommodate the local amateur as well as the visiting professional.

Although we would now question the static concept of such a model, the booklet which accompanied an exhibition which was sent on tour throughout Britain (complete with plans for an all-purpose hall, a foyer large enough for exhibitions and restaurant), set a pattern for the first generation of performance-based arts centres to be established after the war.

The earliest of these, at Bridgwater (a market town of 25,000 people), opened in October 1946. It was established by the Arts

2

Council of Great Britain in a three-storey Georgian house with a garden, over which the theatre was built to seat 200. Its first event was a performance by the Travelling Opera Group, followed in quick succession by a piano recital by Colin Horsley and a concert by the Boyd Neal Orchestra (for which the tickets were 5s, 3s.6d and 2s.) A month later the Arts Council organised an International Conference of Architects attended by, amongst others, Le Corbusier and Gropius.

Meanwhile, in Swindon, the Borough Council were putting the final touches to another project which opened the following month in November 1946:

> An occasion of this kind could not be merely the excuse for ceremony and speeches. With the Arts Centre looking its best in all the glory of new furniture and cheerful paint-work, the second half of the evening, after the modest refreshments suitable to that time of austerity had been served, was devoted to showing how the Arts Centre could work. First came a piano recital ... and this was followed by a reading of *Dr Abernethy – His Book* by the Play Reading Group ... It is a striking fact, incidentally, that half the cast of Dr Abernethy are still very active today in Arts Centre work.[4]

Twenty one years after the opening ceremony, remembered here, Harold Jolliffe, Borough Librarian and moving spirit behind the establishment of this novel social facility, was convinced that his arts centre had been established with 'one aim, one business, one desire and it might be summed up in the single word "opportunity".' The centre, it was felt, 'should be a place where those interested in the arts should have the opportunity of working in congenial surroundings, as far as possible free from interference, and without too great a financial burden. It should be a place for talking, thinking and doing and the Library Committee conceived it its duty to help both directly and indirectly all those who frequented it.' The powerful idealism of the 1944 Education Act can be sensed behind the quiet conviction of his words.

Yet however much it was in tune with the aspirations of the post-war years, Swindon remains exceptional in an important way. As the first arts centre to be wholly financed and administered by a local authority it pioneered ideas which have,

3

even yet, not fully matured. Commenting on its opening, thirty years ago, Peter Brown of the BBC, reporting on the ceremony, observed:

> Swindon's a surprising town ... you will find more civic enterprise in Swindon than in many towns twice the size and its arts centre is part of this surprising tradition. ... And if in spite of all the economic ills that beset Britain, subsidised arts centres may one day become as commonplace as subsidised public libraries, I foresee the one-time dance hall in Swindon's Devizes Road becoming a place of modest pilgrimage, the subject of a footnote in some social history of our time.

The subsequent development of the arts in Swindon is described by Denys Hodson in one of the essays in this book.

Sadly, Bridgwater, which raised expectations of a national policy for cultural decentralisation two decades before their general acceptance, is less likely to become a place of pilgrimage. For in 1952 the Arts Council closed three of its regional offices and engaged increasingly in grant-giving rather than direct promotion. The regional offices in Newcastle, Leeds, (later York), Manchester, Cambridge, Birmingham, Nottingham, London, Southampton and Bristol had been most useful artistic organisations in their areas and the advice given by their staff was greatly valued. Although their closure (which resulted in the withdrawal of direct patronage to Bridgwater) was ultimately influential in bringing about the birth of regional arts associations, it retarded the development of the arts-centre concept for nearly ten years. Indeed, if it had not been for the efforts of devoted amateurs, the story of the arts centres in this country would have been a different, and possibly less interesting one.

So although it was not until the opening of the Midlands Arts Centre for Young People in 1964 that the movement really got under way, the late forties and fifties were far from fallow. A ninety-page report, *Arts Centres in England and Wales*, published by the National Council of Social Service in May 1967[5] observed that 'there are believed to be thirty-four centres in England and Wales' and the majority of these were established in those years.

Besides Dartington, Swindon and Bridgwater, the Report contains information on arts centres in, among other places, St Austell, Doncaster, Falmouth, Weymouth, Shaftesbury, Hastings,

4

Barnstaple, Bristol, Boston and Shrewsbury, all of which besides the Midland Group Gallery in Nottingham (which opened in 1943) were established between 1947 and 1967. Also included were several others such as the Plymouth Arts Centre (1947), the New Metropole in Folkestone (1961) the Guildhall Arts Centre in Kings Lynn (1951), Camden Arts Centre in London (1965) and the Beaford Centre in North Devon (1966), whose subsequent development, based on professional direction, has set them apart from the ethos of the mixed-programme clubs run by amateurs. (Though it was not mentioned in the NCSS Report, the Institute of Contemporary Arts in London, which opened in 1946, also falls into this category.)

To their membership of voluntary enthusiasts the early amateur clubs had a value which no one could deny, for they brought an extended season, if not a year-round programme, of arts events to towns and cities in which professional performances were rarely seen. 'If an opinion may be ventured' observed Harold Jolliffe, 'then one might say that Swindon is surely a richer place because of its arts centre, and the wealth of activity which has taken place within its walls.'[6] If at all times the creation of life is an important achievement, it was all the more so in the difficult circumstances of the post-war years.

Yet in spite of their success, the limitations of the mixed-programme clubs should not be glossed over − if only because these provided a lesson for the arts centres to come. For if the amateur centres brought the arts to many people they brought them to those who already enjoyed a predominantly high level of educational and occupational status − it was no mere accident that the majority were established in the South. If they provided amateur dramatics and painting lessons they offered them as hobbies for the middle class. An introverted cosiness vitiated many of their activities. Looking back, one has a sense that they did not lay their foundations wide enough.

Nevertheless, by the mid-sixties, much progress had been made: the seeds had been planted and the ground prepared. The arts-centre movement was on the very threshold of its future role in cultural and community life. Spearheading this development, the first really major breakthrough, the Midlands Arts Centre for Young People in Birmingham, opened in March 1964. An isolated, private effort, in its promise of a new world it was in

perfect accord with the ideological imperatives which for a time were shaping Labour Government policy. Its programme (as originally set forth by John English, the founder-director) established a blueprint which has subsequently become the common property, if not the aim, of every arts centre in this country:

> We aim to set standards by providing professional performances and exhibitions, and also to give opportunities for children and young people to express their own creative abilities by giving them facilities for practical work. To do this we are building a complex of theatres, concert hall, art gallery, cinema, studios and workshops, with cafes, restaurants and other social facilities, including an arts club. The total cost of the whole project will be considerable, but it is spread over a ten-year foundation programme. The land we are building on is a fifteen-acre strip on the edge of Cannon Hill Park in Birmingham, bordered on one side by a boating lake and on the other by a river. This has been leased to the Cannon Hill Trust, the independent, non-profit-making body which has been set up to create and run the Centre.
> The whole complex is for children from the earliest possible age up to young adults of twenty-five. It is planned as a training ground, as nursery slopes leading on to the major cultural provisions of the community This process is called putting the horse before the cart.
> The current activities at Cannon Hill include professional theatre, provided by a resident company and visiting companies; small-scale concerts; exhibitions ranging from the fine arts to general interest subjects; and practical activities – painting, sculpture, photography, woodwork, music, theatre and so on – in the workshops and studios.[7]

On the surface, John English's magnificent obsession seemed intrinsically different from many of the earlier centres. It was exceptionally ambitious (by April 1974 the total investment in buildings and equipment had amounted to £951,000; while between 1965 and 1974 it has been estimated that more than $2\frac{1}{4}$ million individual visits to Cannon Hill have been made). It was professionally staffed (in 1976 approximately forty full-time staff were employed by the Centre). It included sports and other

6

recreational facilities – squash courts and a pottery – and its concern with arts provision for the majority (as opposed to arts clubs for a minority) was in keeping with other, democratic, expectations of the socialist good life.

Yet Cannon Hill, in company with other contemporary purveyors of cultural orthodoxy in the sixties (such as the network of Maisons de la Culture which André Malraux imposed on France) had more in common with the ethos of the mixed-programme amateur clubs than their advocates might like to think. For in spite of vast differences in scale and funding most of the new projects were posited on the idea that a great cultural heritage should be made available, accessible and alive to each generation of children, adolescents and adults. This is what Arnold Wesker had in mind when he spoke of his desire 'to make the pursuit of the extraordinary experience of art an unextraordinary pursuit'[8], or what Lord Goodman, then Chairman of the Arts Council, meant when he referred to the Council's desire to see 'more and more people become interested in, fond of, and anxious to collaborate in the arts'[9]. But the arts to which John English, Arnold Wesker and Lord Goodman mostly referred were the established or fine arts – the masterpieces of European musical composition, literature, ballet, painting and sculpture which had been created for court or bourgeois audiences between the seventeenth and the twentieth centuries – in fact the same masterpieces that had been presented (in miniature) at Bridgwater twenty years before. It was as broker for 'the cultural heritage', 'the legacy of the past', the 'great masterpieces of art' that these centres, like their predecessors, were defined.

Perhaps then, the main difference between the new professional centres and the old was the conviction that art should no longer be the preserve of a privileged minority but must be made more widely available to the population as a whole. 'Indeed the time will soon come', observed Alexander Dunbar (the first director of what was then called the North East Association for the Arts), 'when people claim this opportunity as a right; as much a right as universal education or public health'[10]. Such a cultural policy would of course have implications for both central- and local-government expenditure on the arts.

The first official recognition of this change in attitude was the

Labour Government's White Paper of 1965, *A Policy for the Arts: the first steps*[11] which argued that 'if a high level of artistic achievement is to be sustained and the best in the arts made more widely available, more generous and discriminating help is urgently needed, locally, regionally, and nationally'. The same year a Ministry of the Arts was set up within the Department of Education and Science, and the question of local-authority support was highlighted in the report *Partners in Patronage*, which appeared in the following year.

In such giddy circumstances it comes as no surprise that the arts-centre concept should be seized upon as the perfect instrument for the democratisation of the arts. It was small, flexible, local; a grassroots place where, in the words of the White Paper, an 'agreeable environment and a jealous regard for the maintenance of high standards are not incompatible. Centres that succeed in providing a friendly meeting ground where both light entertainment and cultural projects can be enjoyed help also to break down the isolation from which both artist and potential audience have suffered in the past'. There was, indeed, the White Paper argued, 'no reason other than lack of energy and interest why every community, large and small, should not form its own arts centre, aiming at growth and improvement of quality'. Within a decade, as if in answer to the challenge, the number of arts centres in this country had risen from thirty-four to four times that number as three-quarters of the centres have started operating since the White Paper was issued. The boom had begun.

It was a phenomenon that could be seen across the world. Wherever enlightened plans to improve the quality of life were part and parcel of coherent social policy, the new architecture of leisure began to take shape. Throughout the sixties over 150 arts centres, of all shapes and sizes, were erected in the United States and some of these, such as the Lincoln Centre for the Performing Arts in New York and the John F. Kennedy Centre in Washington, were overpoweringly prestigious. In Australia, Bulgaria, Canada, Czechoslovakia, Holland, Hungary, New Zealand, Poland, Sweden and Yugoslavia different kinds of centres were established, while in France, André Malraux's projected network of some twenty Maisons de la Culture (of which nine were eventually opened) began to operate between

8

1961 (Le Havre) and 1969 (Nevers).[12] Indeed, before it was discovered that industrial workers made up only two to three per cent (and agricultural workers less than one per cent) of the Maison's audiences, Malraux's noble, if head-in-the-clouds ideal of a 'meeting place intended to bring cultural wealth of all orders, past and present, and of the highest standards, to the widest possible public, with no one excluded', seemed the perfect instrument of cultural diffusion.[13]

Contemporary British achievements, less systematic than the French, were also remarkable – all the more so when we remember that only two theatres had been built in England (and many closed) between 1936 and 1956. Although the most prestigious project, the South Bank complex on the site of the 1951 Festival of Britain Exhibition, comprising the 3,000-seater Festival Hall (1951) and The National Film Theatre (1957), the 1,106-seater Queen Elizabeth Hall and the 372-seater Purcell Room (1967), the Hayward Gallery (1969) and the National Theatre (1976), has been variously described as the epitome of the sixties' concept of an arts centre and no arts centre at all, many other examples were constructed in the decade under review. Most of these, on the French model, were professionally directed and expensive to build: the Billingham Forum, an arts cum sports-and-recreational complex for Teeside, cost its local authority a million pounds in 1968. Other local-authority initiatives included the first multi-purpose urban arts centre to be designed and completed in this country at Basildon (1968); the 620-seater Wyvern Theatre and Arts Centre in Swindon (September 1971); the 500-seater Playhouse Theatre and Arts Centre in Harlow which opened two months later; and the Durham Light Infantry Museum and Arts Centre – a permanent exhibition gallery and arts centre established by Durham County Council in 1968. Other performance-orientated arts centres, this time established by private initiative, include the Gardner Centre for the Arts designed by Sir Basil Spence and associates with Sean Kenny as theatre consultant for the University of Sussex, which cost £250,000 and opened in 1969; Ove Arup's fine conversion of some maltings at Snape (1967); Theatr Ardudwy, an arts centre which forms part of a college of Adult Education in Harlech (1972), and the MacRobert Centre within the University of Stirling (1971). The Aberystwyth Arts Centre within the

9

University College of Wales (1972) and the 450–600 seater arts centre in Christ's Hospital School, Horsham (1974) – each of them costing well over one million pounds to build – are two additional examples of performance-orientated arts centres established by private enterprise within the last few years.

If in retrospect many of these projects – costly to build, no less costly to maintain – can be seen as yet another example of the free-spending and arrogant prescriptions of the sixties (as, for example, the architectural prescription for high-rise urbanity or the educational prescription for universal education embodied in the comprehensive school) there can be little doubt they have helped to foster a new audience for the performing arts. Even so, as they rose in brick and concrete, a reaction against the premises upon which they were founded was turning people's minds in new directions, along strange, unaccustomed paths.

In order to avoid impersonality of scale and appearance, some centres had begun to open in the more characterful surroundings of old buildings where an uninterrupted tradition of community usage went a long way to accustoming people to their newest use. The success of Centre 42's adaptation of George Stephenson's engine shed, the Round House (1968) in Camden Town, influenced many who sought with the playwright Arnold Wesker, to make art 'a natural part of more people's lives'. The adaptation of a church and church-hall in Hull (1970) and of one of the stuccoed terraces in the Mall (for the ICA in 1968) were further examples of the differing ways in which old buildings could be successfully converted into arts centres. But the practice represents only one aspect of the longing to find an authentic connection between art and life, between the private artist and the world from which he had drawn apart.

As early as 1946, the French painter Jean Dubuffet put his finger on this point:

> It is the man in the street that I'm after, whom I feel closest to, with whom I want to make friends and enter into confidence and connivance, and *he* is the one I want to please and enchant by means of my work.[14]

Without knowing it, Dubuffet had spoken for a new generation now seeking to realise a degree of integration of art into everyday

life. Indeed it could be said that the much-publicised Trades Council Festivals which Centre 42 had mounted at the beginning of the decade were belatedly bearing fruit.

In this respect the achievements of Roger Planchon at the Municipal Theatre of Villeurbanne, the working-class industrial suburb of Lyon, have become as legendary and influential as Joan Littlewood's at the Theatre Royal, Stratford. For Planchon's wish 'to bring things away from literature and connect them with real life, the everyday life of the next-door neighbour, the butcher, the grocer on the corner'[15] was shared by a generation of artists seeking to give expression to feelings about the relevance of their activities to the world in which they played no part. 'There are two parallel adventures', observed Roger Planchon, 'the artistic and the social. They must be considered in conjunction. There is a social problem — the audience; there is an artistic problem — the show.'

One of the first demonstrations in Britain of how social and artistic elements might be synthesised were the group-created stage documentaries about local subjects, developed by Peter Cheeseman at the Victoria Theatre, Stoke-on-Trent, and first presented in 1964. But documentaries which gave expression to the life of their home community were only one answer to the problem which Planchon had posed. Elsewhere the arts centres, closer to the ground, potentially more flexible and responsive to local needs than the theatre were beginning to develop their own response — falteringly, at first, but with increasing authority. Street theatre, the travelling community-theatre groups (the first of these, the Orchard, was established by the Beaford Centre in 1969) and radical alternatives involving people in creative situations which had relevance to their own lives, were some of the methods a small minority of the centres were beginning to explore for themselves. There was a new perception that people might not only read, watch, learn and listen to what was deemed good for them, but create something for themselves.

One way and another by the late sixties the scene had been set for the broadest dissemination of cultural 'benefits' any civilisation had ever known.

Sixties revolt:

The arts represent much of the finest achievement of the

human spirit in all the ages. Enjoyment of the arts is not confined to those who have themselves outstanding artistic gifts; it is something which in varying degrees brings insight, delight and pleasure to countless men and women. We believe that this latent power of enjoyment is far more widespread than are the opportunities of awakening it, and that when awakened it can open channels of communication between individuals and groups who share few intellectual or social sympathies and who are unsuspecting of the powers which they possess.[16]

People need not only to obtain things, they need above all the freedom to make things among which they can live, to give shape to them according to their own tastes, and to put them to use in caring for and about others. Prisoners in rich countries often have access to more things and services than members of their families, but they have no say in how things are to be made and cannot decide what to do with them. Their punishment consists in being deprived of what I shall call 'conviviality'. They are degraded to the status of mere consumers.[17]

These quotations, one from an Arts Council Annual Report, the other from a book by Ivan Illich, are placed in juxtaposition with each other to illustrate the great divide between those for whom culture is synonymous with a 'wider and more appreciative audience for the arts' and those, like the authors of a Council of Europe Report, for whom culture is meaningless when defined without 'reference to the population itself':

Initiatives such as the development of public libraries and the creation of further education centres and people's universities all offer admirable evidence of the determination with which the best minds of the generation immediately preceding ourselves set about democratising.culture. The development of education itself springs from equally generous impulses.

But while so much energy was spent on 'raising the level of culture of the mass of the people', the actual content of that culture, the definition of the commodity to be made available to the under-privileged, was never in doubt. The culture they spread was firmly and securely established.

Reference to cultural democracy today implies an entirely

different approach. It is nothing less than a rejection of the patronising notion of culture, and consequently the policy of broader distribution, and its replacement by another conception whereby culture is defined with reference to the population itself.[18]

But this divide, illustrated here, was not limited to a re-examination of the arts: the greater part of life in the industrialised countries of the world underwent a questioning, a critique which still animates both individuals and society alike. Quite suddenly it was as if our internal compass indicated different bearings from those to which we were accustomed.

If there have been numerous attempts to explain the nature of this metamorphosis, there is little doubt that it had its roots in the rich matrix of ideas and aspirations which emerged, took shape and gathered momentum in the mid sixties – a sea-change in the life of feeling so widespread, radical and deeply shared that the counter-culture (as it is called) amounts to nothing less than a change of consciousness. For the first time in centuries a generation – an entire level of international consciousness – rejected the menacing dominance of scientific objectivity in favour of a more human community and a more liberated individual – an individual, always free in Charles Reich's words, 'to build his own philosophy and values, his own life-style, his own culture from a new beginning'. He, and nothing else, was the true reality:

The first commandment is: thou shalt not do violence to thyself. It is a crime to allow oneself to become an instrumental being, a projectile designed to accomplish some extrinsic end, a part of an organisation or a machine. It is a crime to be alienated from oneself, to be divided or schizophrenic being, to defer meaning to the future. ... The commandment is: be true to oneself. ...[19]

Thus the desire for uninhibited personal development, the search for personal transcendence through meditation and hallucogenic drugs; thus the Paris student rebellion, unrest at Essex University, the draft riots in the States and such diverse manifestations of the new consciousness as the 'underground' movement, rock music and 'doing your own thing', all of which, though attributable to a

13

variety of causes, have shared one central belief: that every human being should enjoy the ultimate and sovereign right to search for and express his own innate potential, his own individuality, his uniqueness as a man. It is this rebellion against the *ancien régime*, this new and revolutionary Declaration of Independence which has shattered and shaken – and still shakes – the old post-Renaissance perception of the arts.

To the new consciousness (and the new culture) the assumptions of the old culture were both patronising and inhuman. Once the individual has elected himself the supreme reality, the supreme arbiter of what is right and wrong, art could no longer be viewed as culture to be officially dispensed or as fun and games to be officially ignored. In its stand against amateurism, its loyalty to the past, its conformity to a higher authority, the old culture had implied a cynical indifference to each and every person's varying creative need. It had deadened creative exuberance to the point where the majority of people no longer believed in their expressive power. It had banished art to the museum to the point where people assumed it had no independent life beyond their walls. The great river of art had shrunk into a trickle; a consumer rarity; a tiny, sterile, self-indulgent specialism feeding on itself; instead of drawing its nourishment – as it had done in the past – from the common life of mankind.

The awful ubiquitousness and omnipotence of this situation did not deter the adherents of the new consciousness from a passionate conviction that the creative aspect of life – which found its clearest expression in art – was integral with the responsibilities and potentialities of being fully human. The true direction for art had nothing to do with narcissistic exhibitionism or magpie aestheticism – the twin symptoms of our cultural schizophrenia. It lies in the liberation of each person's spirit and the supreme reality of the non-measurable subjective world. Thus art was always more, much more, than a pleasure or embellishment; as the instrument of personal regeneration, it was not only the key to self-transformation, but, by implication, the qualitative development of the communities in which people lived. It was, to adapt R.H. Tawney's memorable phrase, not merely 'an assortment of aesthetic sugar plums for fastidious palates', but 'an energy of the soul'.

14

Fifty years earlier, a lone voice – D.H. Lawrence's – had made much the same plea about art, creation and the primacy of personal consciousness:

Don't set up standards and regulation patterns for people. Don't have criteria. Let every individual be single and self-expressive.[20]

A new Romanticism ... Only in the 1960s it was not led by a tiny group of artists living in retreat, as the earlier Romanticism had been. Millions of young individuals felt sufficiently in agreement with one another on the major issues of the day for their individual protest to take on the character of a mass expression. The paradoxical nature of this contradiction is a striking feature of a complex phenomenon. The individual is supreme yet he chooses to express himself in a mass demonstration. The individual is supreme yet he involves himself in collective work in non-hierarchical organisations. In the face of the Procrustean limitations of Western capitalism (which has not been slow to exploit young people's rebellions and illusions) the new consciousness demands a classless world of free individuals bowed down under no authority beyond each man's own moral sense of how things should be. The cessation of hierarchy, autocracy, privilege and class – which had lost all moral authority – were aspects of a swelling influence on the arts which bore fruit under the terms 'cultural democracy' or 'community arts'.

Perhaps the earliest overt manifestation of this cultural transformation was the Arts Lab movement, which swept the country from the late sixties to the first years of the next decade.

Of the fifty experimental projects described in the first *Arts Lab Newsletter*, published in October 1969, only six have survived: the Brighton Combination, founded by Jenny Harris and others in 1967 (the Combination has subsequently moved to the Albany in Deptford); the Birmingham Arts Lab (1968); the Great Georges Project in Liverpool (1968); York Arts Centre (1968); and centres in Beaford (1966) and Hull (1969) which have been mentioned before.

The catalyst of these changes, the American Jim Haynes, came to London in 1967 and opened his London Arts Lab in Drury Lane in September of that year. Within an extraordinary short period of time other groups of like-minded young people,

generally an uncatered-for minority with a taste for the contemporary arts − progressive pop, poetry, living theatre, 'underground' literature and so forth − combined with a broad sympathy for progressive values, embraced with an almost religious zeal, were gathering together in towns and cities throughout Britain to create their own Arts Labs on the pattern of Drury Lane. Like the 'underground', the movement mushroomed (within a year there are reputed to have been 140); subsided; and then faded away as suddenly as it had emerged. Yet, even at the end, as in this report from Bletchley, the old and rather breathless euphoria which had sustained the movement from its beginning occasionally broke out:

> So far we've nearly got an old pub to function from, but meanwhile we're running a poetry and music event once a month. And Drama Group and Rock and Pop concerts too. Have lots of potters, a batik lady, an Indian singer/sitar player and various semi-detached artists. So explosions, events, films, exhibitions − next exhibition is American exhibition of 'American Trash' and other things/happenings in progress.[21]

There can be no doubt of Haynes's influence on the development of arts agencies in this country even if the nature of his influence is not easy to define. The London Arts Lab cast a spell over thousands of young people who were searching for non-established forms of expression. It demonstrated the validity of self-determining democratic processes and the central, overriding significance of 'doing your own thing'. The idea of open access, the fluid use of interchangeable spaces, the relaxed mixture of cultures, the informal encouragement of every kind of personal creativity, were all forged and validated there. No better demonstration of Haynes's belief in the delirious fecundity of flexibility can be found than a text he wrote describing the characteristics of an arts lab:

> A lab is an *energy centre* where anything can happen depending upon the needs of the people running each individual lab and characteristics of the building.
> A lab is a *non-institution*. We all know what a hospital, theatre, police station and other institutions have in the way of boundaries, but a lab's boundaries should be limitless. Within

16

each lab a space should be used in a loose fluid *multi-purpose* way – i.e. a theatre can be a restaurant, a gallery, a bedroom, a studio etc.[22]

The distinguishing feature of the small group of projects which survived, phoenix-like, the spontaneous dissolution of the arts laboratories was a fresh awareness of the community outside their walls. This was in striking contrast to the galleries, concert halls and theatres of the nineteenth century which stood like temples upon a podium above a flight of marble steps. Even the majority of the old amateur centres clung to a vision of culture as comfortably upholstered as a gentleman's club. Indeed, while at its zenith the old culture was characterised by an indifference to the harsh and often violent realities of the world, amongst those who sought to begin arts projects in the late sixties, a confident extraversion was soon apparent. Looking out from their centres they perceived the bleak and chilly housing estates and ugly cities in which so many people live. They talked to neighbours for whom the arts were as remote and meaningless as a foreign language they had never learned. Here the carpeted art galleries were no help; the whole symphonic tradition was of no avail. They had to start from scratch, establish a relationship, forge a language; or fail. And failure meant acceptance of the fact that the arts as they were currently understood were ill-equipped to provide people with a richer, more meaningful or liberated life. Not just some people, educated people, or people who already enjoyed distinct privileges of some kind, but everyone; every man, woman and child. Armed with something artistic to offer as well as a lot of enthusiasm and commonsense, the new consciousness began to put theories to the test, to prove that this need not, could not, be forever so.

One of the earliest *community arts* projects to be established in this country to find out how art could be made an enrichening experience in everyday life opened in Liverpool, in the same cavernous Congregational Church that has housed its remarkably variegated activities to this day. The Great Georges Project (described in more detail on pages 105ff) was started by Bill and Wendy Harpe in the summer of 1968, after Bill Harpe had directed the opening celebrations of the new Roman Catholic Cathedral:

I found myself thinking about the relevance of doing a dance opening of a cathedral if the people who attended might, for the next twenty-five years, have no other contemporary dance experience offered to them. What right have you to rush in, do something, and then disappear. I wanted to do some teaching and game playing at a more fundamental level. I was concerned with gardening rather than greatest splendour.[23]

Bill and Wendy Harpe set to work to explore a novel programme of activities including participatory games, play schemes, discos, and activities in the city's streets, all of which 'make possible a creative partnership of artist and "public" ':

We see ourselves in some respects as a 'sports centre' of the arts: a place where people can come to experience the work or performance of the best professionals; where they can come to work or 'train' with the professionals; and where they can come to undertake their own creative work. In the long term any situation which begins to restrict the practice of the arts to a professional class is to the disadvantage of both the artist and the 'public'.

It seems to us that there is a necessary place within the arts both for projects concerned only with the presentation of the best of the professional arts (including works from the past) and for projects concerned, in addition, through workshops, and other participatory activities, with a 'gardening' of the arts, a tilling of the cultural soil: and that both kinds of project should receive support from public funds.[24]

The earliest documentation of Great Georges and other community-orientated projects was a Council of Europe Report (1970) which described the activities of several English projects in the context of cultural democracy as a whole. Amongst those selected for description, besides Great Georges, Stainsby Arts Centre, the Brighton Combination and Billingham Forum, was one which has been described as the most dynamic phenomenon in the British community arts scene. This is Inter-Action founded by another influential American, Ed Berman, in 1968.

Ed Berman's Inter-Action has always operated like the cells of a honeycomb, each activity growing rapidly but dependent on others for support. For Berman has multiple projects going and is

Protean with ideas: he has established a community media-van; a touring Fun Art bus (a re-vamped double-decker equipped with a CCTV studio and cinema); a film unit; an urban farm with allotments and an indoor riding school for children; a street theatre group; a publishing unit; and a repertoire of more than 250 games which are used in play groups, youth clubs, for old-age pensioners and as a way of creating a closer sense of community in difficult urban areas where there is little or no community life. Although its activities have been taken on many different British and European tours, Inter-Action has always taken its primary direction from and aimed its activities at the needs of Kentish Town – a mainly working-class area made up of shabby Victorian rented property, council flats and large expanses of vacant lots. Here, after nine years in a residential house it built a permanent (but flexible) base, the first purpose-built community arts and resource centre in the UK (1977). Different from most arts centres Inter-Action reversed the normal pattern; establishing a relationship with its community *before* committing itself to a permanent building. It has integrated the centripetal and centrifugal elements in its work and developed its own philosophy of play. With Inter-Action the concept of the arts centre has come into its own.

Seventies explosion:

By 1970, through that almost secret, fundamental process by which society evolves the institutions it requires, the basic model of the arts centre had been substantially worked out. The relationship of the centre-as-base to the centre-as-energy-point from which projects surge, of participatory activities to the presentation of the performing arts, of the art of the past to that which is characteristic of a particular locale, had all at this juncture, been explored; so that it only remained, under the growing influence of community arts, for new centres to pioneer their own variations on the quintessential, if hybrid theme. The yet unmeasured potential of this basic model was, indeed, to be endlessly developed by the large number of projects – and almost half the total number of arts centres in Britain are less than five years old – that started operating in the seventies. But if the many-sided nature of their endeavour owes much to the earlier models whose programmes existed to be copied, re-modelled or rejected

at will; the element selected for development, the defining characteristic, was either the result of circumstances or, more probably, the personal enthusiasms of the person or persons who, by their own efforts, guided the new project from birth. Nevertheless, arts centres have been, and continue to be, the developing evolution of a small number of shared ideas, guiding those who use them as much as those who set them up.

One of these, energising and enriching both nomadic and centre-based work, is the idea of community arts − a term which has come into common use only in recent years. In Lord Redcliffe-Maud's words:

> It signifies a special *process* of art activity rather than any special *product* − a process which seeks to involve action by the local population as a whole rather than passive interest of that minority (often estimated at some five per cent of total population) which regularly attends performances of serious music, opera, ballet and drama or visits art exhibitions.
>
> Community artists set themselves to stimulate rather than perform. Their profession is to encourage people of all ages and educational backgrounds to take part in arts activities of their own choice. Their conviction is that local people should not only themselves control the buildings and equipment needed by the arts, but should themselves take the decisions about what is needed and refuse the exclusive role of passive audience. Community artists may be themselves professionally qualified in various art forms; alternatively, they may be full- or part-time *animateurs* with professional skill in no one art form but in the techniques of stimulating response in others to any of the arts. They all aim at making themselves in the end no longer necessary, as they succeed in stimulating the local people to become their own community artists.
>
> The arts are seen as only one aspect of community development, which should embrace community life in all its forms. Community arts are, therefore, conceived less as arts than as creative social activity.[25]

Creative social activity involves local people and many arts centres inspired by the pioneering achievement of Inter-Action, now began to take their projects to the places where people live and work. As the seventies progressed there was also a growth in

groups who sought to encourage the widespread practice of the arts by 'amateurs'. Invariably they worked from the simplest office or workshop space using the city and its surroundings as their 'arts centre'.

Action Space (1968), the Islington Bus Company (1971), Alternative Arts (1972), Word and Action (1972), Free Form (1973) and the Telford Community Arts Project (1974) are notable examples. Word and Action in Dorset goes to schools and youth clubs; Action Space, with inflatables and participatory events, to open spaces, play sites and streets. Yet, even here, no hard and fast distinction between those who work in open spaces or other people's buildings and those who work in their own is possible because Action Space is in the process of setting up its own arts centre, while even the Telford project holds meetings and workshops in its headquarters, a small private house. Conversely, several projects with their own buildings take activities into their neighbourhood. Inter-Play (1970) which consists of a community group of eight full-time workers and an itinerant theatre company does both. The theatre group performs in the streets, in parks and play grounds, at festivals and in pubs, with materials suitably devised for these environments. The community group runs a pre-school playgroup, weekly sessions for older children, discos, an information centre, Christmas parties for old-age pensioners and summer play-schemes. These are based in Armley (a working-class area of back-to-back houses near Leeds) in which the project owns a building, a detached house, where many of its enterprises are organised. Centrifugal and centripetal activity also characterises another project, Shoreham Youth Workshop (1970), which runs sessions in its own premises, an old tithe-barn near a couple of schools and a housing estate in Shoreham-by-Sea. The Workshop team is responsible for putting on community shows in the Barn and for taking these out into the area – to hospitals, old folks homes, pubs, youth clubs and other local organisations. They also take drama projects into schools and some of the local schools come to the Barn for sessions. The team participate in the Workshop sessions, both as a company and as individuals using specialist skills. Bath Arts Workshop, founded in 1971, also acts as an energy point from which a number of activities fan out; it runs a community video project, a theatre company, a civil aid unit, a

21

teashop and a builders' co-operative. For those projects as for numerous others, there is a continuous ebb and flow between the neighbourhood and the project's base. If it were not for the fact that some of the voluntary arts centres now housed in buildings commenced with a very unstructured early period which has been replaced by something considerably less chaotic but still imbued with the importance of community arts there might be a strong argument for excluding such projects from a book about arts centres. The concept of community arts has also permeated projects firmly based in their own buildings which do not necessarily run a community or outreach team. Many youth arts workshops, for example, offer creative facilities as well as performances: while a growing number of centres providing comprehensive programmes, also regard the stimulation of creative activity as the key to an understanding of their work.

The Youth Arts Workshop, the product of several decades of sporadic creative activity in the primary and secondary schools, is another institution to take root in the last few years. One of the earliest, in Basingstoke, Hampshire (1964), grew out of a drama workshop, and the influence of drama has been deeply felt: West End Centre in Aldershot (1975), the Tower Centre in Winchester (1971), the Oval House in Kennington (1968), Zone in Chesterfield (1971), Wallsend Youth Arts Centre (1969), the Brycbox Youth Arts Workshop in New Maldon (1973) and the Theatre Centre in Brent (1968) remain, or were originally, drama-based. Not all of these, however, like the Cockpit in Marylebone (1970), conceived and financed by an enlightened Inner London Education Authority, operate in premises which have been purpose-built; though many, like the Brycbox and Zone have been established by Local Authorities in the context of their Youth Service programme. For as its name suggests, the Youth Arts Workshop, takes as its first priority the engagement of young people in the arts. 'We are trying to get through to young people who may have missed out the chance of participating in the arts at school', says Christine Gregory of Llanover Arts Centre in Cardiff, 'The process of education in schools often tends to get in the way of people getting at the arts.' Like other arts workshops for young people Llanover Hall (1971) offers a wide range of activities including photography, ceramics, drama, painting, music and dance. As Christine Gregory sees it, 'People should be

left alone when they want to be alone. All we do is suggest and offer guidance. In no way do we hold any set form of classes here. I suppose you could say that Llanover Hall is at the participants' disposal.'[26]

The seventies have also seen their share of centres which have depended, at least in the first instance, on the energy and entrepreneurial abilities of one person. Like great trees which grow from tiny seeds most of these had modest, even lowly, beginnings. The Arnolfini organisation, for example, which is now housed in almost 18,000 sq. ft. of space on the ground and first floor of a great warehouse sited in the centre of Bristol, started its life in 1961. It was then that Jeremy Rees, whose vision and persistence has nourished the project through several buildings, started selling pictures above a bookshop with the help of two partners and £300. Today the Arnolfini, one of the most attractively designed arts centres in Britain, incorporates a cinema and performance area for small-scale live music, dance and multi-media events, a bookshop, a bar and generous gallery spaces. The capital cost of the conversion of the Arnolfini areas in Bush warehouse was, in 1975, £400,000. Another person of comparable vision and determination is Chris Carrell who started what is now Sunderland Arts Centre by opening a second-hand bookshop where he also put on art exhibitions and poetry readings in 1969: in a nearby pub he ran music and drama. For these pains he earned press criticism and police raids. Spectro Arts Workshop (1970) started in a photographer's shop in Whitley Bay before it moved to larger premises in Newcastle in 1976. About the same time, also in the North East, the Dovecot Arts Centre in Stockton (1971) opened with a few classes in the YMCA. In the same year Chapter opened in Cardiff, in some derelict high school buildings which the city council offered to rent. Like numerous other centres before and since, the premises were enough to daunt all but the stoutest hearts. 'For two years', observes Chris Kinsey, one of the three initiators of the project, 'it had been left empty. For the most part the whole of the site had been completely stripped of wiring, windows, lead, and absolutely nothing worked. It was completely filthy dirty and there were tramps in it when we moved in'.[27] Today Chapter, in its fine re-furbished premises, is one of the most enterprising and vigorous centres in Britain.

23

Similar determination to create a living focus for the arts has characterised projects in Bampton (1973), Chester (1973) and Salisbury. The latter, established in 1975, in a redundant church should stand for all those projects, great and small, at the very threshold of their development:

> Since January a lot has happened at St Edmunds. We have held several concerts and dramatic events of various kinds, and the Church has been sub-let to other organisations to put on events and concerts. It will be used again this year by the Salisbury Festival of the Arts. Upstairs in two large rooms above the vestry we have set up, with hardly any money and a lot of hard work, art and craft workshops for the use of members. These are manned voluntarily by artists and craftsmen on a rota basis and, so far, though not yet fully equipped we can offer facilities for painting, drawing, pottery, embroidery, batik, woodwork and weaving. We have recently raised enough money to order the more expensive items necessary for the silk screen department, so that we can print out own posters. We hope eventually to find enough space for metal work and a dark room. ... Our hope in running this centre, is to try to close the gap that exists between people and 'many forms of art; to provide a focus where all can share and acquire enthusiasm in an active way – the emphasis being on participation. ... We hope to offer a real stimulus by providing a high professional standard of performance in all fields and at the same time encourage everybody to treat this Centre as their own – a place where informal facilities and expertise are available for any kind of creative activity.[28]

Yet if these centres have grown out of the dedicated commitment of one person and the small band of voluntary helpers who gather round him; others have sprung up, like Athene fully-armed from the brain of Zeus, ready furbished, well endowed, occasionally purpose-built. The arts and community centre in Kendal (1972), for example, was set up in an adapted brewery as the result of a daring initiative of a local philanthropist. The Brewery cost over £100,000 to convert. In Stirling, the MacRobert Centre was built (1971) as the result of a £250,000 gift to the University. The sixty-room mansion at South Hill Park set in fifteen acres of its own grounds was adapted into an arts centre (1973) at a total cost of a

24

million pounds. It has received support from Bracknell District Council, Bracknell Town Council, Bracknell Development Corporation, the Arts Council and Southern Arts Association. In Scotland a sum of around £30,000 was put up by Kirkcaldy Corporation for the complete modernisation of an existing building in the town. The new building, the Adam Smith Centre, which is used for dances, conferences, educational classes and public meetings as well as for musical and theatrical events, opened in September 1973.

Another significant initiative involving a local authority was the conversion of the old Battersea Town Hall into a community arts centre by Wandsworth Council in 1974. The centre contains a fully-equipped pottery; a refreshment area; workshops for video, film-making, handicrafts, painting; an exhibition gallery, rooms in which local groups can hold their meetings and a place − originally the Council Chamber − for films, lectures, drama, folk, discos, puppets and jazz. Significantly, the same year saw the opening of two more of the growing number of publicly owned arts centres − the first in Southport (in a reconditioned civic hall in the centre of the town); the second in central Glasgow. The latter, the Third Eye Centre, was set up by the Scottish Arts Council at a total capital cost of some £116,000 on the understanding that its policy should be built around the visual arts. Besides exhibitions, it can house small concerts, plays, lectures, films, dance, poetry reading, rock music and seminars on different aspects of community arts. 4,000 people visited it in its first week. More recently, The Vale of the White Horse District Council have converted the old gaol in Abingdon into a leisure centre (1975), complete with sports hall, swimming pool, gymnasium, sauna, 150-seater recital room, music centre and exhibition rooms (at a cost of £1$\frac{1}{4}$m) while in the North, Washington Development Corporation have opened a centre, Biddick Farm, in a complex of stone built farm buildings. The total scheme includes a vintage car workshop, community rooms and a space for pottery, rehearsals and workshops as well as an art gallery and a performance area. There will be more and more local authority arts centres as public support for the arts grows on a steadily increasing scale.

As regards the immediate future, arts centres are already under development for Ashton-under-Lyme, Bootle, Brentford,

Bridport, Stevenage, Chiswick and Kidderminster and others are being planned. Growth of arts centres, on a swelling scale, can be anticipated if only because they arose in response to the greatest need of our time and that need, which has its roots in the contemporary sickness of men and their societies, will not lessen in our lifetime. It is tempting, therefore, to predict their future: recent trends extrapolated into the future would bring their number to almost 500 by the year 2,000. In a submission to the Lord Redcliffe-Maud inquiry into future support for the arts,[29] the National Association of Arts Centres has predicted that there could be over 1,000 by the end of the eighties. At all events by the turn of the century they are likely to be as ubiquitous as the free public library service, for every town of any size will have at least one and probably several arts centres.

But if their number must, of necessity, remain conjectural, one thing is certain: the concept of the arts centre will continue to adapt to the enormous personal and social possibilities of the ensuing decades. It will widen and deepen its concerns. It will grow in variety and vision. The existing network of arts centres is only now at the threshold of their life.[30]

2 ACTIVITY

The architectural theorist W. R. Lethaby once observed that there was a brown bread and dewy morning aesthetic ideal, and a champagne and late night supper one − and that ultimately, for the sake of our health, we would be wise to choose the more sustaining diet. Such alternatives merely represent the extremes of a spectrum of possible response which, all too often in the field of the arts, have been polarised into the absurd false opposition of 'elitist' and 'popular' art. The distinction is unnecessary. We need high standards of performance and opportunities for creative expression; champagne and brown bread. The resolution of polarities is an aim of the arts-centre movement as a whole.

Although people involved in the movement would hardly like to hear themselves described in terms of dewy mornings they would nevertheless accept there is a difference between the community-based approach of the majority of centres and the elitist ideals which dominate the rest. These ideals, arising out of an hierarchical society in which the rare individual − as hero or artist − is distinguished from the common herd, have created exalted achievements which it is important to preserve.

Western civilisation would be diminished if growing men and women were denied the opportunity to hear, for example, Beethoven's *Choral Symphony* or Stravinsky's *Rite of Spring*. Yet, paradoxically, this very civilisation by the self-same process which created the concept of the 'artist' as a special sort of man has prevented ordinary people from thinking of themselves as artists in their own right − an attitude ultimately of passivity which has in the past and which continues to enfeeble both us and the arts to this day. However, this is changing and the era we are entering is precisely the one that could make restitution of the crime. André Gide, writing in 1943, prophesies what he sees as the inevitable consequences: a great decline in standards, a great fall in the quality of art:

27

Art – called upon to disappear from the earth; progressively; completely. It was the concern of a choice few; something impenetrable for the 'common run of mortals'. For them, vulgar joys. But today the chosen few are battering down their privileges, unwilling to admit that anything should be *reserved* for them. By a somewhat silly magnanimity, the best of today desire: *the best for all.*

I can imagine a time when aristocrat art will give way to a *common* well-being; when what is individual will cease to have a justification and will be ashamed of itself ...[1]

Yet from another standpoint Gide's sombre premonitions are out of phase with the contemporary search for a more equitable distribution of economic and cultural resources. Common justice now demands that community facilities for imaginative expression should exist alongside theatres, concert halls, museums and galleries. Commonsense now teaches that culture is as broad as life itself. Man's desire for fresh experience and revelation continually gives rise to new kinds of expression which are no threat to the surviving forms. It is precisely at this point that the difficulties facing any attempt at definition emerge.

At first sight few things would seem to be further apart than a performance of Mozart's *Idomeneo* in the Maltings at Snape and Bath Arts' promotion of a dance workshop for the local community in Walcot village hall. Yet are even these differences as great as they might appear? Few would surely dispute that a Gothic cathedral and a primitive dwelling decorated with simple patterns, or *War and Peace* and a folk ballad are both manifestations of man's desire to give order to his existence, to give form to feelings and ideas, to celebrate the incredible experience of being alive. Art functions in our lives in many different, nameless ways. Each individual, each culture, each moment, will arrive at different points of emphasis according to its own need and history. Who can say which is the better? For an answer we could do no better than read what Lord Redcliffe-Maud has to say in response to the question, 'For whose benefit should we support the arts from public funds?'

'The many and the few' is my broad answer. The many, because no one is incapable of some enjoyment or experience of the arts if he has opportunity to use his own peculiar powers of creation and recreation. The few, because at all times and in

all places creative talent is rare and genius is very rare indeed. Our society, it seems to me, will not become more civilised if it ignores the claims of either group. As our resources are, and will always be, strictly limited, some questions of priority cannot be shirked. But if we look more closely at the question 'whom should we public patrons help?' the answer needs to be rather more complicated. The 'many' and the 'few' do not together constitute the whole population. They must be thought of, rather, as the largest and smallest of a whole series of concentric circles. The innermost circle consists of the few people of *genius* − composers, playwrights, poets, painters, sculptors, designers on the one hand, and soloists, conductors, actors, directors on the other. Wider than the circle of genius is that of *talent*, of many various kinds. Still wider is the circle of those capable of professional teaching of their art (for instance, music) though not themselves so talented as the professional performers. Outside that circle are the *active amateurs* − singing in choral societies, playing in orchestras, brass bands and pop groups, acting in drama societies or community art, but earning their livelihood in other ways. Beyond them is the still wider circle of those who enjoy the arts as *audience*, whether of broadcast or of live performance. And beyond them 'the many'. No circle is at any moment static or exclusive. All of them fade into each other like colours in a rainbow. And with *all* of them we are concerned as public patrons.

As patrons *what* is our concern for them? First, it is to give each person in each circle *opportunity* − to compose, perform professionally, teach, perform as an amateur, enjoy as audience − and in each case the opportunity of progress to higher standard, whether of composition, performance, teaching or capacity to enjoy demanding works (say, Beethoven as well as jazz, contemporary music as well as Beethoven).

But we are also concerned that individuals make progress of another kind: from passive to active, lower to higher, standards of enjoyment. The flat image of concentric circles needs to be three-dimensional − a pyramid, with rare creative genius at the top and the base gradually becoming broader year by year. Our purpose as patrons, therefore, must include the hope that individuals in the intermediate circles graduate upwards as their experience widens and their discrimination grows.[2]

29

Thus it is that on the deeper level, far from being antithetical, the twin poles of the arts-centre world, Mozart and the dance workshop, are complimentary because they both offer the seeds of greater becoming which is at the root of all imaginative expression. The arts have always been central to such a quest throughout all societies and at all times. Yet, on the more superficial level − in terms of appearance, activity, quantity and quality of work − the centres have so little in common that it has proved difficult, if not impossible, to find a definition which embraces them all. Some are solely for amateurs to take part, some only present the work of professionals, many mix the two. Some are for every age group, others primarily for young people, or students, or the middle-aged. There are those that concentrate on a single art form, aiming at excellence in a restricted field, while others are devoted to expressive activity on the widest front. Some are funded by trusts, some by the Arts Council, others by their regional arts association or the local authority, some by all of these. The variety of the centres is almost a commonplace. Yet behind these differences, real as they undoubtedly are, there exist a number of shared values and aspirations about the arts.

What, then, are these? First, an overriding concern for art as the essential instrument in the development of human culture; that is human culture in no highflown sense, but in terms of the extension of the range, the depth and the dynamics of each individual's emotional life. Indeed every centre would subscribe to Bergson's view that 'the function of art is to return us to ourselves'. Commenting on Arvon Foundation courses in which students are encouraged to create something of their own, the poet Ted Hughes makes a similar point:

What these courses do reveal is that a great proportion of people have some talent, given the right conditions for it to show itself. It might not be much − not enough to justify them throwing up all ambitions in the hope of becoming an artist. But even the tiniest spark is very important to the person who has it, and very important to the rest of society. The tiniest spark is enough to lead through into the world of perceptions and understandings which art attempts to express. It leads them into a very big world − the world of those who in every age

30

attempt to explore and express the human spirit. It gives them some first-hand understanding of that world, and makes them members of it, which is the beginning of many other developments in a person, some of them perhaps not connected with art at all.[3]

That art should be the basis of education and that man should be educated to become what he is were ideas explicitly formulated by Plato many centuries ago. In developing these ideas arts centres are translating an ancient view into terms more directly applicable to our own time. The new spirit presents itself, as Peter Stark makes plain, in contradistinction to the ideas and assumptions of more traditional attitudes about art:

It gets me so furious with people, say, when you do a painting project with kids, you put the results on the wall in the gallery or on the fences around the project, and people come down (from the Arts Council) and tell you that it is 'bad art'.

The thing that I want assessed is the quality of the animation which got those kids together in the first place, the quality of the influence which the artist teacher had in relation to those kids and what they did – not the product that came out of it. It's what you were giving the kids through the process of what you were doing. ...

What I want to know is how those children have grown in themselves? How have they developed? What is going to come out of it? I don't accept the argument which justifies work on the grounds that a great artist is going to come out of it. That isn't what is important.[4]

But this in itself is not enough. The centres have realised that the exclusivity of the arts stands as a barrier in the way of enjoyment and are inevitably committed to changing this. They accept that they must bring as much creative and original thinking to the job of getting an audience as, for example, the actors do in entertaining it. Jeremy Rees of the Arnolfini speaks therefore for all when he says:

Here we are, in the middle, the absolute centre of the city, saying to the public, '*use us*'.

One tries to make the actual building itself, not faceless exactly, but avoid any particular atmosphere or feel that would

presuppose a certain type of person using it – and to that extent it is gratifying that people do seem to accept it on this basis. In other words it does not have an aloof feeling about it. We are only interested in getting it as widely known as possible and as widely used as possible. Although, having said that, I would stress that quantitative criteria are a very dangerous concept for any centre to adopt.[5]

Like numerous others, Chris Carrell, Director of the Sunderland Arts Centre, adopts much the same approach:

I think that one of our overriding objectives is to make art unspecial. ... For most people art is something experienced by other people who are 'better' at it than they are, and that is what one wants to see the end of.
 By not differentiating in terms of overall concept between the self-taught and the professionally trained, not differentiating in terms of ability or in terms of age, by having a whole number of activities co-existing within the same building, one can break down many barriers. I would like to see many things which are complementary to one another existing together in the same building.[6]

Facilities for jewellery-making, textiles, etching, printing, lithography, photography, painting, pottery, video and film, as well as a bookshop, a restaurant, a cinema, a bar and a theatre workshop were included in proposals for an enlarged centre in Sunderland. At the Arnolfini the new building already incorporates a cinema-cum-theatre, two exhibition areas, a bookshop, a bar and a restaurant. In more modest style the arts centre in Plymouth contains a snack bar, a gallery, a small multi-purpose hall with cinematographic facilities, and numerous rooms for workshops and meetings. Although a programme and a policy for more than one art form is, of course, synonymous with the term 'arts centre', facilities do not always include workshops for active participation. The Arnolfini complex is exclusively performance and exhibition orientated and some would argue that it is greatly diminished to that extent.
 It is important for our theme to understand just how and why these connections are important. In reaction against mainstream traditional attitudes the centres would first dissolve the hard and

fast distinctions between the various art forms. But the search for meaning goes far beyond that. By breaking down the categorical nature of cultural experience, by recognising the need for a holistic view of art as an integral part of life, the centres are also seeking to create fresh and living interactions, social and aesthetic, between art and people, art and social welfare, art and the community in which they live. The search for integration now reaches far more deeply, into almost every centre.

At the heart of this process many centres use their base as a springboard into the neighbourhood or region. From the Beaford Centre the Orchard Theatre tours to over twenty different market towns and villages within a twenty-mile radius. The Breconshire theatre company radiates from its centre into coal mining towns in the valleys and villages in the hills. In London Inter-Action have their media van and the Bubble Theatre have their tents for the parks. Plymouth, Bampton, Sunderland and Hull all promote events outside their centres using different buildings in the towns.

In fact the deeper arts centres go into their communities the closer the identification with each community becomes. There can, indeed, be no other starting point for involvement with the community of which you should be a natural part. Harland Walshaw, Director of the Beaford Centre, reflects the opinion of many when he expressed this view:

> It seems to me that the arts are a reflection and a comment upon the way we live – and, indeed, at their happiest are a celebration of that living. And therefore as an arts centre for North Devon we would be very arrogant, and not only arrogant but irrelevant, if the only art we encompassed took no notice of the fact that our way of life is in some ways different, even now, from other people's lives simply by virtue of the fact that we live here rather than somewhere else.
>
> If we are going to serve this area – and if we are not going to serve it we might as well pack up and go to London – then we should be finding ways in which we can serve the people who are indigenous to this area and those who live and make their being here, as well.[7]

Exhibitions on local themes, documentaries on local issues which some (but far from all) of the centres are systematically creating, are aspects of a close involvement with their local

33

neighbourhood. It is a characteristic of The Combination at the Albany in Deptford:

> We have wanted to tour locally. ... to go to where groups of people habitually meet. To take our shows to the neighbourhood. We have worked in pubs and clubs, in the streets and markets, in playgrounds and parks, in old people's homes and clubs, in church halls and schools, on waste ground, and in the blocks. We have staged shows for meetings and parties, for dances and discotheques, for dinners and buffets for neighbourhood festivals, and for demonstrations,for playschemes and playgroups, for pensioners' knees-ups and for courtyard celebrations, for firework nights and Halloween.
>
> We have tried to interpret our role for the local community. After all, live entertainment is dead in a place like Deptford. The perception of the local people has changed from 'them students' to 'phone them up and see if they can do a show' to '*entertainers*'. It has taken about two years. And if we are even half way there we are lucky. It has been hard but we are all still in the race and are becoming more confident.
>
> We have not presented drama in packages for an already determined audience. We have not said, 'Here is a body of material that has been written for the theatre. ... we are going to present a selection for your pleasure – come if you like'. We have tried to say, 'We are entertainers, musicians, performers, clowns, jugglers, fire-eaters, singers, writers etc. What sort of things do you want us to do? What sort of live drama do you find relevant and exciting? Is it this sort of thing? Or this? Or this?' This process of exploration and experimentation has been crucial.[8]

Out of this kind of close involvement a genuine relationship can be born. Yet identification with a specific community can equally take a more didactic form as was shown in John McGrath's Scottish 7:84 Company's production of *The Cheviot, the Stag and the Black, Black Oil* – a play about the Highland clearances and the contemporary oil boom, about which its author has written:

> Direct Marxist analysis of the Clearances, long chunks of readings from eye-witness historical accounts, facts and figures about oil companies and the technicalities of exploration, all

were not only grasped, but waited for, expected. ... There were no puzzled looks – everybody knew what was happening. That night in Kinlochbervie, 250 miles north of Glasgow, in that so-called backward area, people taught us what theatre has to be about. ...

The theatre can never cause a social change. It can articulate the pressures towards one, help people to celebrate their strengths and maybe build their self-confidence. It can be a public emblem of inner and outer events, and occasionally a reminder, an elbow jogger, a perspective bringer. Above all it can be the way people can find their voice, their solidarity and their collective determination.[9]

There is vast scope for community involvement in the arts to grow.

If we were to take a bird's eye view of the arts centres in this country we would be struck by a confusing diversity of emphasis, expectation and aim: some centres concentrating on the performance element, others on their educational, therapeutic or social role; some large, some small; some well-endowed, some struggling to survive. Yet within the parameters of a continuous spectrum in which process and product, art and the community, historic patronage and the contemporary artist, individual participation and collective involvement are inextricably meshed, the centres share most of the attitudes which have been described so far. The particularities of the centres can and do vary infinitely, without transgressing those attitudes.

Several months after he had arrived in Bracknell to set up a new arts centre in a large country house, Peter Stark presented a report to the governing body of the South Hill Park Trust Limited outlining his overall plans for the development of the project. Those aims, reprinted here with amended titles, provide a convenient structure for a description of the six inter-related functions of an arts centre which the rest of this chapter will now explore in greater depth:

1 *Participation*
 To support all those already participating in creative leisure activities and to encourage as many others as possible to find the activity best suited to their needs and aspirations. (In a sense all the centre's work is geared to this basic concern.)

2 *Presentation*
 To present to the general public as broad a range as possible
 of the arts past and present, and to work to increase
 knowledge and appreciation of these works.
3 *Sociability*
 To provide the general public with a social environment at
 the centre conducive to the first two aims.
4 *Resource centre*
 To act as an information point, and equipment and
 expertise resource for creative activity in the new Bracknell
 District.
5 *Young people*
 To work especially with young children and young people,
 both inside and outside the centre, encouraging and
 assisting their participation in the creative process.
6 *The artist*
 To support and assist in all ways possible the work of living
 artists, especially those just beginning their careers.[10]

Participation

From a limited commitment to provide its membership with
facilities for painting, pottery and acting in plays the arts-centre
movement has developed its concern for participative activity on
a much broader front. For if its classes are indistinguishable from
those provided by the statutory authorities, its community arts
activities and imaginative outreach work are usually far in
advance of anything organised by Community Colleges, Adult
Education centres and the like.

Even then arts-centre workshops are important not only
because they complement existing provision but because they also
point to a future which recognises the reality of personal need. It
would therefore seem appropriate to look at the wide range of
opportunities for creative participation which some of the centres
have been organising in recent years.

At South Hill Park in Bracknell, for example, dozens of
separate courses including silversmithing, enamelling, jewellery
making, lapidary, woodcarving, weaving, spinning, knitting, tie-
dyeing, batik, fabric printing, lace making, embroidery, macrame,
crochet, flower arranging and photography have been offered at
any one time. Kite-making, an electronic music workshop and

video have also featured. At Kendal the arts centre has offered classes in drama, video, guitar, jewellery, photography, wood carving, lapidary and jazz. Inevitably the smaller centres with more limited resources offer a narrower range. Hemel Hempstead has had film animation, a visual arts group and a family workshop every Sunday afternoon. Wallsend provides workshops in chamber music, visual arts, theatre, folk, drama, experimental music, photography and film. The New Metropole in Folkestone which specialises in the visual arts has etching, lithography, fabric and silk-screen printing as well as the more usual art forms.

In London, centres are offering opportunities that are no less varied. Battersea provides workshops for painting, sculpture, printing, handicrafts, music, drama and pottery. Like the Combination at the Albany, Inter-Action and the Basement project in Cable Street, it has also been working with video. Elsewhere, at the International and Camden Arts Centres to mention only two, workshops complement those provided in such well-established ventures as Morley and Goldsmiths Colleges and the City Literary Institute in Drury Lane.

For younger people five ILEA and related theatre-centres such as Oval House, Group 68 and the Greenwich Young People's Theatre are providing a wide range of activities in the arts. One of these, the Cockpit (described by its director, Alec Davison, in a contribution to this book on pages 96–104) runs exploration groups in documentary theatre, stage lighting, electronic music, poetry and improvisation. Its most unusual class is called Buskers Nightschool – described as 'skill-training in all manner of busking, street theatre, booth-entertainment and strolling diversions'. But in addition to the exploration groups which take place on the premises, the Cockpit runs a small outreach team which goes out 'with a view to encouraging usually uncommitted young people to become involved in the process of group creative arts activities'. It is in this field that some of the most exciting work in what is still called adult education is now being done.

Maybe a group goes out and sets something going in a young club, or an old people's home, or a hospital, or a mental home or a village hall or whatever it may be. The aim is to set things up in places – any sort of place – but places where things just

aren't happening. An outreach·team (because it is so trained and inspired) has infinite ways of improvising and showing that in any space things can happen. You don't need equipment though little bits are increasingly helpful once the work gets going. With elderly people in their own club room there is a lot of drama you can do. In hospitals, of course, you do it from the beds. Senior citizens clubs are crying out for activities.[11]

Holiday play schemes, adventure playgrounds, video-taping projects, inflatables, mobile music-workshops and, a case on its own, Inter-Action's community media van are further examples of the widespread commitment of many *animateurs* to serve their community in immediate and direct terms.

The community media van, a large red Mercedes, carries printing, film, video and PA equipment, a radio telephone (in London) and a theatre platform on the roof. On most journeys, the arrival of the van will have been planned well in advance, with the co-operation of local groups. One purpose is to show these groups how best to present local issues by letting them experiment with the equipment. As a tool – and an exceptionally sophisticated tool – to bring issues and opportunities for community development to people where they will most notice it, the media van helps people to perceive, face up to, and ultimately change their own social situation in their own terms.

Sometimes the emphasis is less overtly 'political'. Holiday projects for children, street days, concerts and festivals bring people into the streets to join with their neighbours in creating something of their own invention. There is an emphasis on collective and communal values rather than the concept of the individual which dominates the workshop in the arts centre.

The 1974 Islington Festival is a case in point. Islington's Festival, organised every other year, aims to encourage people to entertain themselves and each other, 'not just to provide them with packaged pleasures'. In 1974 its 170 events included parades, pop festivals, basketball competitions, a fancy dress party, pub entertainment, dog shows, inflatables, a donkey derby, judo championships, puppet shows, fireworks and, last but not least, a Calypso charity cricket match, since much of the vitality and variety of Inner London comes from its mixture of nationalities, classes and pursuits. As a means of uniting individuals within a

neighbourhood and of encouraging them to build up and continue a sense of community spirit the Neighbourhood Festival is one of the most valued weapons in the armoury of the community arts worker.

But festivities, frequently used as a contribution to helping inner-city problems, make a contribution wherever people live. It is not enough that a community should have work and housing and schooling and drains; it also needs to celebrate itself.

In Beaford the arts centre functioned as a catalytic agent in the village (population 300) for a week of festivities in the summer of 1975. Harland Walshaw explains:

We think it is important to create, wherever possible, a context for our events. The festivities in Beaford were organised with the village, and the fete which started the week centred round sports on the green; the Orchard Theatre's live Punch & Judy fitted naturally into the side-shows — the ducking stool, skittles, Aunt Sallies, fairground organ and fortune-teller. The week of events that followed was designed to appeal to different sections of the village community; an afternoon tea concert in the garden organised by our resident composer for the old people, a rock dance in a barn for teenagers, a barn dance, inflatables, a concert on the theme of bells (very popular in Devon), a bonfire and torchlight procession. All through the week an exhibition of photographs from our archive collection of over 2,000 old photographs showed jubilees, junkets and jollities in North Devon villages in Victorian and Edwardian times. Our celebrations were seen as part of a continuing pattern. Another exhibition, 'In Praise of Cider', was also local, and its examples of twelve different brews of Devon farm cider ensure that the revels were, at least, jolly.[12]

Such schemes, tailored to meet the requirements and aspirations of a small village, have been repeated in a hundred different forms in as many different situations; wherever, in fact, people have felt the need to enjoy themselves together. 'It seems to me' continues Harland Walshaw, 'that people have always celebrated the fact of their being alive — they have sung about it, written about it, danced about it and explored it through drama and ritual of many different kinds. The arts in their social sense have been part of the celebration of life. How can you separate this from everything

39

else?' Those who labour to raise funds for banquets for old-age pensioners, who organise discos for teenagers or who build inflatable theatre environments for children to climb on in the waste plots of our cities (where the authorities provide ten times more space for car-parking than for play), would doubtless agree that fun and games are of the utmost importance to the sanity and well-being of men and their societies.

Play, in fact, is central to any understanding of the arts centre's work — but not merely play in terms of physical games, in terms of sport; but play of the mind, play of the spirit, play of the creative imagination — which is, perhaps, but yet one more way of talking about the arts. Alec Davison observes:

> We have always thought that plays stops at about eight or nine, but increasingly I see that play is an essential element to everybody's life until death. The person who can continue to play in various forms in the arts, or whatever else, is a richer person, a more fulfilled, better nourished person than that person who can't. When you see young children stunted because they can't go into imaginative play in the blocks of flats near where I live then that seems to me a lifetime's deprivation.
>
> Play has many facets. It has a lot of physical elements — so that we play football, climb rocks or simply kick a ball around. Play's also got an exploratory element — we are actually exploring new things, tactile things, new tastes and sounds. But the dynamic of play is far deeper than this. It is to do with trying to cope with our feelings. In play we re-live, re-form, we re-structure the outer world. We digest it within ourselves. We assimilate and accommodate it. A lot of play takes place unconsciously. Art is the ordering and playing with these experiences.[13]

Here we have to do with an absolutely primary category of life the full significance of which has been lost to our society. For in spite of all appearances to the contrary (its apparent waywardness, its spontaneity, its voluntary nature, the element of fun) the instinct for play, at variance with the work ethic, the character structure derived from industrial discipline, not to speak of our ubiquitous puritanism, is central to the quality of life. One of the most promising developments in the last decade has been the emergence of a new demand for play. Indeed the many

thousands, even millions, who demand sports facilities, craft instruction, language tuition and so forth are only a small part of that greater number who find their real fulfilment not in work – which is merely instrumental in earning a living – but in their play. Play, in fact, is often the only compensation for the meaninglessness which affects us all in our personal work and condition of being.

Perhaps it is not altogether surprising nevertheless that the work of the community artist is still regarded in terms of simple-minded messing around. Besides the great achievements of the human spirit which we call art it must seem trivial, unexalted, uncritically banal. Besides many of these so-called trivialities, if looked at in this light, have more to do with provision for the less talented than with any strongly intellectual pursuits and are therefore less respectable on that account.

Bill Harpe, choreographer by profession, and one of the most experienced practitioners in the field, should have therefore the last word:

> In all these aspects of working we would be concerned to work to the highest standard. There is a temptation to feel that providing people are learning or developing then this validates the activity. It may be true that one learns from making a less than perfect tape but one learns more from making a good tape.
>
> Standards of work are as important to us as they are to the directors of the National Theatre. In this way we are like any other working artist – the main difference is rather that we involve more people in the creative process.[14]

Presentation

It is certainly true that the arts-centre movement, both in this country, in Europe and the States is more concerned with presentation – with performance and exhibition – than any other single element. The MacRobert presents the Gabrieli String Quartet, and the Pitlochry Festival Company in *The Master Builder*; Christ's Hospital, *The Coronation of Poppea* and the Contrapuncti Ensemble; the Gardner, a sitar recital by Narendra Bataju and *Who's Afraid of Virginia Woolf?*. At Battersea preparatory workshops for sets, costumes, masks and music are interleaved with a lunchtime record recital of *Noyes Fludde*.

41

Harlech presents the Moving Being; Great Georges, Meredith Monk. The most solid and developed side of the centre's work inevitably takes place in the field of the performing arts.

Acting as a cultural supermarket poses many problems. For who is capable of taking so many diverse cultures and transmuting them into something uniquely their own? How can programmes be selected in order to satisfy so many different people? Who, indeed, is the centre to attempt to please: the majority, represented by popular taste, or the minority with enthusiasm for the comparatively esoteric and unknown? How can balance be achieved? Who is responsible to whom? Recognising that no two people will ever agree as to which of the arts should be given prominence, and that finance and talent for a given approach fluctuates over a period of time, the questions of balance, responsibility and standards of excellence are capable of many different interpretations. For some, high standards, perfection in performance, are the chief interest and pleasure in life. For others, new adventure in the contemporary arts is satisfying enough. Yet others, with less concern for rare moments of distinction and more concern for breadth, regard a balanced programme as of overrriding importance. For,in aiming 'to select from those performing activities … the maximum possible variety of material and styles in the performing arts which can be engaged within the centre's strict financial limitations' York Arts Centre's policy is characteristic:

Equal favour is shown to professional and amateur material, to theatre, music and film, and to classical, mainstream, modern, experimental or popular works and styles of production. Unlike some similar establishments which have an avowedly experimental or radical policy, the Centre has no bias in theory or in practice towards the experimental arts or any other particular or limited style or form. Bias is admitted only in the deliberate encouragement of all kinds of local activity.[15]

Three elements are recognisable here.

First, a recognition of the responsibility to present a wide variety of the vast repertory of works of art which have survived from the past and which, together, make up what we call our Cultural Heritage. If one believes − as a substantial number of those working in arts establishments do believe − in the power of

42

art to enchant both mind and heart with the serene conviction that human life is, can be, more, much more, than merely nasty, brutish and short, then the opportunities to experience Schubert's songs, Chekhov's plays or Rembrandt's etchings – to name only three examples out of thousands – needs no further justification. There are works of art where for a suspended second mankind does appear to have become divine. There are works of art which give one exalted pleasure. The importance of keeping them alive for every succeeding generation hardly needs to be questioned: John English has never been the least reticent in asserting his own attitude to this question:

> The fact is people do use words to express their creative imagination. They invent stories; invent situations; they begin to act them out; they begin to involve themselves in the ritual situations: in sport, in dance, in theatre, in religion, because it's a thing which people do and have done for thousands of years. And are they good in terms of making life richer and more considerate and compassionate for other people? Yes, of course they are. I never argue about it. ...
>
> I simply believe that we owe it to each new generation to be put in the way of acquiring this basic received experience. To put it in simple, callow terms, one would like every adult to have had an opportunity to have seen a significant number of images that have been produced by human beings in the past, and heard an assemblage of sounds that have been produced before – of being given an opportunity to listen to Beethoven and Mozart as well as Webern and John Cage. And one would have liked every adult participator in the theatrical occasion to have experienced, say, the work of a hundred great play-wrights, or twenty-five different styles. And not to have done this in an academic way.[16]

None the less, the arts centre has other responsibilities; responsibilities to a public, a very large public, for whom neither nineteenth-century *lieder* nor Russian theatre have any relevance. All culture ranges along a continuum from the most esoteric, private and exploratory to the most accessible, public and easily understood: from Messiaen to the Beatles, Samuel Beckett to Z Cars and the Cup Final. Such manifold richness of experience can be enjoyed when the arts centre accepts a comprehensive

responsibility for a number of broad cultural bands. Thus Sunderland presents Cousin Joe from New Orleans the day after the Purcell Consort of Voices has given a programme of madrigals from Italy, England and France. At Swindon, the Wyvern's winter season includes Victoria de los Angeles, Jacques Loussier, *Hair*, Jake Thackray and the Cory Brass Band. Aberystwyth presents *Hamlet* and *Dick Whittington and his Cat* in the same month.

Even if patronage of the arts is mainly directed towards the art of the past, a surprisingly high percentage of centres reveal a commitment to the living artist and the art of our own time. There are, indeed, a number of centres – the Birmingham Arts Lab, the Third Eye Centre, the Arnolfini, Chapter and the ICA – which are genuine shrines of the contemporary arts. Films by Ray, Fassbinder, Goretta and John Eustache, paintings by Howard Hodgkin, music by the Grimethorpe Colliery band and the Philip Glass ensemble feature in an Arnolfini autumn programme. At Chapter, a month's programme includes electro sculpture and live electronic music with video, film and slides. Elsewhere, outside the largest cities where specialist centres complement existing cultural establishments, arts centres must appeal to a broader range of tastes in which the contemporary element is only one aspect of a comprehensive programme. In fact over ninety per cent of the York Arts Centre's programme for 1973/4 was devoted to the work of our own time. Three of the four events promoted by Wallsend in March 1975 were also by living artists. These examples, chosen at random, indicate the extent to which the professionally-directed centres have accepted a responsibility for the contemporary arts.

But responsibility does not always end at importation. Some centres have endeavoured to produce their own creative product or invited artists to work in the locality. At Dartington, the composer Malcolm Williamson was commissioned to write an opera for performance by local students and schoolchildren. *The Red Sea* was subsequently performed to great acclaim. The Third Eye Centre and Sunderland have commissioned artists to paint murals on the end walls of houses in crowded estates. Hull, the Combination at the Albany, Beaford, Cannon Hill, among others, now run their own theatre companies. The future will see more centres responsible for their own product, commissioning their

own work, generating local talent, touring plays and music and exhibitions which have been created in the locality or by their own staff.

The sheer range, quality and volume of arts activity presented by the centres is hard to summarize. The Maltings at Snape premières a new Britten opera; the Harbour arts centre introduces the inhabitants of Irving to the songs of Marie Lloyd. World in Collision gives a programme incorporating electronics, large percussion set-ups, and space projection techniques in the Birmingham Arts Lab. At the New Metropole in Folkestone, the Alfred Deller trio sings Purcell and Dowland accompanied on the lute. In city after city, night after night, presentations are making the arts accessible for every man at all stages of life. The diversity of this activity is abundant evidence of the continuing vitality of the nation's artistic life.

Sociability

Why do people visit arts centres in the first place? Is it because they have seen a poster or been attracted by a specific event? Because they have a feeling they would like to take up an activity, or because they are invited along by friends? Whatever the reason that brings them there in the first place there is no doubt that it is the hospitable ambiance which makes them want to return. For, as Alec Davison observes, 'having liked the feel of the place they may like to join and do something for themselves – particularly when what they have seen doesn't look all that difficult and looks fun.[17] From first to last the emphasis must be on making the place an attractive one in its own right.

There are numerous ways in which people can be attracted, and once attracted made to feel that they belong. The building itself must have a sympathetic quality: clean and bright and warm; affectionate like the best primary schools. There must be a sense of purposeful activity: plenty of spaces for talking and relaxation, workshops, and an auditorium (or auditoria) where performances take place. Ideally the visitor should be able to spend the whole day there, eating, resting, watching a film, reading, making something, looking at things, meeting friends.

The social area provides not only the focus but the services which make visitors and members feel at home: a bar with refreshments, a restaurant providing full-scale meals. Some

45

centres include a pre-school playgroup, a crêche, a book room or old person's room. Food and drink provide wonderful stimulus and support. At Bracknell, one of the bars leads directly on to the terrace so that visitors have a drink without feeling an obligation to get involved. 'One thing an arts centre can do', comments Peter Stark, 'is to pull people together; provide a focus. It can provide mutual support through new friendships which are made outside the work situation, outside the street, but within a community of interest. The arts lab is particularly relevant here. There was nowhere for people of the type who now go to the Arts Lab in Birmingham before it existed, apart from a few pubs in Moseley'.[18]

Yet if one of the prime functions of an arts centre is to bring people together, its ambiance is, of necessity, more complex than that of a pub. Even the marvellous community singing at the Red Lion at Dinas Mawddwy is, in that respect, not enough. Vastly more important, as the focus of unfolding sensibilities, the arts centre must provide a shelter where vulnerable people can develop the courage to dig deep into themselves. As a place in which 'this pervading sense of support, used not as a prop but as a springboard for a peaceful explosion of imaginative activity and learning'[19] can take place, the arts centre, in its appearance and ambiance, is a means of aesthetic education in its myriad forms.

Obviously running an arts centre is a more complex business than running a pub; as Chris Carrell has pointed out, success depends on balancing up various factors:

One needs to get over the danger of being seen as an institution, as a bureaucracy, which is so hampering to, say, art galleries and further education classes. I think that the feeling there is both detrimental to the public's response and the actual quality of the work. One of the main problems of an arts centre is actually to woo people in. Not only are we dealing with subjects which are difficult but arts organisations are such that the public need to be persuaded to come into them – and once in, to feel welcome, feel happy, feel relaxed.

A tender approach is essential. But a tender approach that can be varied according to the different needs of, on the one hand, disco kids and on the other, the middle-class people who are put off by the discos. So one has got to look after the

ambiance for them as much as one has to look after it for young children, teachers, old people, for all kinds.[20]

It can be freely admitted that if few centres achieve this tenderness, Sunderland does. Inhabiting a corner house in a row of nineteenth-century domestic dwellings it contains not only a print workshop, bookshop, social club and bar but a gallery and performance area. The atmosphere enlivened by posters, paintings and flowers, is a sensitive amalgam of the intimate and cheerful, the fervent and sane, the visually handsome and the intellectually alive. Down-to-earth conviviality and rare aestheticism are equally at home. Yet in the last analysis Sunderland, like all the centres, has less to do with works of art − objects and performances − and the buildings in which they are housed, than with people; the people who manage them, the people who go to them, the artists who perform. It is the rich pattern of contacts, meetings, and shared experiences within a cultural situation which, as Robert Atkins observes, is what they are all about:

> I can come in to the bar in the evening and there will be a group of lads who have arrived on their bikes playing darts, and, perhaps, another group from the Ladies Circle. I won't say actual exchanges take place between them but at least people no longer question it. They accept that if they come here they will see people other than their peer group and they must share the facilities with them. I ask you, do you believe this could happen anywhere else?[21]

It is a question which some institutions have yet to ask.

Resource centre
In a chapter of his book *Tools for Conviviality* Ivan Illich writes about his vision of a new kind of society resulting from 'social arrangements that guarantee for each member the most ample and free access to the tools of the community and limit this freedom only in favour of another man's equal freedom'.[22] Appropriately enough the chapter is called 'Convivial Reconstruction'.

'Tools' include equipment, advice and information which enables people to make things for themselves, freely, and at their

47

own pace. 'Convivial tools' says Illich 'are those which give each person who uses them the greatest opportunity to enrich the environment with the fruits of his or her vision.' Three London projects, the Combination at the Albany, Inter-Action and the Islington Bus Company, demonstrate varied ways in which convivial reconstruction is now taking place. The concept of the arts centre as a resource centre is illustrated through their work.

A distinctive feature of the Combination's work is its concern for children. That the arts could play a primary role in meeting the challenge of poverty seems at first glance a frivolous notion – a strained attempt to relate an essentially peripheral, ornamental pastime to individual deprivation and a deeply disturbing social problem. Yet the Combination provides some of the evidence that makes it foolhardy to dismiss the proposition:

Deptford is an area of multiple deprivations and little or no playspace, and so providing resources for play is an important part of the company's work. Basically, it has two aspects: the first involves the larger resources of land, buildings, finance and skilled people. Here it has been necessary to connect with local people and the local authorities, and help create an awareness of the potentialities of, and need for, children's play. Play was encouraged first of all on derelict sites; now there are six adventure playgrounds, four full-time, two part-time, where before there was only one. Local, voluntary, playground committees have been set up, money has been obtained from the local council and other sources, and paid play-leaders have been taken on.

The other aspect of the group's resource role is the provision of all sorts of things and people when they are needed. They include:

Inflatables	Live band	Painters
Mobile disco	Video equipment	Mobile music
Tape recorders	Theatre lights and	workshop
Mobile print	control	Supplies of play
workshop	Three vehicles	material
Clowns	Film projectors	Volunteers
Puppet makers	Costumes	

... and other assorted fire-eaters, jugglers, acrobats, stuntsmen, singers, stiltwalkers, tightrope walkers, magicians ... [23]

The Combination's belief in the importance of play is shared by other projects who have discovered that children are a common ground for activity, one on which adults can build a collective responsibility.

One of these, Inter-Action, has harnessed the power of children to involve adults, to help the community articulate its feelings and catalyse whatever action may be necessary to improve its social and physical environment. Dedicated to helping people find solutions to their own problems it has established a veritable panoply of 'tools' to build self-reliance among adults as well as their children. There is a free consultancy service for community and voluntary groups seeking advice on a whole range of problems, including fund-raising, pressure-group tactics and community festivals. There are a number of excellent handbooks of interest to individuals, voluntary groups and statutory authorities which tell you how to convert a bus into a mobile accommodation for educational play or the position of the battered woman in relation to the law. There is, too, a supportive structure of materials, equipment and advice on offer to community and voluntary groups. These include the free use of a Super 8 camera, tape recorders, portable video-tape recorders, TV monitors, loud-hailers and costumes, and the opportunity to hire (at cost) mini-buses, disco equipment, an electronic stencil scanner, typewriters and meeting rooms. Significantly, training courses are given in the use of all equipment as well as play-leadership, drama for young people, work with handicapped and special problem groups and so forth.

The third example of a resource centre providing practical support and training to community groups operates from an office and workshop in Islington open to every group in the borough. In fact the first essential feature of the Islington Bus Company is that it has financial security from year to year as a result of a contract with Islington Council who meet all running costs, even though it is accepted by the council as an autonomous body. Ian Fletcher explains: 'Islington Council originally accepted the proposal that the Bus Company should study social and recreational deprivation in the borough and try to help stimulate self-help neighbourhood groups. Obviously many of these groups will exist to pressurize the council and criticise it for failing to provide adequate services, and many if not most local authorities are

unwilling to fund a resource centre which encourages and helps create neighbourhood attacks on its policy. In Islington the Bus Company has succeeded in persuading the council that strong voluntary organisations are an essential means of ensuring that local people can present their views and participate in decision making processes.'[24]

Almost everything the Bus Company does has, in fact, a training or an information function. The office has an electronic stencil cutter, a duplicator, collator, guillotine, IBM golfball typewriter, photo copier, simple layout equipment, silk-screen printing equipment, disco, barbecue, loud-hailers, Polaroid cameras, 16mm film projector and portable video equipment available without cost to groups. However, the equipment is not just left for anyone to use or misuse; it is part of the Company's policy to ensure that one member of their team is always available to train groups how to use the equipment. As their name suggests, the Bus Company's resources are also mobile. They organise projects on housing estates and playgrounds and in the summer of 1975 three projects were carried out each day. The Company offered the 200 groups in Islington a selection of projects which could be booked and these included kite making and flying, mask making, use of video, do-it-yourself newspapers, bus and fishing expeditions and a puppet show. Their twenty-six seater bus is on the road every day. The lower deck is designed to encourage play activities for under-fives and there is a sitting and cooking area for mothers. The upper deck can be used for meetings and outings. Like Inter-Action, the Bus Company also publishes roneoed leaflets and organises courses and training workshops for play-leaders, youth workers, tenants and parents.

The Bus Company has succeeded in the difficult job of gaining acceptance with a wide variety of community groups. Yet although the present range of its work is exceptionally broad almost every arts centre which is anything more than a performance arena can also be described as a resource – a resource which may have a role of unexpected importance in the future.

Cultural change occurs so quickly in our society that the concept of continuing education has rapidly gained ground on both sides of the Atlantic. Although longer school attendance is currently popular among politicians the end of the present school

50

and university system may be in sight – men and women may then increase their knowledge (using that word in the widest possible sense) whenever and wherever the process of learning can take place: in many of the cultural and scientific institutions, for example, whose resources might be tapped for a 'school without walls'. The arts centres throughout Britain are models of the kind of agency where self-determined learning, pre-training, in-service training and re-training can naturally take place. They are the new resources of an educational revolution in the making. We shall need them if the future is to belong to the small and the personal, to a reintegration of art with life, and to the interplay of real community feeling.

Young people

According to the American writer Charles Silberman, most schools giving their students a powerful and effective aesthetic education, teach them

> that an interest in the arts is effeminate or effete, that study of the arts is a frill, and that music, art, beauty and sensitivity are specialised phenomena that bear no relation to any other aspect of the curricula or of life. ... Children also learn to disparage the arts and to relegate them to a highly specialised and trivial segment of life by the way in which schools deal with the aesthetic. If taught at all, art and music generally are taught as separate subjects, offered once or at most twice a week by specialist teachers. Beauty is thus defined as something to be concerned with for an hour or so a week, not as an intrinsic part of everything people do.[25]

This is a good description, even though it may seem a little pessimistic. Or is it? By the time his schooldays are at an end the average young adult has prepared himself for the world: he will have discovered that the fine arts are not functional in terms of his emotional needs; that creative expression has no place in the work where he will spend the next fifty years. On the whole ugliness will pervade, like salt in the sea, every aspect of his life.

Commenting on the position of the creative arts in the secondary schools, Malcolm Ross, Project Director of the Schools Council's curriculum study *The Arts and the Adolescent*, has observed that 'arts education, for all practical purposes, remains a

matter of only peripheral general concern. Neither the arts subjects nor the teachers have ever been taken seriously. Such has been the reluctant conclusion of every major educational report published in the last fifty years and such is ours'.[26] It is abundantly clear that in this, as in so much besides, the school is a microcosm of the world.

Yet the prospect is not wholly bleak. As the educational climate becomes more sympathetic to their work, arts teachers are beginning to achieve more success than at any time since the introduction of compulsory schooling. Up to a few years ago it was necessary to be 'artistic' in order to account for an interest in the arts. Now with the support of a more understanding attitude concerning the role of creativity in schools a growing number of children and young adults are discovering the pleasures of expressive activity for themselves.

Even the Schools Council's report concludes on an encouraging note as it describes the resurgence of artistic activity at the grass roots of our society: the main theme of this book.

If we take a bird's eye view of arts education for a moment and in particular of that shadowy border country that lies beyond the school ... we shall notice much that is exciting and encouraging.

Art is now taught in every school in the country – primary and secondary; music and drama in one form or another are also widespread. ... Testifying to a growing interest in the arts, local authorities are steadily increasing their specialist advisory staff. ...

In different parts of the country specially-equipped arts centres have been established, and these offer teachers and their pupils resources and opportunities they have been quick to take advantage of. Judging by the number of schools recommended to us as remarkable for their work in the arts, it would probably be fair to assert that there are more good teachers at work in our schools today than ever before, many of them bringing to their schools a new breadth and liberality of outlook – linking their pupils with the artistic resources of the local community. Schools are visited not only by musicians and actors but by poets and writers, artists and craftsmen – many of whom, like the actor-teacher for example, are ready to

52

work with the children. There has also been recently a vigorous growth of opportunity for young people to follow up and develop their interests in the arts outside the school, continuing after they have left. Art colleges open their doors to youngsters after school hours; teachers, students, youth leaders and artists themselves give up their evenings, weekends and holidays to work in drama workshops, music centres and in the clubs.

Equally encouraging, if not more so, children and young adults are involved in their own culture outside the school context. The world of rock music combining elements of drama, dance, music and ritual in an entirely original way, has meaning for millions for whom 'the arts' have no meaning at all.

Against this background of activity the arts centres have an untraditional role to play; a role defined as much by their independence from the schools, their ample resources and specialist staff as their commitment to and understanding of the arts. Within the formal system collaboration between voluntary centres and the statutory authorities is often very close. Kendal runs a linked course programme for South Westmorland schools which includes video, woodwork and jewellery-making as well as photography, painting and pottery. The Cumbria Education Committee pays the salary of a full-time craft teacher on the Brewery's staff. At Beaford, Devon Education Committee have appointed a full-time teacher to direct the residential courses which are held for primary and secondary schools throughout the year. The courses are often children's first experience of sustained activity in the arts. Other independent projects like Shoreham Youth Workshop and Cannon Hill have made special provision for children and young people whilst they are growing up. The general programming plan at Cannon Hill is to provide for young children in the mornings, older children in the afternoon, young adolescents in the early evenings, and in the later evenings, to provide for young men and women. A continuous day-time programme of theatre, puppets, films and music is visited by many thousands of school pupils every year. On a rather less formidable scale every director anticipates and welcomes parties of children to exhibitions, films and performances – a number of which are specially arranged during school hours. Occasionally a

centre seeking a new relationship between artists and the schools, one that is direct and takes place in the classroom, not in the auditorium, will send its own staff into a school. This can mean personal, active participation, rather than the anonymous viewing of performances or one-shot demonstrations – engagement rather than detachment, involvement rather than entertainment, questions rather than answers.

The specialist local-authority youth arts centre is a relatively new kind of educational phenomenon. This is also a place of exploration and experiment: a place where the processes of education develop uninterruptedly, a place without division into fragmented, sequential episodes. Alec Davison, Director of the Cockpit Youth Arts Workshop, notes acutely that 'single periods on the timetable circus are invariably non-starters'.

> The practicalities of running a school for anything from 600 to 1,200 young people in forty-minute 'gobbets', punctuated by bells and the whole rigmarole, often works against all the intangibles at the heart of education. It seems to me increasingly that 'education by gobbets' is just not sufficient – it may be useful in the learning of languages though even that is in some doubt nowadays – but for most other things it seems to mitigate against itself: whatever you generate in forty minutes you have lost and have to regain when you are together again. Working for whole days, or even for a week, on intensive projects, without bells and without the constrictions of a time-table, may be more helpful but it is extremely difficult to set up in a school. So I think that what an arts centre can do is provide a different atmosphere for young people to work in. Here is a chance to work with creative staff from the arts centre itself, a relevant form of in-service education; new ideas, approaches and techniques are experienced and the pupils seen in a new light.[27]

Each of the existing workshops, of which there are now over twenty, is very different. But any one of them is likely to fulfill all or some of a number of roles described by Alec Davison, in the following terms:

> *A specialist group-activity youth centre*, a bridge between school and the wider society, focused in creative explorations

in the fields of drama, music, visuals, movement, film, and allied arts, in the main for young adults but with widening concern.

A human resource centre of practising animateurs – artists, actors, composers, musicians, film-makers and craftsmen who have a rich and inspiring contribution to make to education at all levels but not necessarily in terms of commitment to the classroom.

A practical resource and experimental training centre for teachers and youth leaders to share with the *animateurs* in the development of materials and techniques, gaining a clearer philosophy of aims, objectives and practice for their work in the creative arts in schools and clubs.

A regional resource centre of alternative education through the arts ... for all kinds of non-academic and academic pupils and students to share new relationships, understanding and awareness through a strongly felt experience of the participatory arts during their school day for follow-up back in the classroom.

A welcoming and lively social and community centre partly for its own community of users; partly for the wide range of ages and conditions of people who will make up its audience when projects are publicly presented; and partly for the community of its immediate neighbourhood in which it finds itself and in which its members will want to involve themselves.[28]

Many of the youth arts workshops have been established by the Youth Services, some operate within the framework of adult education, others solely as a teacher centre or as a youth club; a great part of their time, therefore, is devoted to youth activities and evening work. Many operate a different workshop session every night. At Shoreham the evening courses include a scratch orchestra, dance and mime, jewellery-making, play rehearsals and stage management, film and theatre workshops and pottery on successive nights. There is a full-time workshop team of fourteen. At Cannon Hill between 250 and 300 club members enjoy a wide range of different activities including fencing and woodwork every night. The Cockpit offers sixteen exploration

55

groups as well as regular programmes of performances by visiting companies. Public performances by such groups as Moving Being, Hull Truck Company and the General Will are interleaved, at the West End Centre, Aldershot between courses in drama, mime and dance. Similar programmes of courses and events are offered at Llanover Hall, the Tower in Winchester, Wallsend Arts Workshop, the Dovecot in Stockton and Oval House in Kennington, the forerunner of all youth arts workshops since Peter Oliver joined it in 1961.

Unlike their parents before them, children have been taught since the war to have confidence in their own creative powers. Many are richly creative, ambitious, aroused by what they have discovered in themselves. Yet how often do they leave school only to find little or no outlet in work or leisure? How often do they hit back in the shape of violence, hooliganism and despair? This single fact − the revolt of the young − is the most damning evidence of the 'system's' inability to prevail on its own terms.

Yet if it cannot solve this problem, the youth arts workshop is a model of the kind of agency which could provide a sympathetic and supportive bridge between school and the world outside.

The tremendous concern of the arts centres for young people is not, however, limited to a direct relationship with the formal educational establishment. The majority of *animateurs* prefer the liberty of the streets to the imprisonment of the schools. Their work in all its rich variety is described in many pages of this book. But wherever the activities take place, in schools, in specialist youth arts workshops or in the environment in which young people live, the aim − expressed by Christine Gregory of Llanover Hall − remains substantially the same:

> Of course, there are people who say 'Why bother? What's it all about? If people are getting along without the arts, why go to the trouble of getting them involved?' The answer is that young people shouldn't be content just to switch on a TV to entertain themselves. Llanover is a place where they can come and switch themselves on. And we like to think they can get something valuable out of it.[29]

Underlying this aspiration, underlying the work of arts centres as a whole, is a passionate concern for the capacities of each of us − young children, teenagers, men at work, women at home, the

retired, the lonely, the old. Within the period of little more than two decades we have seen the steady destruction of the myth that material abundance, based on materialism, can conceal the inherent poverty of bourgeois life. We have seen the rise of a new demand for the realisation of human potentialities, in a fully rounded, balanced, totalistic way of life. The new order, as John English observes, is rooted in the recognition that the barrenness of the age lies in the deprivation of man's imaginative life:

> By and large the old causes, the old deprivations that want relieving – like absolute poverty, holidays for kids, boots, soup, things of that kind which were only the day before yesterday – have largely disappeared. And in many ways voluntary service through hospitals and care for the sick and so forth has largely disappeared too. But for the next 20 or 25 years there is a cultural deprivation to remit – in the sense that 99 per cent of the children in this country have to be thought of as cultural orphans: their own parents would not feel equipped to introduce their children to things of which they have no experience themselves – like taking them to the theatre or introducing them to making music. This is a whole new area of concern.[30]

The artist

It is one of the centre's primary aims to institute a programme of fellowships for young talented artists who will be invited to live and work at the University with as few strings attached as possible. If there are new means of presenting or integrating the arts, the centre should be among the first to bring them. The presence of painters, sculptors, actors, musicians, writers, dancers, should help to emphasise the inter-relationship, the essential unity of the arts – an idea that has been fundamental to the entire Sussex approach. Artists who are often isolated in their own discipline need opportunities of closer, at times, active, contact with their colleagues in other disciplines. And there is a gap between art and the academic world that needs to be filled. The arts centre should enable faculty and students to gain informally, and through personal contact, a deeper insight into the creative process and an awareness of the arts in modern society.[31]

The Artists-in-Residence scheme, described above by Walter Eysselinck, the first Director of the Gardner Centre for the Arts in the University of Sussex, involves a residency of one term. The artists are paid a fee, given accommodation on campus and the use of a small studio in the building so that they can concentrate, at least for a time, on their own creative work. Elsewhere bursaries and fellowships have been introduced to encourage photographers, musicians, sculptors and dramatists to work in community situations. In remarkable contrast to the immediate post-war years patronage of the living artist during the seventies has advanced by leaps and bounds.

Direct help to artists, however, is not necessarily restricted to awards. The Chapter workshops and arts centre was set up, as Chris Kinsey explains, to provide a 'centre that contained studios where artists working in all fields could rent space on the same basis on which they rented space at St Katherine Dock at a half-penny a square yard That was something which Cardiff really lacked.' A third of the building in Canton (the old high school) is now let to potters, painters, sculptors, designers, film-makers, poets and musicians who work there 'because they have space to do their own thing'.

> Few of the people who rent the studios can make a living from it and most of them have to supplement their income by doing other jobs, like lecturing in colleges. One lecturer from Newport College of Art rents space. They haven't got anywhere to work in their own homes and they work here, but although these people work here individually in the building there is a strong community feeling between everyone. Chapter is a sort of umbrella over all these individual groups. ... They are left very much on their own to do their own work and of course with Chapter able to offer things like dark room facilities, performance spaces, exhibition spaces, and the cinema to show films, a piece of work can start in Chapter and go right through to the finished product, from beginning to end.[33]

On a smaller scale, projects like the Dove Centre near Glastonbury – a residential centre for craftsmen – and A.C.T. (the Young People's Arts Centre Trust) in St Albans offer space and enough teaching (and sometimes studio and workshop facilities

58

out of teaching hours) to enable artists and craftsmen to earn a living and practise their own work. The Arvon Foundation's two centres at Sheepwash, in Devon, and Hebden Bridge, in Yorkshire, are used for residential courses in music, poetry and jazz. All the courses are tutored by practising artists who live in with the small number of students attending each course. Practising artists and craftsmen often tutor the day and evening workshops run by the arts centres. Most *animateurs* have been trained as musicians, actors, visual artists, film-makers and so forth. Increasingly artists are natural members of a centre's staff, either for a limited duration as Artists-in-Residence or, more permanently, as actors, designers, musicians, or playwrights, on the full-time staff.

There remains, however, an extensive and very important domain of responsibility to the living artist: to wit, performances and exhibitions of his work. The whole of this sphere, so extremely important in itself, is an aspect of the centre's encouragement of the cultural life of the town or region in which it is situated. To exhibit paintings by local artists, to commission plays and music for performance, to publish new poetry, to create the opportunities for professionals and amateurs to work together, are all aspects of the responsibility to foster the artist and his work. Even when, as more often than not is the case, an artist's work demands a passive and accepting audience, when it interests a mere handful of people, when in fact it can only be taken on its own terms, even then, it is often important to make sure that it is seen and heard for its own (or its maker's) sake. In the final analysis the validity of any action cannot be assessed by its relevance to the general good: art by numbers is as dangerous a precept as art for art's sake.

3 OPERATION

Buildings

Arts centres shouldn't be necessary any more than churches. Art should be part of people's lives and they should not have to come to a special building to practise them. Ideally an arts centre should have an area of three hundred acres.[1]

So wrote the late Sean Kenny when approached to design a theatre and arts centre for the University of Sussex. Although he then went on to create a very solid building many working in arts centres would subscribe to his idea. One building, one focus for the arts, is not enough. Maybe this is simply because no building, however lavish, can compensate for the divorce of art from life.

Yet if we must have buildings, as it seems we must, for these to be reliable they must grow organically out of local conditions and local need. One example will highlight this point: Peter Stark's regret that he could not operate in Bracknell before he took on South Hill Park:

If I had been given the brief for the arts in Bracknell I would no more touch this building than fly – certainly not for five years.

It would be lovely at the end of five years, with a really vibrant thing going on in spaces all over the town, for the Development Corporation to come along and say, 'Look, we think we can let you have South Hill Park', because we would have had no building contractors in (except for specialist workmen) but the local community doing it for themselves. It would have been animated.[1]

Animation, like the arts, can take place anywhere and some would argue that there is no need to build a specialist facility of any kind; there are halls and rooms in every neighbourhood. In San Francisco there is, for example, no monolithic, centralised, arts centre but a number of co-ordinated facilities, a network of five district centres, centrally co-ordinated, but largely

autonomous. It is the Neighbourhood Arts Program. Play schemes, festivities, workshops and events flower from the tilth of daily life in the streets of each neighbourhood where an organiser and workshop co-ordinator are responsible for local programmes. There is an appropriate scale for every human activity and the more active and intimate the activity the smaller the number of people that can take part.

In a contribution to the report *Socio-cultural facilities at the urban level*[2] Birgitta Mattsson makes the same point arguing that there should be a pattern of cultural provision at many different levels: theatres, art galleries and opera houses in large cities; smaller but still considerable cultural centres, like the French Maison de la Culture, in towns (or districts of towns) with a population of around 100,000; different kinds of facility for populations of about 10,000, 5,000, 1,000, and even less – groups as small as 30 to 50 people. A glimpse of the essays at the end of this book will show that although we are still far from realising the ideal in all its complex potential, the individual models for the different scales of cultural activity are in existence. Perhaps we should now turn our attention to complementing the post-war flowering of large, purpose-built arts centres with thousands, even hundreds of thousands, of modest projects at the neighbourhood level before any further large scale developments take place?

The future is not only likely to see more ventures in smaller buildings – buildings as small as pubs or corner shops – but ones which have been established on a commercial base. The possibilities for this are manifold: a coffee bar or restaurant, a launderette, a co-operative food store run by local housewives, a printing works or a reprographics centre, a craft shop or agency. The point here is that the base offers a central focus to the project as a whole as well as providing a needed service; it offers an entrée to the local community and one healthily free of unhealthy inhibitions about 'the arts'. An interesting example, Centerprise in Hackney, operates as a bookshop, coffee bar and restaurant from premises in a row of shops in Kingsland High Street. A Hackney Play Association and a play-bus, summer and youth projects, a Women's Aid group, a housing association for the single parent, an advice centre, a food co-operative, local publishing and a community paper, silkscreen workshops and

adult education courses all owe their existence directly or indirectly to Centerprise. It is important to remember that existing barriers between 'education', 'commerce' and 'community development', can be broken down; that the concept of the school without walls, moreover, is no less meaningful than the existence of an arts centre in a shopping complex, in a pub or museum. Tomorrow the correspondence between 'art' and 'life' may be so close that one will be the simple manifestation of the other.

The astonishing variety of arts centres – and arts centre buildings – is now a commonplace. Those seeking to establish their own projects have a choice of visiting existing centres which have been housed in a fourteenth century city church (York), a maltings (Triad at Bishops Stortford), an engine shed (the Round House, Camden Town), a county jail (Abingdon), a disused school (Chapter in Canton, Cardiff), a wallpaper store (the Third Eye Centre in Glasgow) and a hotel (the New Metropole in Folkstone). There are arts centres in a fire station and a bath house. Other conversions include the adaptation of a magistrates' court in Hemel Hempstead; a run of British Rail arches in Kentish Town; and a range of stone-built farm buildings at Washington, Tyne and Wear. In the States there is an arts centre in a Methodist church (the New Place in Tampa, Florida) and a walnut store (Walnut Creek near San Francisco). There is no special or conclusive place.

Direction and staff

The recipe for an exciting arts centre is well-known: sufficient finance, an enlightened management committee, a building of some kind. But even when the finances are healthy, the committee liberal and the building has been featured in the *Architectural Review*, the level of meaningful activity can remain distinctly low, unless a final ingredient is supplied for the recipe: a coherent vision. The person who must supply that is the director.

The successful director is more than an able administrator, important as that is. As Chris Carrell observes:

If one becomes involved in an occupation like this then one becomes part administrator, part critic – in the sense that one chooses the activities which take place and one chooses them on critical grounds – part educationalist and part social

historian: a mixture of things combined. This is an aspect of arts-centre involvement which is often misunderstood because it is too frequently seen in terms of administration alone. That is only one aspect of what is far more exciting creative involvement.[3]

This creative involvement calls for qualities rarely found all in one person: a genius for enthusing people, a sympathetic understanding of the aims of artists, a wide knowledge of the arts and the capacity for maintaining a constant flow of dynamic new ideas (so that nothing becomes stale), must be combined with diplomatic, administrative and fund-raising skills of the highest order. The director must survive a regime of day-to-day pressures and remain as committed and inspiring as on the first day he started work.

It is therefore hardly surprising that the number of creative arts centre directors is so small. Those with creative ideas often flinch from the more mundane aspects of organisation, and those who understand the necessity for a strong organisation are often unheedful − or incapable − of vision and inspiration: the ideal director balances the freedom of creative endeavour with the discipline of corporate control; he provides the context in which individual members of staff are given the chance to innovate and experiment within an orderly financial situation and a shared philosophy about methods and aims.

What style is appropriate? It depends on what the centre is trying to do. The question of shared decision-making is crucial today. Some centres are run (more or less) democratically with decisions being made by the staff − and some of the users − as a whole. The Islington Bus Company and Great Georges project, for example, formulate policies at a democratic weekly meeting to which in the former case, all Islington groups are invited to send members. One person is frequently dominant in terms of sustained commitment and quality of ideas. In the larger centres the director often acts as a co-ordinator of a small team, each member of which, as the head of a department, is responsible for a different art form. The extent to which a director confers with his chairman or management committee also varies a great deal.

Yet, in spite of the pre-eminent importance of the director, it is important to remember that no centre is a 'one-man band'. The

best projects are staffed by a group of individuals working as a team.

The staff structure varies enormously from centre to centre. The larger organisations can employ people for their specialist contribution, but the smaller ones rely on all aspects of work being done by a few overworked jack-of-all-trades. It is the staff which are the centre-in-action, and their energy, skill and ideas, rather than the building, its greatest asset.

Finance
How are the arts centres financed? In theory funding is straightforward. The organisation raises revenue through the sale of tickets at the box-office, by charging fees for workshop sessions and by running a bar. As much as two-thirds of its total income can be raised in this way. But unless an organisation sets out to make money and do nothing else (in which case it would hardly be serving every sector of the community) the gap between earned income and running costs has to be filled in the form of subsidy from local, national or private sources available to the arts. There would be no arts centres in this country if support in the form of grant aid were not available. And what artists and the arts in Britain most of all need is money.

There are several sources of support to which an arts centre can go but it does not necessarily follow that help will be forthcoming. First, there is the Arts Council of Great Britain which assisted 1,220 client organisations or individuals in 1974/5. Few of these were arts centres. Separate councils take direct responsibility for grant aiding arts centres in Scotland and Wales. Second, but still within the domain of public funds, there are the fifteen Regional Arts Associations in England and Wales (and some area associations) which are far and away the most substantial patrons of the majority of arts centres (and their most valuable source of advice). Third, there are Local Authorities who, notwithstanding their unequal response, have now begun to take the arts more seriously. In recent years a number have established their own arts centres and it is worth remembering that it was a local authority which initiated the second arts centre to open in this country: Basildon, in 1968. But local government is important less in terms of the actual amount of money it is

64

currently contributing as in terms of the future. The final source of support to which the arts centre can turn is the private sector – industry and commerce which have made contributions, charitable trusts and individuals. Before discussion of the problems of financing an arts centre it will be useful to consider each of the four patrons in turn.

In 1976/77 the Arts Council received £36,000,000 (not including an additional £1,150,000 for housing the arts) in grant aid. In the context of government subsidy this is an almost invisible sum. We are spending £5,000 million on education but in 1972/73, the last year when statistics were available, we spent as a nation less than £100 million of public spending on all forms of the arts, from museums to galleries to music and the theatre. More recently the government has found £163 million to rescue a single firm. The arts cost very, very little money compared with national investment in any other public service.

About one third of the Arts Council's total budget goes to music, opera and ballet and a quarter to drama. In 1975/76 the Regional Arts Associations received 7.3 per cent (£1,777,000), the Scottish Arts Council, £3,000,000; Wales, £2,050,000. At the time of writing the Arts Council has direct responsibility for a small number of arts centres but these may be devolved to their Regional Arts Associations in due course. Arts centres which obtain their basic funding from their Regional Arts Association may nevertheless receive assistance from the Arts Council for special projects, touring, community arts and so forth. Other central government agencies which have provided grants include the Urban Aid programme and the Manpower Services Commission.

The majority of arts centres are the 'clients' of one or other of the fifteen Regional Arts Associations which receive on average about two thirds of their total annual income from the Arts Council of Great Britain (or Wales). As a consortium of the local authority, the private sector, the artists and others in the region each Association receives most of the remaining third from local government which also makes direct grants to arts organisations in some areas. There is wide variation in the total budget of the Regional Arts Associations which have diverse forms of organisation, constitution and aims. As a result, and because of the difficulty (not to say impossibility) of rationalising criteria for

giving grants to organisations with totally different individual requirements, arts centres are receiving different amounts of money commensurate with their needs. Naturally enough, the scale also varies: amateur clubs which present a limited programme of performances and exhibitions may receive a revenue grant or guarantee against loss of a few hundred pounds while the smaller centres with only one or two full-time members of staff may receive a few thousand; in 1975/76 Falmouth received £675; Plymouth £3,500, from South West Arts. In the same year two of the largest centres in the North received substantially more: the Brewery in Kendal £9,546 and Sunderland Arts Centre £22,500, from Northern Arts. Other arts centres in the Northern Arts area including the Dovecot in Stockton, the Holm Cultram Abbey arts centre in Abbeytown, Newton Aycliffe arts centre, the Carnegie theatre and arts centre in Workington, the Spectro arts workshop in Newcastle and Wallsend arts centre also received grants. In fact out of a total £543,933 which went to arts organisations and individuals in the five counties of Cumbria, Northumberland, Tyne and Wear, Durham and Cleveland in 1975/76 Northern Arts gave £92,723 to arts centres in its region.

Although local authorities have been empowered to spend money on the arts since 1948, before reorganisation of local government in 1974, it was only the county boroughs, the London County Council (later the Greater London Council), London boroughs, seaside resorts and certain local authorities, like Swindon, that had special interests in the arts in their areas that made most use of their powers. Little was spent at all in other parts of the country. The average rate product raised was less than 1d (in 1961/2, the net expenditure on the arts and entertainment of 532 authorities was a mere £2,549,186). Local government reorganisation included revision of the 1948 Act. In clause 142, the new Act removed the limitation on spending and all the new councils became free to spend at their own discretion on arts and entertainment. Notwithstanding the patchy response to the earlier Act there has been an encouraging increase in local authority spending on the arts over the last decade. Total local authority expenditure on the arts was estimated in 1972/3 at about £15 million, as opposed to the £2$\frac{1}{2}$ million net expenditure in 1961/2 mentioned above.

There is still wide variation in the way different local authorities approach the arts and the whole leisure field, and their readiness, or otherwise, to see them as an essential part of local life and something therefore that is part of the main fabric of local government responsibility. There is substantial hope that the greater emphasis on local community involvement and the growing debate about the *quality* of life will encourage local authorities to develop their own arts centres as, indeed, several already have done. Substantial annual revenue subsidies are accepted as a norm for Billingham, Basildon, Harlow, Battersea, Kirkcaldy, Abingdon and Swindon where arts centres have been accepted as an integral aspect of civic life. Yet this very roll-call of local authority arts centres would suggest that they are better fitted to run the more conventional and well-established arts functions than those which are more innovative and experimental in kind. The United Kingdom is rich in such institutions and it is essential that they should be preserved.

Local authority support for the arts is still so low down on the list of their priorities – beneath housing, education (of which, of course, it is an integral part), public health and the other public services – that support for the voluntary centres is often meagre. Chapter and York are average examples. Out of a total budget of £84,000 the Cardiff centre has to find nearly half of the money it spends: the Welsh Arts Council contributing £25,000 but the City Council only £4,000 and South Glamorgan £2,500. In 1975/6 out of York arts centre's total subsidy of £8,765 only £600 was contributed by York Corporation. Continuing support depends on council decisions year by year, so that precariousness as well as stinginess are characteristics of local authority patronage. In North Devon, for example, the grant earmarked from one council for the Beaford Centre was reduced from £2,500 to £1,750, not on account of any failing on the centre's part but because the opening of the council's own sports complex, absorbed virtually all its Leisure and Amenity Committee's annual budget. In company with other arts organisations arts centres do not know what they are going to get in subsidy from local government (or regional arts associations) until each new financial year has actually started. They have to assume that they are going to get something because they have to plan ahead. The vulnerability of their dependence on piecemeal and voluntary patronage has, and

67

will continue to have, a debilitating effect on those who staff the centres who claim with reason that it is they who largely subsidise the arts.

There is no requirement for commercial enterprises to support the arts, although many firms have given support for individual events, and occasionally, large amounts. The help given over the years by such grant-giving trusts, charities and foundations as the Pilgrim, Calouste Gulbenkian and Carnegie has been large in measure and adventurous in policy. In 1974 the Gulbenkian Foundation alone gave £289,070 to the arts. The continuing and substantial contribution of private philanthropists is no less impressive. Half the total capital costs of the Arnolfini conversion in Bristol were given by an anonymous benefactor and it was only through the enterprise of Peter Scott that the Brewery in Kendal was initiated.

These, then, are the waters of the lake of patronage in which the voluntary arts centres must go fishing in the hope of landing a catch. But the sport, though appealing to a gambler, gives little satisfaction to those who seek to sustain an enterprise without visible or guaranteed means of support. For them, the subsidy game is a cruel and wearing battle against an insecurity which should not and cannot be indefinitely sustained.

Like so many other aspects of our cultural life – like, for example, public libraries which now cost £100 million a year – arts centres must be considered beyond the economic criteria of the commercial world, and seen as just one of a whole set of cultural needs of which free, though compulsory, schooling is probably the most dominant.

Those who work in arts centres have faith that the waywardness of the present subsidy method, so wasteful in terms of lost time and nervous strain, will not continue indefinitely. In the long-term future they believe that both central and local government will consider that more expenditure can be allowed for the arts and that a larger and larger share of these monies will be allocated to those working in the regions and in the field of community arts.

At the time of writing, however, the arts are in such bleak financial straits that all those who are responsible for running projects can hope to do is secure survival. Several of the smaller, voluntary arts centres have suffered cut-backs upon an already

over-stretched (and therefore inefficient) organisation which give grounds for thinking that they will not survive. Others may be crippled by circumstances out of their control – a change in the balance of power in local government or the inability of local authorities or regional arts associations to sustain the level of grant aid they have given in the past. Like trees which shed whole branches in a drought they are visibly shrinking in size, health and confidence. Most of the longer-lived arts centres have passed through numerous ups and downs but the present period of economic restraint will prove the most testing if only because their grants, though large, are often unrealistically low. It is encouraging to find that although one might expect the arts to be such a low-down priority that they would be the victims of the first cut-backs, most local authorities have sustained the level of their support for the arts in 1976/77. Local government has begun to take the arts more seriously so that in spite of gloom there is real hope for the future.

Governance

In the topsy-turvy world of arts centres the role of the management committee is as variable as everything else. In Kendal the arts centre was not brought into existence through local demand, but through the vision of a local philanthropist who conceived the need for the kind of cultural and community development with which the Brewery has become associated. In Kentish Town, Inter-Action came into being through the work of an exceptional individual and the small team that he created. In Battersea a centre was set up because the local authority deemed it right that the citizens of that borough should enjoy recreational activities. It is hardly surprising that the controlling committees or boards, of the three centres should differ from one another, or that the relationship of the director to his committee should be different in each case.

Several particular obligations fall on the committee of an arts centre: to try to lay down a general policy in collaboration with the director (who should be an integral member of the controlling board); to control finance and approve the management pattern; and to try to weld the centre's activities into the life of the community. In fact the definition of a good board member, according to Hellen M. Thompson, former director of the

69

American Symphony Orchestra, is that person ' ... who is willing and able to exercise a considerable amount of influence on behalf of the organisation'. Although the committee normally require the director to work in regular contact with their chairman it should leave the day-to-day running of the centre to the person they have appointed to direct it. Artistic direction must never be stifled by over interference, excessive accountability, doubt. By its nature it can be evaluated only in subjective terms and the nervous committee member must, of necessity, leave a great deal on trust.

The actual membership of a council of management usually consists of representatives from education, local government, arts groups and community organisations and individuals chosen for their knowledge and understanding on the community, finance and, of course, the arts. As A. H. Marshall, in his excellent guide *Local Government and the Arts* has written, 'a knowledgeable and perceptive local government nominee, selected for his suitability, and backed by his authority, should strengthen an organisation which may well be in need of support. A good board will always welcome such a representative. The advantages are two-fold: to the local authority who benefits from the knowledge he acquires, and to the society which learns the local authority's views at first hand and at the same time enjoys the representative's personal help.'[4]

The problems inherent in local-authority control of artistic enterprises – which Dr Marshall discusses at some length – are likely to come increasingly to the fore as more and more authorities contribute towards voluntary centres or, more generally, initiate their own. In the latter case there is widespread agreement that the best formula is for the local authority to channel support through an independently-constituted, quasi-public organisation on which the local authority is well represented or even in the majority. The BBC and Arts Council have their own Charters which gives them a certain independence from straight political football. Chris Carrell of Sunderland discusses the main points:

I think it is as important for the organisation to be independent of the local authority as it is for the local authority not to have full responsibility. From the latter's point of view arts and

leisure – arts in particular, leisure to a lesser extent – are controversial subjects: hot politically. And on a political platform it's more easy to lose the support of the ratepayer that voted you into power by supporting arts and leisure than to win their support ...

I think the arts are far more controversial than the educational sphere so that there is far more likelihood of strong and public conflict. In most local-authority galleries and museums that I know, the level of independence, of judgement, of the specialists running those organisations is seriously hampered. Now this does not stop them doing very useful work certainly, but it does inhibit a fair amount of activity from being done which I consider to be vital for the creative well-being of an organisation. For example exhibitions or activities which only appeal to a minority have to be justified in terms of audience figures and are therefore filtered out. The balance is therefore lost: the development of minority interests in the community and the encouragement of experimental work in the arts are as important as anything else.

There is another point: it is the need for a very flexible approach in terms of day-to-day finance, which is another area where local authority and arts centres' methods are quite incompatible. We have had talks with the Borough Treasurer's department about our system of financing compared with theirs – well, it's as though one is talking a totally different language. For example when a young poet gives a reading, he wants cash on the night, to get on a train the next morning. We can't wait for four, five or six weeks for a cheque to be processed. Our petty cash needs are vast; more than any self-respecting local authority finance department could ever contemplate.

So one needs this day-to-day flexibility, this independence of judgement and this ability to operate in a controversial area without over-dependence on the demands of the lay public. Now these needs have got dangers and one has to rely on the sensitivity and integrity of organisers not to abuse this position of privilege. Of course, if the programme offends ratepayers to a quite disproportionate degree, the local authority has the power to cut the grant.

A certain independence by-passes all the dreadful, crippling,

bureaucratic structures which deaden initiative and vitality. And the interesting thing is that talking to the social services and education departments in this town they are also equally conscious of the need for the independence of this organisation. They don't want us to be, if you like, ensnared, because that would cause problems for them too.[5]

Lord Redcliffe-Maud reaches much the same conclusion when he observes that there will be no future for arts patronage through local government until locally elected representatives 'come to recognise that the public only gets full value from public money spent on the arts if politicians by a self-denying ordinance, keep themselves at arm's length from the artists and art organisations that they subsidise.'[6] It is nicely put.

4 MEANING

The mushroom growth of arts centres is a social phenomenon which, by any standard, calls for comment of some kind. Why have they arisen? What were the forces that have gone into their making? What purpose do they serve? In the course of looking at their history, their activities and operation it has been possible to glimpse some answers to these questions which, by their nature, are perhaps the most interesting and certainly the most intriguing we can ask. Before the final section in which the work of seven projects is described, we shall therefore endeavour to understand why at this particular moment the arts centres arose, coming into being not only because we have more leisure but out of some necessity, some great hunger of our time. So deep is the hunger, so great the quest for meaning, so powerful the wish for a return to a saner, more organic and unconscious life, that sooner or later our time will be seen by all for what it is: one of the great turning points of history in which new values, new aspirations and the new institutions in which to express them arose almost spontaneously and as if in accordance with some hidden will.

For in endeavouring to create a vital democratic art in correspondence with our democratic civilisation, the voluntary arts centres are not only working to dissolve the barrier which divides the specialist (who produces art) from the non-specialist (who consumes it); they are seeking, in their partial way, to reclaim the feeling values which are fast vanishing from the West. Each of the elements at the root of their work – the primacy of personal consciousness, the concern for meaning, the longing to wrest the arts from the professional and return them to the people who have somehow been left out – is worth detailed examination. Together they constitute a vital part of the reaction, perhaps revolt is not too strong a word, against the bleakness of depersonalised materialism so characteristic of the present reality.

The slow turn of consciousness 'inwards' and away from the objectification of existence which has dominated the Western

way of life for centuries, is a movement, only now beginning, which we must look into the past to understand. For as we are now experiencing them, some of the problems of contemporary life might have been avoided – or at least mitigated – if we had been able to understand the inexorable progression of objectivism in Western thought. This began in the seventeenth century when man, developing his scientific knowledge, his curiosity and mechanical invention, first mastered nature – in Francis Bacon's words, that he might 'be enabled to enjoy without any trouble the fruits of the earth and all its comforts' – by means of an entirely spurious ideal of objectivity. This objectivity derives from the procedures of Galileo and Newton and from the insistence – derived from Descartes – of a logical, deductive mechanism of thought and reality. It prefers the mechanistic to the living whole: the parts to the totality; the measurable 'product' to the immeasurable processes by which and through which an organism grows. It creates the illusion of an absolute reality 'out there', quite apart from the vivid participative sensory life of minds which experience their own reality in themselves. Thus the will to dominate, to specialise, to ´eliminate chance and the irrational has been implicit in all Western thought and behaviour since that time.

Such mastery of the external universe was acquired, as Roszak suggests, at a terrible psychological price. 'With Bacon and Descartes, we are legitimising an act of depersonalisation, a censorship of the very qualities of mind and spirit which have always been regarded as indispensable to the health of culture. Bacon had no doubt that act of censorship would be worth the cost. How confident can we be today that he was right?'[1] A growing number of people, for whom the narrowing of consciousness now falls within the compass of their daily life, are beginning to be aware that the price of finding oneself in the world has been that of losing the world in oneself. They are aware that people are increasingly incapable of experiencing emotion and recognising and honouring subjective experience in others. They know that the churches are empty and art degraded because we are starved and empty in ourselves. They are questioning the rational, extraverted assumption upon which the Western achievement (and Western culture) has been built.

We do not have to travel to the ends of the world nor return

many millenia in time to discover other societies in which the body's organic nature, the mysteries of the imagination and the capacity to dream are or were treated with great, but commonplace respect. Here is a mode of experience, wide-ranging and spontaneous, which returns in waking life as *art* – art as creative spirit; art as the embodiment of rich inwardness; of feelings and ideas as deep and fountain-like as the springs in the earth. Here, too, the most commonplace objects – a Sioux buckskin shirt, a farm waggon from Sussex, or a pitcher from medieval Spain – are irradiated by the energies of a creative power which heightens every act.

The same joy, the same delight in pleasurable creation characterises the collective life. Music and song are intimate elements of the ceremonies in which the meaning of group life is consummated. Dancing and ritual are aspects of religious rites and celebrations. Athletic sports, as well as drama, celebrate and enforce traditions of race and group, instructing the people, commemorating glories and strengthening their civic pride. Under these circumstances the idea of 'art for art's sake' cannot be even understood. People are simply, unselfconsciously, expressing an imaginative life which we and our ancestors have wilfully destroyed.

Can this be revived? What possibilities for regeneration, if any, can be envisaged for the West? The spirit of an impoverished people is not easily revived. Yet many people are already aware of a sense of longing for something which cannot be named: a feeling of being off-centre; of missing something which possessions, family, travel, wealth or status can never adequately replace. Though desertions and dropouts are still insignificant in quantity, something like large-scale withdrawal and reversal may actually be in the offing. Our grave labour problems, growing with an almost geometric progression as living standards have risen and social security increased, are a notable symptom of this all-pervading unrest.

Here, then, is a link between the growth of arts centres and the poverty in response to which they have grown up. For if work is meaningless, degrading and inconsistent with self-realisation, at least some people have found well-being and fulfilment in creative activities which enable them to give shape to their own feelings and their lives. If others are lost, cut off from one another,

75

no longer members of sustaining groups, small communities or boisterous families, they can be brought together in the celebration of each other and the communities in which they live. If opportunities for heightened experience grow rarer, people's hunger for transcendental intimations can be restored by experiences which fulfill their longing to be increased. Participation is individual self-determination: the antidote for powerlessness. Community is togetherness: the antidote for loneliness. Creativity is contact: the antidote to alienation. The necessity for art is again manifest, at crucial points in our social and personal styles of living.

But the signs of regeneration in our society are not limited to a revival (and re-interpretation) of art. There are many men and women on the path to liberation through new forms of spiritual communion, religion and hallucogenic drugs. Others are exploring the serious or joyous interplay of persons and busy working to recover the dynamic and transforming world of feeling, the subjective life. Yet amongst so many and varied manifestations of a fresh cultural transformation in the making the human imagination has played, and will continue to play, the supreme regenerative role as the solvent our world lacks. More than any other agency or medium, it was pop music which generated and energised what is called the youth culture. According to the psychologist, Erich Fromm, what he describes as 'collective art' might yet help to restore man to a spontaneous and complete expression of himself.

Man, in order to feel at home in the world, must grasp it not only with his head, but with all his senses, his eyes, his ears, with all his body. He must act out with his body what he thinks out with his brain. Body and mind cannot be separated in this, or in any other aspect. If man grasps the world and thus unites himself with it by thought, he creates philosophy, theology, myth and science. If man expresses his grasp of the world of the senses, he creates art and ritual, he creates song, dance, drama, paintings, sculpture.

Using the word 'art' we are influenced by its usage in the modern sense, as a separate area of life. We have, on the one hand, the artist, a specialised profession — and on the other hand the admirer and consumer of art. But this separation is a

modern phenomenon. Not that there were not 'artists' in all great civilisations. The creation of the great Egyptian, Greek or Italian sculptures were the work of extraordinarily gifted artists who specialised in their art; so were the creators of Greek drama or of music since the seventeenth century.

But what about a Gothic cathedral, a Catholic ritual, an Indonesian rain dance, a Japanese flower arrangement, a folk dance, community singing? Are they art? Popular art? We have no word for it, because art in a wide and general sense, as a part of everybody's life, has lost its place in our world. What word can we use?. ... For lack of a better word, I shall use 'collective art', meaning the same as ritual.

'Collective art' is shared; it permits man to feel one with others in a meaningful, rich, productive way. It is not an individual 'leisure time' occupation, *added* to life, it is an integral part of life. It corresponds to a basic human need, and if this need is not fulfilled, man remains as insecure and anxious as if the need for a meaningful thought picture of the world were unrealised. In order to grow out of the receptive into the productive orientation, he must relate himself to the world artistically and not only philosophically or scientifically. If a culture does not offer such a realisation, the average person does not develop beyond his receptive or marketing orientation.

... In considering how we can build a sane society, we must recognise that the need for the creation of collective art and ritual on a non-clerical basis is at least as important as literacy and higher education. The transformation of an atomistic into a communatarian society depends on creating again the opportunity for people to sing together, walk together, and not, to use Reisman's succinct expression, as a member of a 'lonely crowd'. ...

What are we to do? Can we invent rituals? Can one artificially create collective art? Of course not! But once one recognises the need for them, once one begins to cultivate them, seeds will grow and gifted people will come forth who will add new forms to old ones.[2]

Looking back on the last two decades since those words were written, seeing how much has been achieved, how much

accomplished, one has a sense that although the new synthesis in our social and spiritual life will not come easily, come it will. The first seeds have been planted. The people have come forth. The existence of the community arts centre which draws people together that they may sing and play and dance, is a demonstration that Fromm's analysis of the cultural situation was as far-sighted as it is exact. For it is the nature of life itself, after a period of growth, to seek to resume equilibrium, in order to be ready for the next act of growth.

In 1878, William Morris, poet, socialist, designer, delivered his first public lecture in which he spoke of the growing evidence of spiritual starvation in the prosperous society of Victorian Britain. Looking ahead to our own time almost a full century ago, he clearly saw where an exclusive concern for materialism was leading us. He saw, too, that the state of art was an expression of something degenerate in the general mind; the outward mirror of an impoverished inward condition from which we have not yet escaped. On these terms, he observed,[3]

> I do not wish her to live. ... I do not want art for a few, any more than education for a few, or freedom for a few.
>
> No, rather than art should live this poor thin life among a few exceptional men, despising those beneath them for an ignorance for which they themselves are responsible, for a brutality they will not struggle with − rather than this, I would that the world should indeed sweep away all art for a while as I said before I thought it possible she might do: rather than the wheat should rot in the miser's granary, I would that the earth had it, that it might yet have a chance to quicken in the dark.

Four years later, peering even further into the darkness of the future, concerning which he had many searching and some inadequate intimations, Morris spoke of his belief in the changes ahead, his 'hope for the days to be'. He called men back to the way of happiness which they had missed in the labyrinth of industrial life. And, in a powerful passage, sketched a sequence of events which anticipate the new culture we are now making, will continue to shape, and which has still to emerge. That the arts refused to die, and are now on the edge of a marvellous revival is due, in no small measure, to such a man:

Once men sat under grinding tyrannies, amid violence and fear so great, that nowadays we wonder how they lived through twenty-four hours of it, till we remember that then, as now, their daily labour was the main part of their lives, and that their daily labour was sweetened by the daily creation of Art; and shall we who are delivered from the evils they bore, live drearier lives than they did? Shall men, who have come forth from so many tyrannies, bind themselves to yet another one, and become the slaves of nature, piling day upon day of hopeless, useless toil? Must this go on worsening till it comes to this at last — that the world shall have come into its inheritance, and with all foes conquered and nought to bind it, shall choose to sit down and labour for ever amidst grim ugliness? How, then, were all our hopes cheated, what a gulf of despair should we tumble into then?!

In truth, it cannot be; yet if that sickness of repulsion to the arts were to go on hopelessly, nought else would be, and the extinction of the love of beauty and imagination would prove to be the extinction of civilisation. But that sickness the world will one day throw off, yet will, I believe, pass through many pains in so doing, some of which will look very like the death-throes of Art. ...[4]

5 THE LONG PERSPECTIVE

The sister arts of work and leisure were not always so estranged from one another as they are now. There was a time, and that time is not so far back, when both were thoroughly combined, when work was not experienced as something unpleasant to be avoided, or leisure regarded as a compensation and reward. In so-called 'primitive' societies, life follows a predetermined pattern in which both are inextricably combined. In such societies there are no clearly-defined periods of leisure as such; activities like house-building or hunting have their recreational aspects, as do singing and telling stories at work. 'Primitive' people tend to approach a great many of their daily activities as if they were play.

The slow pattern of life in pre-industrial Britain followed a similar course for hundreds of years. The actual scope or room to live had not been curtailed and work and leisure, man and the land, utilitarian necessity and creative expression, in spite of much oppression, were still woven together in one seamless web. George Sturt, an acute, sympathetic, but wholly unsentimental chronicler of change in the village describes the life of one small area that must stand for all the rest:

> Amongst themselves they would number a few special craftsmen – a smith, a carpenter or wheelwright, a shoe-maker, a pair of sawyers, and so on; yet the trades of these specialists were only ancillary to the general handiness of the people, who with their own hands raised and harvested their crops, made their own clothes, did much of the building of their homes, attended to their cattle, thatched their ricks, cut their firing, made their bread and wine or cider, pruned their fruit trees and vines, looked after their bees, all for themselves. ... Not one of the pursuits I have mentioned failed to make its pleasant demand on the labourer for skill and knowledge; so that after his day's wage earning he turned to his wine-making or the management of his pigs with the zest that men put into their

hobbies I think it likely, also, that normally even wage-earning labour went as it were to a peaceful tune. In the elaborate tile-work of the old cottage roofs, in the decorated ironwork of decrepit farm-waggons, in the carefully fashioned field gates − to name but a few relics of the sort − many a village of Surrey and Hampshire and Sussex has ample proofs that at least the artisans of old time went about their work placidly, unhurriedly, taking time to make their products comely. And probably the same peaceful condition extended to the labouring folk. Of course, their ploughing and harvesting have left no traces; but there is so much suggestiveness in some little things one may note, such as the friendly behaviour of carter-men to their horses, and the accomplished finish given to the thatch of ricks, and the endearing names which people in out of the way places still bestow upon their cows. Quietly, but convincingly, such things tell their tale of tranquillity, for they cannot have originated amongst a people habitually unhappy and harrassed. ... The Cottage crafts were not all strictly useful; some had simple aesthetic ends.

Still, their useful work must, after all, have been the mainstay of the villagers; and how thoroughly their spirits were immersed in it I suppose few living people will ever be able to realise. For my part, I dare not pretend to comprehend it; only at times I can vaguely feel what the peasant's attitude must have been. All the things of the countryside had an intimate bearing upon his own fate; he was not there to admire them, but to live by them − or, say, to wrest his living from them by familiar knowledge of their properties. ... He did not merely 'reside' in it: he was part of it, and it was part of him. He learned to look with reverence upon its main features, and would not willingly interfere with their disposition. ... [1]

But then came the machines and the first maniac onset of the Industrial Revolution took its toll: the link which had formerly connected work with leisure and both with nature was severed for ever. Millions of labourers, driven away by sheer force from the land, gathered in the cities in search of work and Britain turned over from a rural to an urban civilisation within two generations. In the course of less than seventy years − from 1810 to 1878 to be exact − fifteen thousand miles of railway were built

and scientific invention so multiplied man's power of production that when the population rose from ten to forty-one millions, the average production was perhaps ten times as great. 'What a nation this is!', exclaimed Lord Shaftesbury, 'What materials for happiness and power!'

True, the results were spectacular as regards the increase of the productive powers of man. True, in a span of only nine decades – the years between 1850 and 1940 – Western society created, passed through and evolved beyond two major epochs of technological history – the paleotechnic age of coal and steel, and the neotechnic age of electric power, synthetic chemicals, and the internal combustion engine. Recent years have finally opened the prospect of leisure-time and material abundance for all to enjoy on a scale the world has never seen before. Yet in our admiration of this 'progress', we have overlooked the advantages of the old system under which the tiller of the soil was a craftsman, and thus an individual, rather than a unit in an undistinguished mass of wage-earners with little personal pleasure or economic interest in his labours. We have doomed to disappearance all the skills which formerly used to prosper in the villages and condemned man to an urban culture which, for its many advantages, has prevented him from living out his own ancient culture. In such a situation no amount of material progress can make up for lives ground down by tedium and routine or the more impalpable sorts of bondage which threaten personal dignity. The great decline in feeling values, the repression of the religious sensibilities and the almost total destruction of the arts as a field of living experience continue to call into question the wisdom of a system in which productivity is pursued at the expense of the human satisfaction it is supposed to serve.

Although any generalisation about the *quality* of the work-experience which the working population as a whole are familiar with would hardly be worth the paper it was printed on, it is recognised that the majority of those who earn their livelihood in factories, down the mines or on building sites, regard work as an indignity or oppression. These, the producers, working in what Peter Berger has described as the 'basement of the industrial system',[2] comprise about one third of the total labour force. The repetitiousness of the chores, the lack of freedom to make decisions, and the impersonal nature of the organisation in which

such work is done have a deadening and depressing effect on most individuals. If much of this work has long ceased to be physically exhausting it has not ceased to be emotionally, psychologically or spiritually crushing.

An operative on the line at Fords reminds us:

> You don't achieve anything here. A robot could do it. The line here is made for morons. It doesn't need any thought. They tell you that. 'We don't pay you for thinking', they say.
>
> Everyone comes to realise that they're not doing a worthwhile job. They're just on the line. For the money. Nobody likes to think they're a failure. It's bad when you know that you're just a little cog. You just look at your pay packet — you look at what it does for your wife and kids. That's the only answer.[3]

The work of the bulk of white- and blue-collar workers — the giant armies of clerks, middle men, administrators and salesmen now servicing the producers — frequently less exhausting, is no less stultifying: 'a sort of gray, neutral region in which one neither rejoices nor suffers, but with which one puts up with more or less grace for the sake of other things that are supposed to be important'. In similar vein to the Ford operative a clerk remarks that 'unlike even the humblest worker on the assembly line, he doesn't produce *anything*. He battles with phantoms, abstracts; runs in a paper chase that goes on for year after year, and seems utterly pointless'.[4] Tasks such as these which seldom satisfy, enrich or confirm the personality are now the lot of the majority of workers in the developed countries, the beneficiaries of affluence chained to a lifetime's concentration upon a single occupation or task.

It is a sorry testament to the meaninglessness of work that men and women whose working week, reduced from eighty hours to forty hours in their lifetime, are still demanding more leisure for an intensification of life.

That leisure is a 'good thing', that there should be more of it, and that its pursuit provides the foundation of human happiness, are ruling assumptions scarcely, if ever, questioned. Yet one may look in vain for evidence that the leisure classes of the past were not bored and listless or that today's unparalleled recreational opportunities have even produced as much contentment, to say

nothing of life's fulfilment, as is taken for granted in those societies where the word leisure does not even exist. More than one observer has pointed out that the prospective achievement of universal leisure carries the threat of intolerable emptiness and boredom. There is no substitute for work except other serious work: varied forms of intense activity, multiple occupations, paid and voluntary, intellectual and physical, private and public. Relaxation, distraction, the slowing down of the tempo of all activities, may be needed to maintain psychological balance but cannot in themselves provide that recognition and fulfilment which our natures crave.

Unfortunately this is rarely achieved. The stultifying nature of most routines have an effect of what Thorstein Veblen ironically called 'the performance of leisure' which is so closely related to work experiences and attitudes that it is frequently a continuation of them. 'A stupid boring job makes a stupid boring mind', as Polly Toynbee experienced at first hand when she spent time working on a cake-baking assembly line. It is a lesson for those educationalists who believe that what we have failed to do is so to educate people that they welcome and use wisely the hours of leisure they have gained:

I was horrified by the work, and became depressed within a few days – tired and bored. In the evenings I had meant to take notes, but was too deadened by the day to do anything except watch television. That kind of work gets right into the system. You can't shake it off when you get home and settle down to something rewarding and creative.

Sociologists who examine the so-called leisure problem might find the answer lies in work. What will people do with more leisure time? Look how they waste it now in bingo halls, the palais, the pub and down the bowling alley. Why don't they go home and read a good book? Throw a pot or two in the pottery at the local arts centre? Have play readings and chess tournaments? Take evening classes, learn a language or two? Paint pictures of sunsets in the municipal park? Read poetry beside the fire, or even write it? Couldn't they expand their minds in the evenings, so that they wouldn't mind about the drudgery of their work? Can't they spend their money on anything other than drink and the dogs?

84

Such William Morris thoughts about the worker who loves to weave and paint of an evening are a long way from how things really happen. ... It seems to me, from my own experience, that the level of interest in one's work corresponds exactly with the level of interest in one's leisure. ... The mind is like a stomach; it expands or contracts to suit the requirements. If it isn't required to stretch itself, it will tailor itself neatly to become a machine.[5]

Bored by work, estranged from experience, cut off from those sources of imaginative and social experience which nourished their ancestors, people are manifesting their deep-rooted dissatisfaction in a variety of ways. Behind the constant bickering, the sudden walk-outs and strikes, the growing incidence of crime, mental breakdown, escapism and stress, lies a mounting anger and frustration. Millions of individual men and women, neither stupid and insensitive, have blindly sensed that our vision of life is all wrong. They are questioning their commitment to society. A great change is evident, and must come. What we need is some glimmer of a vision of a world that shall be, beyond the change. 'Otherwise', as D. H. Lawrence observed fifty years ago, 'we shall be in for a great débâcle'.[6]

Symbolising this transformation the voluntary arts centres are now beginning to feel their way towards the values and aspirations of the new age – a reverie of what might be, and a reminder that only we can make it. But 'art' for them is not a separate or specialised activity. It is a set of active decisions about how we shall live: how we shall work, how we shall regard the natural world and its many forms, how we shall liberate the creative power and initiative latent in every human being. They therefore abjure all specialised facilities, professionalism, expertise which denigrates; seeking, rather, to absorb the aesthetic into the general stream of life, so that the meaningless or sterile dichotomy between work and leisure, art and life, is finally broken down.

Then, perhaps, no longer at war with ourselves and therefore with one another, no longer divided from work, families, God, the inner life will once more blossom and flower, not as the mere delicate growths of a sequestered hot-house culture, not as 'art', but *spirit*, spirit imbuing everything a man touches with the same sense of liveliness and beauty which once vitalised the earth.

85

Matter at the service of spirit, matter become one with spirit; that should be the aim of our future.

At that decisive point we shall perhaps all have gone back to manual and more diversified work — not for profit, but for the sake of living a fulfilling and a balanced life. We shall perhaps have gone back to the small face to face community, the decentralised unit, because it is through community and work that the fulfilment of personality can alone be achieved. We shall perhaps no longer need the arts centres. But who can tell? The future has many unknown elements that cannot be discovered until they make their appearance.

First and foremost, however, we have a responsibility to our own time and place; for whilst we may dream of a better world we must do our best in the one in which we live. Work is often dreary, art a refuge; the centres, small and insignificant, poorly financed and little used. Yet whatever our assessment of their individual or collective value they, too, are doing the best they can in difficult circumstances by quickening and vivifying the life of the neighbourhood in which they exist. Robert Atkins expressed this to perfection when, speaking of Kendal, he observed that the true meaning of an arts centre — to borrow a phrase of John Cowper Powys' — was 'the attainment of as thrilling a response to the magic of life as a person's temperament allows':[7]

> What we would hope to do here is simply enable people to find ways of coming to terms with other people, to find satisfactory relationships with something outside themselves; a book perhaps, or birds, steam engines, Beethoven string quartets. There are different kinds of pleasure. If your love is requited; that is it. That is enough.[8]

What he is trying to do must now be shared and taken up, taken further, by thousands of others. The seeds have been sown. The gifted people will come forth.

6 SEVEN MODELS

The remainder of this book consists of essays concerning a wide variety of arts projects all but one of which is building-based. The Telford community arts project has been included because it would be dangerously misleading to think that the work of an arts centre takes place exclusively under one roof. It does not. In fact this project (and others like it) is important precisely because it is meaningful in its own right and not merely as a development which finds its final fruition in a centralised arts building. An 'arts centre' can be a single room.

The selection of these rather than other models may require a word of explanation if only because the omission of several projects such as Cannon Hill or Inter-Action, may be noted. Those included have been chosen according to no qualitative measure but because it has been judged that their stories deserve to be better known. With the deliberate exclusion of a large performance-orientated centre (such as the Arnolfini or the Gardner) it is to be hoped that this choice presents as representative a picture of the complicated and many-sided nature of the movement as space allows.

The account of the arts in Swindon also calls for explanation. It has been included not only because it is a notable example of enlightened local government patronage but because it places the arts centre in its rightful context alongside theatres, sports activity and museums, not to mention schools, colleges, polytechnics and universities.

A PEOPLE, NOT BUILDINGS

The Telford Community Arts Project by Catherine Mackerras
and Graham Woodruff

*Catherine Mackerras trained at the Centre d'Animation Culturelle
in Montbeliard, France, working with Jean Hurstel on a grass-
roots community arts project in council-housing estates.
Subsequently she ran an Adventure Playground in Sparkbrook,
Birmingham. Graham Woodruff, formerly an actor and theatre
director, has experience in adult education, youth work and
remedial drama. He was Director of the Department of Drama and
Theatre Arts at the University of Birmingham until 1974.*

*Together they drafted a proposal for a community arts project at
the beginning of 1974. They were able to interest West Midlands
Arts and the Telford Development Corporation in the idea and so,
with further support from the Arts Council, they started work on
the Sutton Hill estate in September 1974.*

*Telford Community Arts is an independent, non-profit making
company, registered as a charity which now receives financial
assistance from the Arts Council, West Midlands Arts, the Wrekin
District Council and the Telford Development Corporation.
Initially the work was concentrated on the Sutton Hill estate, but in
1976 they appointed a further three full-time workers, and are
about to open a community print shop and expand activities to the
South Telford area.*

Approximately 5000 people live on Sutton Hill, one of the new
housing areas of Telford, Shropshire, of which 80% are
corporation tenants and the rest owner-occupiers. Some basic
social and recreational amenities were planned from the outset,
and on Sutton Hill these comprise three shops, a pub, play-centre,
primary school, library, church centre and community centre. In
the surrounding area there is also a youth club, a comprehensive
secondary school, and a joint-use sports and leisure centre, as well
as the amenities which existed in the neighbouring village of
Madeley before the New Town was built. There is no public
building specifically for the 'arts', not even a cinema, although the
Telford Development Corporation has planned an arts centre as

part of the phased development of Telford Town Centre — which is four miles away from Sutton Hill on an infrequent bus service.

On Sutton Hill itself, most social and cultural activities focus around the local centre, particularly the community centre, the regular meeting place of several clubs and groups organized by the residents, such as the Senior Citizens' Club, Chess Club, Gingerbread Group, Keep Fit Club, Bingo Club, Pre-School Playgroups, etc. However, there are considerable barriers even to full usage of somewhere as local and familiar as the community centre. A huge percentage of Sutton Hill residents never go into the community centre, either because it has nothing to offer them, or because many are too timid, too tied down, too weary, too cut off from each other or too self-demeaning to come forward of their own initiative and participate.

The problems of isolation and alienation which are said to be characteristic of New Town life certainly exist on the new housing estates of Telford. The corollary of this, however, that its inhabitants are apathetic, pill-popping, self-centred cogs in the machinery of our consumer society, has been so grossly overstated that local residents often identify their neighbours as such. We have been repeatedly told 'You'll never get anything going here! People just dont want to know! Everyone here is out for themselves,' usually by people who themselves engage in a whole variety of creative and recreational activities in their spare time. In our experience, the people who live in the new town are individually no more lacking in opinions, interests, or 'culture' than anywhere else, but often the social relationships have yet to be developed, the channels of expression to be organised. This lack of communication, and the devaluation of themselves and their neighbours, are the main barriers to participation in community affairs, and the provision of buildings bears little or no relation to these problems.

In order to stimulate participation and motivate interests, the policy of Telford Community Arts has been to invest in *people* rather than bricks and mortar. Initially choosing to work in depth with the residents of one housing estate, we decided to live on Sutton Hill, using our house as a working base and finding existing buildings if necessary once the interest for activities had been generated.

Starting with two full-time workers living on the estate, our

first job was to discover the demands, interests, activities and existing resources in the community by making contact with as many local residents and groups as possible. Many methods of contact have been used, from leaflets and articles in the local press to meetings with local organisations and societies and becoming involved in existing community activities such as the Senior Citizens' Socials and children's playgroups. The most fruitful methods, however, have been systematic door-to-door contact for specific projects (e.g. forming the Women's Group) and the informal and random contact gained by virtue of living on the estate. We believe that it is essential to live as part of the community for a considerable time, using the same pub, shops and other facilities, in order to be in a position to offer an identifiable contribution to the community and be of real use in their terms. Local people are rightly suspicious of 'professionals' who pop in and out of similar situations, staying for a year or so and 'experimenting' with them. The community artist's credibility and effectiveness depends on his or her long-term commitment and presence in the area.

Sometimes we have tried to meet a very clearly expressed demand, such as that for a Film Society giving regular screenings of popular films in the community centre (the nearest cinema is six miles and an awkward bus ride away): at times we have built on initiatives from a group, such as organising a community pottery at the suggestion of members of the Women's Group, and at others have encouraged an individual interest to become more community-based – the formation of a brass band, for example, which is run by a local enthusiast. On some occasions we have provided the initiative ourselves, such as drama workshops, video projects and May Day festivities which local people would probably not have identified with their own interests until they had experience of them.

Our immediate task on arrival in September 1974 was to offer our services to the Carnival Committee, as the first Sutton Hill Carnival was to take place a week later, organised entirely by local residents. Our suggestion of making a record of the day on video was enthusiastically welcomed, so we borrowed some equipment and made the tape. A week later, the video was watched by about five hundred local people during a day of continuous showing at the community centre. When the Carnival

Committee reconvened for the following year, we were asked to be members, and the involvement of artistic activities in the carnival has developed at their request.

This introduction to video aroused interest in the potential uses of a video-tape recorder in the community, and several projects emerged quickly. Since then, more than twenty-five projects have been undertaken by groups of all ages. These projects have varied from records of community events (May Day, Carnival, Sports Day) to original TV plays by teenagers (about baby snatching, getting away from Sutton Hill, teenage pregnancy etc.) and an elaborate adult documentary project on local history as remembered by the old folk in the neighbouring village. An awareness of the role of video in community action has also developed, and several tapes have been made by groups to further their particular cause. The Women's Group made a tape about the inadequacies of existing play provision on the estate, with proposals for a site that could be developed into a local park for mothers and toddlers; a group of residents in one street are making a tape about the dangers of heavy traffic near their home, and the pre-school playgroup is making a tape to illustrate the need for more extensive play facilities. In such situations, the process of making the tape is generally an important factor in strengthening the unity of the group, and the presentation of their case to the relevant authority is considerably more forceful. Many of the Women's Group said they would have felt intimidated and tongue-tied if asked to present their case verbally at a public meeting with the local authorities. However, when the meeting took place, the video was simply switched on, and the eight council representatives listened to the women's case uninterrupted for twenty minutes. In the right hands, the potential power of video as a weapon in the cause of community action should not be underestimated.

The policy of Telford Community Arts towards buildings, of first stimulating interest in an activity and then finding the right place for it, also applies to the provision of resources and equipment. We wanted to prove there was an active demand for video before deciding to invest in our own, and therefore made the first twelve of the twenty-five tapes mentioned above using borrowed equipment. We believe this policy not only to be sensible economically, but also in terms of impact in the local

91

community. We have found that people are suspicious and resentful of the 'fairy godmother' approach where everything is handed on a silver platter, not least because it means decisions have been made on their behalf without consultation. However, once the interest has been motivated and the demand expressed it is important to act quickly and not to be restricted by bureaucratic procedures.

The other major resource which has been provided on Sutton Hill, again in response to a clear demand, is a dark room, converted from a bedroom in Telford Community Arts' base in Severn Walk. We intend the next important development of resources to be a print-shop, probably based in the district centre, and designed to serve several estates in South Telford. The aim of the print shop would be to assist all forms of printed expression and communication in the area (posters, leaflets, magazines, art-work, design, etc) and to enable local people to learn and control the processes involved (duplicating, offset-litho, graphics, fabric printing, silk screening etc). As with the video, this would be an area of close relationship with community action, and, as with all physical resources, will need a full-time community artist to develop such a relationship successfully.

It is evident that the pattern emerging with regard to the provision of facilities is not oriented round any one centre. The need for equipment and workshop space will certainly grow, but such provision is likely to evolve naturally round many varied focal points throughout the area (e.g. converted garages, corner shops, community houses, playgrounds), so that facilities will be dispersed rather than centralised. This spontaneous pattern of development is continually thwarted by laws, restrictions, and notions of prestige, and particularly so in a new town where the planners have left very little room for unplanned growth or alteration. However, if the majority of the population is truly to participate in decisions affecting their environment and lives, this problem of dependency on the authorities must be challenged and changed. Community Arts or 'cultural animation' can be only one of many factors in this change.

Many community arts activities on Sutton Hill have required a building, at least to begin with. We have used the sitting room at Severn Walk for the initial meetings of several activities (Drama Groups, Folk Club, Women's Group, Film Society, Video

The old Coach and Motor Car Works building in Chester was due to be demolished in 1973. The Arts and Recreation Trust now runs an active and successful programme of classes, exhibitions and events there and provides a meeting place for many of Chester's voluntary organisations. *Photography by ICI Mond Division*

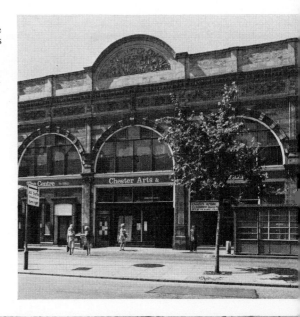

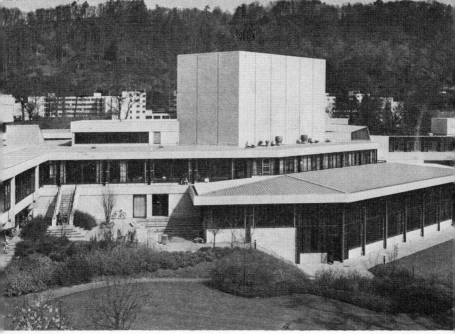

The custom-built arts centre at the University of Stirling opened in 1971 and presents a regular programme of touring drama companies, music, films and exhibitions. There is a Theatre-in-Education company which performs from time to time in a small studio theatre. *Photograph by Audio-Visual Aids Unit*

3 The Cockpit in Marylebone, London, is a purpose-built arts workshop being visited by many hundreds of young people every week. Yet to make contact with those who might not visit it the Cockpit Outreach Community Art Team takes performances and activities into the neighbourhood. Here they are presenting a project on the Lisson Green adventure playground. Many of those presen will be encouraged to take part in Saturday sessions in the Cockpit.
Photograph by GLC Photographic U

4 Audience participation in the conte of a play *Hello Sailor* created and performed by The Combination at the Albany. The Combination's energetic advocacy of agit-prop-style performances in the streets and community halls of Deptford laid sound foundations for this anc other popular productions in its own theatre, the Albany Empire.
Photograph by Chris Schwartz

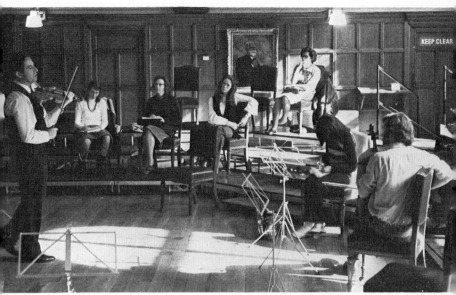

Battersea's workshops opened in 1974 after the local authority had agreed to turn the old town hall into a community arts centre. They encompass a wide range of popular classes but minority interests are important too. In this photograph a master-class in violin playing is held over a weekend. *Photograph by Chris Schwartz*

Arts centres have a responsibility towards living artists and minority interests no less than the art of the past and that which appeals to large numbers. A photograph of Tom Leonard reading his own poetry, in the Third Eye Centre, Glasgow. *Photograph by George A. Oliver*

7 Cardiff's Chapter workshops and centre for the arts was established in an abandoned secondary school in 1974. Yet in addition to its activities in the building – performances, films, exhibitions – it sends activities into the streets. Seen here with local schoolchildren are Cardiff Street TV, a group of professional video workers originally set up with a capital grant from the Calouste Gulbenkian Foundation and the Welsh Arts Council, and now fully integrated into Chapter with a grant from the Manpower Services Commission.

8 To celebrate the centenary of their Primary School in 1976 the market town of Hatherleigh in Devon organised a week's festivities culminating in a fête and pageant in the school grounds. The pageant, co-ordinated with the help of one of the Beaford Centre's community arts workers, involved local people in a dramatised reconstruction of the history of its school.
Photograph by Chris Schwartz

Groups) and have spread to other places when necessary. We frequently use the community centre, just as other community groups do, but for some activities we have used other venues – a local pub for the Folk Club, someone's home for the Singing Group, the playcentre for the Youth Drama Group, etc. However, the tendency towards activities which are not building-based at all has increased significantly. Nearly all the groups have at some time done projects in the open – the Brass Band in the shopping square, folk-singing and dancing in the street on May Day, street parties organised by local mothers, building an outdoor brick kiln, street processions and open-air play-schemes for children, video 'on location', and street theatre from a lorry in the car park. Despite the weather, this appears to be a welcome and natural development, mainly because the response to outdoor activities tends to be much more positive, and people are contacted either as participants or spectators who would never go to anything in a building, even in their own community centre. Also, the design of the new estates in Telford lends itself perfectly to such activities, with their traffic-free streets, grassed squares and neighbourhood centres.

The development towards street activities has been clearest in the adult drama group, who have written and performed four shows in their first eighteen months, mostly unscripted, and based entirely on their own ideas and improvisations. The first, *Something Old*, *Something New*, was a full-length music-hall style show about life on a new housing estate, including scenes about family life, social security, shift work, the doctor, getting a house, and many other familiar situations. The second show, a twenty-minute street play, was an adaptation of *Jack the Giant Killer*, telling the story of Jack, a resident of Sutton Hill, and his struggle against the 'giants' who have robbed him of his independence and rights through history, and was designed specially for the Carnival, to be performed from a lorry. The third play, a modern version of *A Christmas Carol*, was also created for a specific event, the Senior Citizens' Christmas party, which took place in the community centre, and the fourth was a Mumming play, performed in the local shopping square as part of the May Day festivities. By attaching itself to community events of this kind, as on the last three occasions, and by performing in situations where a special audience does not have to be found, the Drama Group

has not only reached a wider public than in its first performance, but has also clarified its own role. By developing towards being a truly community-based theatre, many people have become aware that the public expression of local residents' views and experiences in theatre form can have a cohesive and stimulating effect on community relations, as well as being a convincing statement about everybody's spontaneous creativity and right to expression.

The most significant events in terms of community participation are, of course, the moments of wide-scale celebration, such as May Day and the September Carnival. The May Day festivities, which were initiated on a small scale by Telford Community Arts for the first year, included maypole dancing, folk singing, refreshments and an International Labour Day display all provided by local residents, with puppets and Morris dancers 'imported' from outside. Over five hundred people joined in the occasion, which took place in the shopping square on a drizzly weekday evening, and enough enthusiasm was generated to want to organise a much more extensive celebration the next year, this time to last over three days and include puppet workshops, more folk music, a Ceilidh, a larger Labour Day exhibition, a street market, and more visiting performers.

The Carnival is the biggest event of the year, planned by a committee of local residents throughout the year, who organise fund-raising, bookings, floats, side-shows, Carnival Queen, competitions, and all the other traditional ingredients of a carnival. Telford Community Arts has been involved in the carnival chiefly through the participation of the groups it has helped to form, and by setting up workshops through the summer months to assist the more creative and imaginative elements of preparation. For Carnival '75, the Drama Group and Brass Band both performed, Film Society members ran a display and a video tent, and most groups contributed stalls and floats. We also had overall responsibility for the procession, which consisted of twenty-two floats from the locality, headed by two giant carnival puppets representing Old and New in the region (an old farmer and a young woman factory worker) which had been made during a summer puppet workshop. Events such as these are not only important as an opportunity to share work done in the

smaller groups throughout the year, but also for the community to celebrate itself, to assert its identity and to create enjoyment and participation on a fuller scale.

It is our belief that community arts activities should aim towards a situation where everybody's right to artistic expression is recognised, where people participate in all the creative and decision-making processes involved, and, ultimately, where they control and are responsible for their environment and the issues that affect their lives. Community activities can help generate an energy and awareness that the community must organise itself to this end, but only if they are truly based on broad participation and collective decision. In our experience, the attainment of these depend more on people and processes than on buildings.

B SERVING YOUNG PEOPLE

The Cockpit Youth Arts Workshop in Marylebone by Alec Davison

After teaching English for six years in a North London school (taking productions to Germany, Czechoslovakia and Rome), Alec Davison lectured in drama at Jordanhill College of Education, Glasgow. Founder of Enfield Youth Theatre, author of Gaming and Simulation in Action, *he has been director of the Cockpit Youth Arts Workshop in Marylebone since its inception.*

The city of Westminster knows every urban contrast. Moving northwards from Parliament Square, Soho, Belgravia, Mayfair, the West End, up the Edgware Road life gets progressively seedier until Westminster disintegrates into Kilburn and Queens Park. Before this, however, lies the ward of St Marylebone, an unremarkable nineteenth-century network of artisan terraces, now being added to by a vast £15 million housing development built on the former site of the Marylebone station goodsyard. Sleepy and uncomplaining, Marylebone is squeezed between fractious Paddington and affluent St John's Wood.

Virtually linking these two sundered worlds is Church Street Market where antiques jostle with junk and where at the weekend everybody goes to ferret out cheap vegetables or occasionally gathers to watch the Cockpit Cart Theatre with another Saturday interlude entertainment on its medieval-style pageant float – the only licensed street theatre in the history of London. For off Church Street in a nondescript back street lies the Cockpit, a small, frantically busy theatre and arts workshop built by The Inner London Education Authority to serve the young people of NW London but especially of Westminster, a borough where over a third of its population changes every year, where a third is immigrant, and which has neither unity nor identity.

Of course it is an impossible task. But it is one that none of us involved would have wanted to miss the chance of trying. For though the Cockpit is open seven days a week from 9.0 a.m. to 11.0 p.m. or later, for fifty weeks of the year (and in one of its years of activities worked with over 35,000 young people for a

half-day or whole-day session – over half of that in schools and youth or community situations – as well as with its 250 regular members) it cannot hope to touch the imaginative needs of all the young people in an inner city. Yet after eight years of energetic striving, pioneering a wide variety of new activities and approaches within both the school and youth-service patterns of education, we can now champion the creative needs of young people and testify that they can only be met with much greater provision. Generous though the Inner London Education Authority has been in inspiring, building and managing the Cockpit, this must only be the foretaste of much more to come throughout London.

For there is an urgent need for people of all ages to be able to *play*. Not to watch and listen but to do and to make. Our imagination that enables expression to be given to the inner world of man has as much need for nourishment as all our outer-world needs of shelter and food. In fact play is the great negotiator between the unconscious and conscious within the human organism. It is the instigator of social relations, the source of all fields of endeavour, and the means, especially when shaped in some symbolic expression, of our coming to terms with some of our inherent 'divine discontent'. Group expression through a committed involvement in a visual, sound or action media can enrich relationships, make discoveries and generate new awareness, by giving a sense of worth, provoking fun and, through its insights, deepening values. It is *re-creative*, sparking always from enjoyment, and part of that vitally necessary balance to the materialism of a civilisation based on competition, acquisitiveness and beggaring our neighbour. Play-spaces or centres are as crucial to modern man, jam-packed in his overcrowded cities, as drains and hospitals – and all are equally concerned with health.

For too long creative play has been ignored as a dimension of the formal educative process of the secondary school which has straitjacketed young people to prepare them for a society of outer-world reality and then wondered why its pupils become so bored, alienated and aggressive when so little of their deep selves is called into play. The Youth Service has only echoed this and been bold in its Outward-Bounding and neglectful of any significant inward-bounding. Creative play, whether preliminary to

97

exploration in science and technology or the arts and humanities, is the central mode of experience on our quest for meaning in the life game. The city child, already hounded off the streets by motor-car and property owner, is doubly deprived of such outward and inner experience on that quest.

We find ourselves at the Cockpit attempting to explore that quest in very different ways from the expectations of our founding fathers. For the Cockpit was conceived in the heyday of the youth-theatre movement and was designed to be the most flexible but functional youth theatre built so far. It sprang from a most enlightened administration. In 1954 the London County Council appointed the ebullient Maisie Cobby as its first full-time drama inspector. She had immediately helped to construct a network of thirteen voluntary drama associations covering the whole of London. From the encouragement that these gave to school theatricals a pattern of link groups evolved as a series of bridges into the youth service, spanning that twilight zone before marriage or entry into the adult amateur theatrical company. In 1956 Michael Croft by founding the National Youth Theatre gave further focus to this spontaneous youth movement. But most such link groups or youth theatres frequently had no available school or club theatre to perform in and throughout the country were campaigning for some kind of provision. In most cases local councils did not acknowledge that need, and so the youth-theatre movement never caught fire.

In London, however, William Devereaux, then assistant education officer for further education, with Reginald Keeble, the principal youth officer, did respond to that campaign and conceived the idea of initiating four youth theatres in the four 'corners' of London. Each was to be something of a cultural Everest, with resources that would challenge young people's communication skills to their uttermost. But the youth service was impoverished and the arts had low priority anyway. In 1960 Geoffrey Hodson was also appointed as a drama inspector and was made responsible for all such developments, with a brief to be ready for the time when resources became available. In the meantime the only alternative was either to convert or to assist private initiative.

So in 1964 the darkened theatre of the Toynbee Social Settlement was refurbished and, directed by Donald Walker,

made into the LCC's first drama centre, later called the Curtain Theatre. In 1967 Peter Oliver, the 'patron saint of fringe theatre', was enabled to transform the Oval House Youth Centre at Kennington into a Youth Arts Centre. In 1968 the LCC gave 'Link Group 64', led by Maurice Copus, an old church to convert into the S. W. London Centre; and a team from the new Greenwich Theatre led by Ewan Hooper in S. E. London moved into another old church to create the Greenwich Young People's Theatre with some financial support and eventually 100% annual funding from the ILEA. Two private schemes evolved in North London, Ed Berman's Inter-Action at Kentish Town in 1969 and the Anna Scher Children's Theatre in Islington in 1968.

It was not until 1971, however, that the ILEA music inspectorate moved into its own music-teachers' centre and three years later that the art inspectorate set up one of its own. Finally 1976 saw the drama inspectorate moving its London drama concerns into its own base which, like the music and art centres, is also a school conversion. The Cockpit, the only purpose-built arts centre of them all, stands as witness to the dedication and persistence of those early pioneers.

For it was during the late sixties that a site of land from the clearing of an old primary school had been made available to the youth service and monies allocated. Edward Mendelsohn, who was involved with both the Jeannetta Cochrane Theatre and the Questors, Ealing, was appointed as theatre architect. As modern in feel as the local schools, in bush-hammered concrete, aluminium, natural wood and variously coloured brickwork, the Cockpit's total footage in two floors is 10,689 square feet, and its cost, including all equipment was £105,000.

The central arena of the Cockpit is an easily adaptable, grey brick box, 45 feet square and 26 feet high where 'anything can happen'. It looks most unlike a theatre, more like a television studio or a small aeroplane hanger – hence the Cockpit! Well provided with professional theatre lighting and sound equipment, a balcony, overhead grid and control box, the studio can be used as an activity area for stimulus and experience in any media during the day. Then with its four independent retractable seating units that are stored along each wall, it can be adapted into a theatre-in-the-round, thrust-stage arena or end-stage performance space within half an hour for the evening. Two dressing rooms, a

99

workshop scenic bay and small base for the theatre-in-education team service this space. Leading into it is a foyer which accommodates a small restaurant and a 100 feet of exhibition space to house monthly exhibitions of young people's or students' work. On a second floor are three studios, one for music and drama rehearsal and studio presentations, another excellently equipped as an electronic music workshop and sound laboratory, and a third a reprographic resource area and staff room. Our newly acquired van transports scenery to and from the basement of the parish hall a quarter of a mile away which now houses our construction workshop, wardrobe and dark room. Within two years we were bursting at the seams.

So the Cockpit, opening in January 1970, became the first new theatre of the seventies. From two of us at the beginning, there are now thirty full-time staff, boxing and coxing to keep the centre always ticking over – that is twenty-three *animateurs*, four technicians and three administrators, as well as many part-time staff. The *animateurs* form one arts-in-education team with a director co-ordinator. The team is divided into five close-knit departments in music, art, drama, community arts and theatre presentations; each has a great degree of independence but there is always scope for inter-action. This is a useful model for a faculty of arts in a comprehensive school (a concept which we are vigorously trying to promote) or in a specialist teachers' centre in a county or borough where local authority music, art, drama and dance advisers might be based together. In such an association there is political strength; integration is possible where relevant and desirable, yet each of the specialisms can operate in its own right and with its own discipline.

Our staff are employed under the terms of engagement operating in Further Education, some on established, some on annual terms of engagement. We work within the community education and careers branch of the local authority but a House Committee of authority members, elected representatives and co-options offers guidance and support, while artistic and educational policy is determined with the ILEA arts inspectorate. Ultimate responsibility is with Geoffrey Hodson, whose enthusiasm and encouragement have facilitated such rapid development. An arts workshop must be one of the most stimulating places in the world to work, especially where so

much freedom and trust has been given to get on and do what we think needs to be done. Like any arts centre we seem always to be going in a dozen different directions at once but out of the welter of a week's activities six distinctive areas of concern can be seen as the dominant elements of the pattern.

The Cockpit is first, and now perhaps most importantly, a regional *teachers' centre* in the arts for in-service education. All staff have an advisory element to their work. Regular workshop courses for teachers and youth leaders are conducted in all the arts and allied activities, especially in areas of drama and role-play across the curriculum; here theory is drawn out of practice. Classroom materials are devised, often with teachers, and produced on an invaluable off-set litho printing machine. Special teachers' and youth leaders' courses are also run in a variety of other establishments on request, increasingly in schools, with more extended courses during vacations, perhaps with the Department of Education and Science or other bodies.

All the work of our teams with pupils during the day, in schools and in the centre, also has an important in-service element with teachers able to see new ideas and techniques in action and watch their pupils react in different circumstances. Whole days or half-days, and not single periods, are essential for this.

Secondly, the Cockpit is a *workshop for professional artists* to work with and for young people and teachers. We can commission a playwright to write a play for our summer youth theatre or a new music-drama, can employ actors for young people's theatre, or musicians for a concert in the Queen Elizabeth Hall and composers to write pieces for it. An artist whose works hang in the Tate can explore visual ideas with young people on a weekend's workshop. Such people have an enormous amount to offer to the young and can relate to them in a personal and infectious way; yet they would feel castrated by the routine in most schools. It may be that increasingly schools have to look to a variety of nearby interest centres for the complementary education of senior pupils. Our own full-time staff is a mixture of professional artists and teachers, but because time-tabling is flexible they can still undertake commissions in their own field and we benefit from that experience and new contact.

In its third dimension the Cockpit is an *experimental resource*

101

centre of creative stimuli for senior pupils and students. The teams offer a whole or half-day's event that will leave a 'burning tracer' for further exploration in ongoing curriculum work. Over half of this kind of work is brought to the school or college, the remainder taking place at the Cockpit with up to fifty pupils, sometimes coming from two or three schools, a social education in itself. The *Theatre-in-education Team* of five actor-teachers, director and stage manager present one major project each term in association with teachers and advisers for fourth, fifth or sixth formers, using a variety of theatre-in-education and educational drama techniques. Usually once a year a GCE or CSE English drama text is explored; other projects will be concerned with social studies, or humanities, topics of general interest, such as Trades Unions, women's rights, law and order. In most projects the pupils are put within a participatory role or involved in active decision making. In *Coriolanus* sixth formers became citizens of Rome having to evaluate what the death of Coriolanus meant to them, with actor-teachers recapitulating as citizens some of the incidents that had led to his death. Sometimes introductory sessions are held in class at school and usually follow-up materials are provided.

The Visual Workshop is a four-man team contributing to art education the idea of large-scale environmental events based in the classroom. Frequently taking their stimulus from works of art in London galleries, the team transforms the space into an animated three-dimensional representation of aspects of the original, in which the group will then set up happenings, games or events within the theme. As with *Coriolanus*, here is a means of art appreciation that starts from engaging feelings and perceptions in action and within a structure that allows for play and further insight. The team works closely with an increasing range of galleries and museums, especially the Tate. Only slowly are these national institutions beginning to be used as a more positive educational resource. A recent major project on the Civil War involved three such galleries and proved a fascinating way of exploring history as well as art.

The third schools-based team, our *Music Workshop*, comprises four teacher-composers who are sometimes augmented into a larger ensemble for stimulus concerts. Otherwise they work as a unit or individually to make new kinds of music, or restructure

the established. Stimulus music will come from any century or style and team members have their own specialisms in pop, singing, electronics or percussion. Most of the work is group-centred, sound making, using instruments, electronics or arbitrary sound sources from the environment or the body, setting this in the framework of a game that will slowly be shaped into a 'piece'. Frequently this may be part of a movement or visual exploration demanding inter-group sensitivity. Lengthier teachers' courses and CSE music projects are run in electronic music studies for teachers and pupils to learn how to handle equipment which is increasingly available in London schools.

Fourthly, the Cockpit is a specialist activity *youth centre* in the arts for young people of 14–23 during the evenings and a wider age-range over the weekends and holidays. These exploration groups are on a continuum from absolute beginners, who mainly come locally or have worked with our schools teams, to those who have previously acquired skills and enthusiasm and want to work at depth. As with our work in schools our concern must be to be comprehensive, appealing to all sorts and conditions of young people, not only one class or kind. Of these fourteen or so groups, some are ongoing drama and music workshops and 'open' Saturday Sessions, others like the National Youth Jazz Orchestra, Cockpit Youth Theatre and the Movement Workshop aim at excellence. It is always more difficult for young people to feel that a place is their own when it is run by a local authority but there is wide enthusiasm and care for the facilities, and appreciation of the professional leaders.

The Cockpit is fifthly a *publicly licensed theatre*, professionally equipped for performances of music, mixed media and drama by young amateur and professional companies. In 1973 over 100 different groups involving over 1,600 performers were able to share their work over an evening, three nights, a week and sometimes a fortnight, with average audiences of 110 in the house. The centre is the only amateur performing space in Westminster, so attracts many local groups of all kinds, and its programme is comprehensive and catholic in taste. Some will be well-known material presented in new ways but more is experimental, often group created; and there have been scores of presentations of new plays and new music pieces, some now published. Summer productions have usually been the theatrical

highspot of the year, either with our own youth theatre or the National Youth Theatre working on a new piece. Regular festivals or educational arts jamborees are held. Whatever the event, the intimacy of the performing space brings a feeling of community rare among audiences in most other public theatres.

Finally and sixthly, the Cockpit is a springboard for *community outreach* into our own neighbourhood and the city of Westminster at large. Our *Outreach Team* of five community arts workers (with part-time helpers) working either as individuals or in pairs, have regular weekly commitments of many kinds; story-telling in local playgroups and nurseries; after-school children's arts groups in local clubs or schools; drama groups in a boys' hostel, schools for the handicapped, youth clubs, community centres, FE colleges and Senior Citizen's Centres. Special day or two-day projects at half-term, week-long Easter projects for special groups, an annual summer residential course for local school leavers (many of whom will then join our evening groups) and special courses for youth- and play-leaders are all daily grist to their mill. Stimulus theatre-in-education style projects on football hooliganism or justice have been taken around clubs and centres and a project on job redundancy toured adult day centres with subsequent follow-up and at times the permanent placing of a drama part-timer whom we can subsequently support. Advice and support is given to a host of youth-service situations and special undertakings made; all are completely varied and an enormous flexibility is required. Role play and improvised drama lie at the heart of the work, along with discussion, sensitivity exercises and good relationships. Whether in a youth club in the heart of Soho or off the Harrow Road, Outreach is a symbol of all our work – the constant blazing of new trails in the urban jungle orientated and empowered from a cockpit of educational change.

C SERVING AN URBAN AREA:

The Great Georges Project, Liverpool compiled by Dave Ward

Great Georges Project was set up by Bill and Wendy Harpe in 1968. Before this Bill Harpe had worked as a choreographer and theatre director: he was responsible for creating a touring production in Africa, and for the opening celebrations for Liverpool's new Catholic cathedral. Wendy Harpe had taken over the Bluecoat Arts Forum (as artistic director) in 1965, establishing it as Liverpool's major promoter of contemporary and experimental arts, and − as an arts association − providing services for fifty member societies.

All work at Great Georges is shared: this piece was compiled by Dave Ward, a poet who was a full-time member of staff at the Project in 1971–72, and is now running poetry events and publications in Halewood.

A large black chapel in Great George Street, Liverpool 1, one of the finest examples of classical architecture in the city: 'This TV recording is a commercial for the cultural project operating from this building. Anyone who is interested by the activities on this tape is welcome to come and join with us. The tape was originally made as a letter to a friend in America who had worked with us for a period of twelve months.'

Cut to
... *visiting jazz singer Jon Henricks hollering* Watermelon Man − *a concert in Great Georges basement, 1972.*

Cut to
... *a hideous moaning voice, electronic screams, a masked figure in a black cloak throttling a pretty girl − a fairground horror house created by John Ignacio (one of the older lads from the neighbourhood) with help from multimedia group Death Kit, 1971.*

Cut to
... *kids clambering all over an inflatable play structure − jumping and climbing to the disco sounds of Stevie Wonder singing* Living in the City, *1974. ...*

105

Great Georges was set up in 1968 by Bill and Wendy Harpe. Peter Moores was persuaded to buy a disused church, called 'The Blackie', which has been the base of the project ever since. From the start it was intended that the activities of the Project should begin to bridge the gap between 'the arts' and those who ignore, or who are ignored by 'the arts'.

Activities include playgroups, concerts, discos, film shows, street events, etc, with the participation of kids, teenagers, parents, pensioners and artists. The budget for 1975 (not including redevelopment costs) was £30,000. Income is mainly grant aid from such bodies as the Arts Council, the Home Office, the Granada Foundation, Liverpool Education Authority, the Rowntree's Social Service Trust, and donations from some forty companies in Merseyside and the North West.

The Blackie: First National Purpose-built Community Arts Project, a Building that is Unique in this Country, and probably Europe. From *7-UP*: a newspaper/report published by Great Georges.

The Blackie is currently being redeveloped. The interior of the old church, which focused totally on the tall central carved pulpit, has been stripped, and is being replaced by a structure of interconnected staging areas, workshops and playrooms where the artists are as likely to share the stage as take the stage.

This will mean that in the new Blackie everyone has even more chance of meeting and working with people from different cultural backgrounds. So, inside, the building will reflect the Blackie's location within a low-income, multi-racial area, at an almost magical point where the city centre, Chinatown, the Kent Gardens neighbourhood, Liverpool 8, the docks, and the University converge.

The first stages of redevelopment are being undertaken by building contractors with some help from Great Georges staff and friends – including a series of events set in the building site itself: such as a performance by sax-player Lol Coxhill, and a delicate 'balloon sculpture' stretching its way through the steel girders to the open sky. The later stages of rebuilding will be undertaken solely by Great Georges with local help from the neighbourhood: the people who will use the building will do the building.

While redevelopment takes place in the main body of the church, Great Georges has been concentrating on its activities as a publishing house, producing reports on its activities to date: including 7-UP, a tabloid newspaper covering the first seven years. Anyone visiting the Blackie will find games and workshops continuing on a smaller scale in the old domed entrance hall, where they can also see the redevelopment progressing through a special observation window; while in the office they can watch an extensive catalogue of TV recordings shot by Great Georges themselves using their own video equipment, showing activities and events at the Blackie past and present – including the video letter/commercial to America.

In 1972, Anna Lockwood's group of musicians visited the Blackie, not only to give a concert but also to take part in play-groups. They were invited to build a musical obstacle course for the kids to attempt to complete in total silence. Any slip or mistake would trigger off a sound. The challenge for the musicians was to devise not only an obstacle course which would be as exciting for the kids as balancing on a warehouse roof, but also present sounds which would stimulate an interest in how they were created, whether electronically or on small instruments.

In this way, practical music-making workshops were set up with some of the kids who would probably not initially be interested. This is an example of how the Blackie is able to create and stimulate an interest in new experiences without any form of 'cultural bullying'. This technique forms the basic structure of playgroups, where kids first enter a room of high-energy activities – swings and inflatables. From here they may be attracted into another room of quiet games and workshops which would probably be pushed aside or ignored if presented by themselves in an open playground.

A similar principle has been applied to the Blackie's open-air summer events: as in 'City of Games' (1973) which laid on activities and games in public spaces, launderettes and bus shelters – rather than the visual, verbal and cultural attack of a 'street theatre' performance which people are helpless to do anything about except just stand and watch. Or, as in 'Gifts to a City' (1971), a series of events which included waiters serving free tea,

coffee, biscuits, cigarettes and newspapers on an early morning bus: a subtle disorientation rather than a confrontation.

The question is no longer one of educating people to appreciate but of providing facilities and environments in which people can and are encouraged actively to use their own creative faculties. Wendy Harpe·

In 1973 Great Georges were invited to become visiting artists at Liverpool's Walker Art Gallery. They chose to present a participatory exhibition: 'Towards a Common Language'. A variety of 'works' – all rectangular, of various sizes, and made up of blank paper, blank board, and blank canvas – were displayed against a black background. The works were hung and lit with all the care of 'completed' works – and the exhibition was accompanied by a tape of Japanese woodwind music. The arrangement, at the opening of each day, had something of the formality and pleasure of an oriental garden.

On the floor under each blank work was a black box containing artists' materials – charcoal, ink, pencil, pastel, watercolour, gouache, acrylic paint, traditional oils and dry transfer. Some 1,000 people created drawings, watercolours, paintings or posters which they could put on exhibition in display racks, and then take home with them.

Participatory art requires, for success, as much daily practice as ballet. Bill Harpe

The staff were able to handle the mood of an event like this not only through a knowledge of the materials involved (in this case paint, canvas etc) but by dealing with people on an individual basis, controlling the atmosphere of background music, allowing instinctively the intensity of activity to rise and fall, to find its own level without them imposing any authoritarian control: in short, the skills which have been built up through playgroups, workshops and discos with kids.

The inner rapport which a team needs to deal with this manner of audience contact has been developed through staff games, which involve all the six to ten full-time staff, the seasonally varying number of part-time workers, and occasionally visiting friends.

The building is closed for one day each week for the staff games, and the evening staff meeting where all decisions are arrived at by communal discussion rather than a vote which splits the staff between those who have 'won' and those who have 'lost'. It is during staff games that the physical aspect of this philosophy is explored. For example, one of the first games played with the work-camp in summer 1971 was musical chairs (using boxes). First the traditional version, starting with forty-six people and forty-five boxes. As the boxes were taken away there was fierce competition to stay in the game, and not drop out and become part of an audience. Finally there was just one winner and forty-five losers. Then the boxes were put out again. This time when the boxes were removed everyone had to find a box; this meant people had to start sharing, holding each other to keep balance. Finally there were three boxes left round a central pillar and forty-six people all working together until they found a way of balancing everybody onto the boxes: forty-six winners and no losers at all!

In Easter 1974 the Blackie turned the senior playgroup into a 'casino': it was like a theatre event, with the whole set constructed as a gambling house, with plush carpets, low lights and drapes; roulette wheels and gaming boards for blackjack and dice; and the staff all in correct costume as tellers, card dealers, croupiers and house managers. The gamblers were the kids. At the start of the night they were each given the same number of chips and taught the techniques of the games of chance that they would already be picking up elsewhere in the city. Only here they could discover for themselves the problems and pitfalls of gambling, and hear each other talking about them on the casino's own radio station. By the end of the night they'd know whether they were really more likely to win or lose: and all without putting any of their own money at risk whatsoever.

The use of chance procedures — throwing dice, tossing coins, random selection — can reveal relationships and suggest new solutions which would otherwise remain hidden, can create an atmosphere of discovery and a greater readiness to accept the unusual. State of Play: a report on summer play activities, 1971.

Chance provided the basis for several other play events before the casino, and the recurrence of this theme emphasises the way in which the whole structure of the project is continually working to set up chance meetings and develop friendships between people who might otherwise make no contact with each other at all.

People who use the building regularly for one purpose can, and do, go on to explore other activities within the building with which they were originally unfamiliar. They might not be so keen to explore unfamiliar activities in an unfamiliar building.

... They do not sing as they Dance, They Dance silently like Wizards. From *Song of Lawino* by African poet Okat p'Bitek.

The kids who come to the Blackie have confidence in their ability to dance — both as a performance, and socially at discotheques — but lack the same confidence when it comes to singing. Generally they will dance when and wherever music is played, but only really sing when they are forming a group which hopes to perform.

This situation changed when The Persuasions came to the Blackie as part of their British concert tour in 1973. The Persuasions are an American 'a capella' group singing unaccompanied harmony based on gospel music. Though they generally tour big concert halls — such as the Empire in Liverpool — they were persuaded that if they came to the Blackie for something less than their normal fee then, although their visit might be a loss in financial terms, it would bring gain in every other way.

During their stay at the Blackie the Persuasions not only gave a concert for 400 people but also each member led a series of workshops. The kids not only learned to sing, but developed, through singing, 'the power to think, the power to remember, the power to listen'.

If you can walk
You can learn to dance.
If you can talk
You can learn to sing.
Jerry Lawson: The Persuasions.

The Persuasions themselves sing all the time — not just when they're performing, but in taxis, shops, and on street-corners.

Their presence, particularly in the workshops, seemed to release some of the cultural inhibitions against singing – and now at the Blackie people will spontaneously sing together in much the same way as they have always danced together.

Cut to
... a shape – a moving, abstract design. The camera pans back to poet Dave Calder sitting beside a video screen. He explains that the shape was created with video feedback by Paul Brown to accompany electronic music by Mick Trim for the multimediamoviemyth Kong, *1973.*

Cut to
... Jay-Jay, who has grown up with Great Georges playgroups and discos, performing warm-up exercises before he goes off to dance school in London.

Cut to
... the exterior of the Black Church, slowly filtering into focus: 'This gently distorting picture of the Blackie ends this commercial.'

GREAT GEORGES IS A

Community
for the benefit of the artists who work there, for the kids from the neighbourhood, for friends and new faces from the neighbourhood, the surrounding region, this country, and abroad, and for everyone young and old who comes into the building.

Cultural
for creative activities in the arts, games and sports of today (new ideas, very old ideas, the fine arts, the popular arts, the practical arts).

Project
for the benefit not only of people who come to the Blackie, but for people who don't (by way of Blackie tours, films, TV programmes, books).

7-UP

D SERVING A MARKET TOWN:

The Brewery Community Centre for the Arts and Sciences by Robert Atkins

Born in Leeds, Robert Atkins studied English Literature and Fine Arts at Cambridge. After working in formal education − he was Senior Lecturer in the History of Art and Complementary Studies at Birmingham College of Art − he moved to London first as Administrator of Joan Littlewood's Fun Palace Trust, and then as Promotion and Entertainment Manager of the Round House. He was invited to establish an arts centre for Kendal in 1971. In 1976, after he wrote this article, he took up his present post as Director of the Midlands Arts Centre in Birmingham.

Seen from London, the idea of establishing an arts centre in Kendal was attractive because of the size and nature of the town itself. Along with many others I had become frustrated in London because the various projects with which I had been involved were − perhaps necessarily − less concerned with any broadly-based neighbourhood community as with various communities of like-minded people drawn from different parts of the city. I imagine most big cities have developed along similar lines to London, into a number of districts with distinct social identities. 'Tell me where you live and I'll tell you who you are.'

This situation tends to dictate the sort of cultural provision which is possible. Central institutions, which aim to serve a whole city, specialise in particular areas of work because they have no neighbourhood roots and in order to survive they need to foster the loyalty of patrons on the basis of shared expectations rather than shared locality; neighbourhood centres in such a city are limited by the social and cultural uniformity of their particular area.

Kendal is certainly no ideal community, but it is of such a size (21,000) that the whole town could be regarded as one mixed neighbourhood. It seemed that an arts centre in Kendal would have the opportunity − denied to its opposite number in a city − of sustaining a broadly-based programme and of establishing a pattern of use which touched all sections of the population. That

possibility has been the fundamental challenge of the Kendal project. Everything we have done has been related – directly or indirectly – to that challenge and it is in terms of our success in meeting that challenge that I would like our work to be judged. We have been criticised locally – and by our Regional Arts Association – for the relatively low proportion of professional art activity in our programme, and also for what those committed solely to the maintenance of high standards in the professional arts sometimes regard as 'a permissive and uncritical approach'. I believe our programme can only be fully appreciated *as a whole* and in the context of the target we have set for ourselves. This target can be defined in terms of an attempt to minimise the effect of social barriers on participation in cultural activities.

The Centre tries to provide for the needs of those who have little and who demand little, as well as for the legitimate desires of their more articulate, sophisticated and assertive neighbours. The balance of the Centre's programme is intended to reflect the balance of the community and to establish – as far as possible – equal right of access for all. This is initially more a matter of respect and recognition than an attempt to foster instant 'cultural mobility'.

Clearly Kendal does not suffer from the deprivations of some areas of our cities – indeed it has numerous advantages as a place in which to live and work. But because many of the urgent and overriding social problems which prevail elsewhere are absent here, it *does* give an opportunity to study and experiment with the provision of cultural amenities in a relatively privileged area. It would seem that even when you have provided jobs and reasonable housing you still find monumental obstacles lying in the way towards a community which provides a full and satisfying life for all its members.

I was appointed a full year before the Centre opened to the public and this provided the opportunity to get to know the area, meet a large number of people, and form some ideas about what was going on in the town and ways in which the Brewery could contribute. It also – very fortunately – meant that the programme of drawing up the conversion plans for the building could be stopped until we had established through consultation a clearer idea of what was, and was not, required.

A couple of public meetings had been held before my

113

appointment and these showed a positive interest in the project but this interest had come mainly from art groups and from particular individuals, almost all of whom were apparently looking forward to an expansion of facilities in their own area of interest. I organised a repeat survey, but this time of *all* organisations and societies in South Westmorland. The response was poor, but I believe it had a value in that all the organised groups had at least the *opportunity* to express a view. I got some constructive ideas out of this survey and it did also produce a few additional contacts. Otherwise, I went the round of Women's Institutes, Lunch Clubs, local societies and public meetings wherever I could, in an attempt to explain the concept of an arts centre, answer questions and pick up ideas. I was invited out a lot – the Kendal Jazz Club, for example, spotted the possibility of a new home (the County Hotel was shutting its function rooms). The Westmorland Youth Theatre were also discussing their future and planned to move out of the YMCA building and in with us as soon as possible. These are just a few random recollections. In fact that year was very full. There were meetings of all sorts, including, of course, meetings with our own Trust which culminated in their acceptance of a policy statement which is still recognisable as an expression of the Brewery's aims (it was a flexible document!).

Lots of time – and lobbying – was spent over the matter of licensed bars. There was, initially, strong opposition on our own Trust to this proposition. Some members were totally opposed in principle; others felt that it could be bad for our public image. In the end we made an application for a full Justices' Licence. It was an act of faith by the licensing magistrates and we have not abused that trust. At this stage I should mention the continuous support we have had from the police. Apart perhaps from the Education Officers of Westmorland, and now of Cumbria, no other group of public officials caught on more readily to the potential benefits of the Centre nor gave more consistent help.

Slowly, the pattern was emerging, out of a compromise between my own – largely theoretical – ideas, and ideas that grew out of observation or suggestions that were made. I was more than ever sure that the 'open access' idea was right, but further, I could now see that the actual programme of activities would be best organised as a 'mixed economy'. By this I mean that some

events (mostly professional performances) would be promoted by the Centre, others by the users themselves, functioning as tenants, and still others as joint promotions. This pattern has stuck and a very large number of people are directly or indirectly involved in making decisions about the Brewery's programme content. I had also become convinced that our early programme should stress the popular, rather than the specialist side of our work. I felt it would be easier to draw in the specialist users when the popular audience had got its feet under the table, than the other way round. I think that has been the right decision, but all the time, and whichever way we play it, we do have the problem that an organisation which tries to cater for all (and has no membership scheme) denies itself the natural loyalty of any one group.

We opened to the public on the 9 May 1972, with a production of *O, What a Lovely War* which I directed, performed by a mixed company of amateurs drawn from several local societies. This was followed by a party in the Cellar Bar with music provided by the Kendal Jazz Band. The actual opening ceremony was performed by Stephen Lewis and Bob Grant (from ITV's *On the Buses*).

Among our earliest events were a number of regular weekly discos, aimed at particular age groups. The licensed discos for the over-eighteens presented little difficulty despite being full to capacity. All our serious problems came from the discos we organised for the under-eighteens. There were occasional fights (interestingly nobody ever hit us) but we managed to keep going until the final dramatic night which involved broken bottles, the police and − eventually − a conviction. We got more publicity in the local press for that one night's work than for anything − good or bad − that has happened before or since. The effect on our reputation was dramatic. We stopped these particular discos but the damage was done and we still haven't lived it down in some quarters. After an interval we started up again, but this time with professional assistance and with the whole event organised by a committee of the kids themselves. There was no more trouble.

Apart from the discos we have developed a highly successful regular programme of popular music − folk, jazz, rock and, recently, country music. On Sundays we have free licensed lunchtime sessions when local musicians come to play together. Out of these formal activities and the informal relationships that

have built up through them, the Brewery has become a place of resort for amateur and professional musicians of widely differing tastes as well as for their audiences. We have even produced a Brewery Big Band consisting of some twenty local musicians who arrange, rehearse and present an ambitious and successful concert four or five times a year. The Jazz Club continues to flourish and present a programme of major artists, mostly in the traditional field, but not exclusively so. Ronnie Scott has, for example, played at the Brewery more than once. The Brewery Folk, on a Sunday night, is also consistently successful, and has been for some time one of the major folk clubs in the North. Our music programme has gone from strength to strength and is probably our most effective single activity in terms of participation by local people.

Theatre has been a difficult area. Again we made early mistakes, particularly by booking shows unseen, on the basis of a hunch or unreliable recommendations. There is a major problem facing small venues like ours which has to do with the type of professional product available on tour. Most companies who are currently willing to undertake tours to small theatres are really best suited to universities and colleges or smaller city venues where 'fringe' productions can complement an existing conventional theatre. Although small, our theatre is the only one in the immediate area presenting professional work, and although we want to present a selection of experimental work from time to time there is a greater demand for solid conventional drama and we wish to meet this demand. Unfortunately, it is only companies like Alan Ayckbourn's Scarborough Library Theatre and Theatre North who are willing to work in places like Kendal at anything like an acceptable fee. Children's shows, puppets and – of course – amateurs do well, though the standard naturally varies. The Brewery has its own 'resident' amateur company and houses the Westmorland Youth Theatre. The theatre is also used for chamber-music recitals, public meetings and lectures and is currently having film projection equipment installed. Visits by companies performing outside the theatre in the grounds or in the town have usually worked very well.

As far as the visual arts are concerned there is a fundamental dilemma. We have always found 'performance' artists the most effective in our situation. Our gallery (which is in an open non-

secure area around the main entrance staircase) mostly shows the work of local artists on a first-come-first-served basis, with occasional low cost professional shows of, for example, prints or photographs. I'm not entirely sure what the right policy is but I am sure that most contemporary gallery work has very little impact on the casual visitor. Gallery work tends to have meaning solely for the initiated and these are a small minority in Kendal, whose needs, it could be argued, are met elsewhere. Kendal already has a museum and art gallery at Abbot Hall.

Craft work is a different proposition. We have yet to reach out beyond the first rank of enthusiasts, but a very high standard of work — particularly in jewellery — is being produced in our workshops by regular users, most of whom have had no previous experience. The member of staff responsible organises classes for adults and schoolchildren, and day and evening classes and special weekend courses. We have also set up a number of self-governing workshop groups who use our facilities without formal instruction. The available craft facilities cover jewellery, lapidary, print-making, photography and painting.

The extensive video set-up at the Brewery has up to now been regarded by us as a 'craft', mainly because of the restriction on its power to reach an audience beyond those directly concerned with handling it. This situation would change either if we had a full-time 'community television' *animateur* working here, or if we could obtain access to the local cable network — or preferably both. We are hoping to get partial access to the cable for schools broadcasts next year. The equipment is, however, used intensively.

Apart from these main areas of work, the Brewery houses numerous society meetings, a playgroup, a ballet and tap school, OAP's organisations, union and tenant association meetings, private parties and so on, in addition to the people who just drop in to sit around. We also work outside the building in schools and other centres, but, so far, only to a limited extent. Two squash courts are currently being constructed in the grounds by Kendal Squash Club. All in all around 3,000 people use the Centre every week, which makes for a busy life.

Although financed substantially from local private sources (the Scott family charitable trusts) the Brewery receives increasing grant aid from the public sector (County, District and Town

Councils, and Northern Arts). The costs of operating the Centre are high, at £67,000 in the current year, though they compare favourably with any equivalent local authority project. Eleven full-time staff are employed and this represents the largest single revenue budget item. Heating, cleaning, maintaining and servicing a building which is open 361 days in the year from 9.00 a.m. to midnight – and often later – is a necessarily costly undertaking, both in terms of direct costs and administrative effort. The sheer complexity of our financial records reflects the variety of the Centre's many activities.

We were trying – with considerable success until the current economic recession had its inevitable effect – to shift the balance of revenue support from the private to the public sector at present about 50/50. In this context, the LEA have been most responsive. Earned income from all sources (catering net profits, box office and hirings) continues to grow at a very satisfactory rate – £14,000 last year to a projected £20,000 in the current year. Costs are unfortunately also rising, but we are now changing to a system of triennial budgeting.

The Brewery has succeeded – painfully at times – in its aim of bringing many different sorts of people under one roof to pursue – actively or passively – their own interests. As in society at large, however, cultural apartheid prevails, and we have only really succeeded in improving the facilities for separate development rather than making a significant contribution towards integration. This work has certainly been worth doing in itself, although we are aware that we could have served any one group in the community far more effectively if we had specialised in their particular needs to the exclusion of all others. But I feel we could not have justified the resources involved being distributed on a deliberately selective basis when we constitute virtually the only comprehensive leisure provision in the area. Ultimately the barriers are created outside and will only be changed if and when society itself changes.

In one particular area there are grounds for guarded optimism. Our research project (see below) has established that social barriers affect young people here far less than they do the adult population. In addition the fact that it is a mixed-age centre rather than a 'Young People's Centre' is a positive attraction to many youngsters who – unlike the adults – do not seem to wish

for separate provision for themselves. They actually enjoy the experience of equality with other users. If the attitudes expressed by the young users do not change significantly when they themselves become adults, there is reason to hope that the Brewery will have been and may continue to be a healthy influence in the cultural life of the community.

I would like to conclude with an extract from the Research Project which has been conducted here over the last three years by Charles Wilsher. The project was financed by the Joseph Rowntree Memorial Trust and organised by the Sociology Department of the University of Lancaster:

To summarise the findings on the Brewery: during its first year of operation visitors to the Brewery, and users of the particular facilities there, were more likely to be drawn from two distinct social groups than others. Firstly adults, probably under 45 and almost certainly under 65, likely to live in owner-occupied premises, work in non-manual occupations, or to have completed their education at public or grammar schools or in the tertiary sector. Secondly, school pupils – differentiated by school or sex on some issues, but *not* differentiated by the social background of their families. The process of 'filtering' was thus operating in two ways: to filter out the old, and to filter out less socially advantaged adults. In other words, the association between stratification and participation in particular leisure and cultural facilities, widely observed elsewhere, applied to adults but not to schoolchildren. For an institution aiming at the celebration and regeneration of community the implications could be important; the long-term empirical question is whether the adoption of adult social roles will lead to the adoption of leisure patterns more closely linked to those roles. If not, the Brewery will be succeeding in the breaking down of social barriers to cultural participation, the removal of some social filters channelling people into particular kinds of leisure activity, which has been the object of idealistic cultural policy. If, however, the very attraction of the Brewery for young people – indicated by their high participation rates, and by the views of adults about the Centre – means that the Brewery becomes a teenage ghetto, left behind when independent income and the legitimate use of personal transport and

licensed premises become available, then its adult habitués will continue to be drawn from those social groups traditionally associated with 'culture'.

E SERVING A NEW TOWN

South Hill Park by Peter Stark

After taking a degree in sociology at Leeds University, Peter Stark taught for one year in a Birmingham technical college, gradually becoming involved with the embryonic Birmingham Arts Lab which he administered on a full-time basis until 1971, when he failed to enjoy an arts administration course and became administrator of The Welfare State. He was appointed director of South Hill Park in Bracknell in September 1972.

Bracknell, one of the first designated New Towns, is generally held to be one of the gentlest and most successful. With industry based predominantly on electronics and the advantage of a naturally wooded site, it has grown steadily over the past twenty-six years to its present size (47,000) and is still growing. Socially Bracknell is characterised by the young married couple who moved out from London in the 50s and 60s. The husband will have a reasonably secure skilled manual, administrative or junior managerial job and the wife, once the family is complete, will look for work to supplement the family income. They will live on one of the neighbourhoods into which the town is divided, in a house which they will rent, or be buying, from the Development Corporation. A car will be seen as, and may well be, a necessity. The family's discretionary income will be low. Unemployment has also been comparatively low, but the town shares with most other large-scale urban developments the problems of personal and cultural *anomie*.

In the early sixties the District Council built one of the first large-scale Sports Centres in the country, but there was no existing arts provision other than some support to the surprisingly small number of local amateur societies. With London and other cities only fifty minutes away by train, Bracknell is surrounded by a ring of professional theatres. Research indicated that use of these arts facilities was lower than would have been expected. The local College of Further Education offered the usual range of non-vocational arts-oriented courses which were, in general, adequately supported.

121

South Hill Park and its grounds were purchased by the Development Corporation in the mid-sixties as part of their plan for the expansion of the town. The house was let to industry on a short lease while support for an arts centre was canvassed, and quickly received, from both the town and district councils. The Arts Council and Regional Arts Association were consulted, and an independent charitable company created to administer the project giving the three founding authorities guaranteed representation. At this stage the building of a new 400–600 seat theatre was the centrepiece of the plan. In September 1972 I was appointed as director, and a combination of my ideas and national economic factors speedily placed any major new building plans in abeyance.

The house itself was built between 1880 and 1902 and is a Grade II listed building. It has sixty rooms and just under 30,000 square feet of usable floor space on three storeys. The largest single room could have a seated capacity of no more than 100, there were another four which could seat sixty to eighty and the rest varied from eight to forty in potential capacity. The landscaped grounds contain a lake, a wooded hill and a large area of lawn. The complex, two miles south of the town centre and originally isolated, is now being surrounded by two new neighbourhood developments. Over half of the town's population will shortly be within fifteen minutes' walking distance of South Hill Park.

All of the above seemed to demand a new approach to making both the presentation and the practice of 'the arts' accessible and acceptable. There could be no justification for directing the centre to the established Thames Valley arts audience (already well catered for compared to the rest of the country). This was an opportunity to direct a major arts resource towards the entire local community. It is easy enough for official bodies to deduce levels of 'need' for cultural provision from either the size of membership of local societies, or attendance at the occasional performance in an inadequate hall. South Hill Park's central aim is to demonstrate that the level of 'need' – no matter how latent – is much higher; to break once and for all the fatalistic conventional wisdom that the 'arts' are for a tiny percentage of our population as a whole.

After an intensive six-month research period, I decided the centre's programming should be based on the following six components (for more detail see pp. 35ff), each one of which

plays a significant role in the total structure: Activity, Presentation, Social, Resource, Young People, The Artist.

The conversion of the building, in terms of these aims, has given us a wide range of specialist studios equipped for silversmithing, enamelling, lapidary, photography, film making and video, painting, etching, textiles (including weaving and spinning), professional-quality sound recording, lithography and screen printing. There are three general meeting and/or activity rooms, music-practice rooms and a rock rehearsal room. In addition there is an eighty-seat studio theatre, a sixty-seat cinema, a hundred-seat library and recital room, one small and one large gallery. To provide the general public with a sociable environment there are also a cellar club room with capacity for a hundred, a playgroup and creche, a restaurant, two bars, a shop and a coffee bar.

From the beginning I identified four major problems of which, perhaps, the problem of 'art' was, and is, by far the greatest. The word itself is terminally ill and would be a fit candidate for euthanasia if an adequate successor could be found. At South Hill Park we try never to refer to ourselves as an 'arts' centre, and have had considerable success in becoming known as 'the Park' – we repeatedly say that our brief is 'everything to do with leisure which the Sports Centre does not cater for' – but the word remains as a barrier perpetually reinforced by the media, some artists, and by a thankfully dwindling band of the old guard, barricaded in the Arts Council, protecting 'standards' – whose standards? In our case this problem was accentuated by a building which had never been open to the public, looked like a genteel country club, and contained several fine and fragile examples of the builder's craft which had to be preserved.

The other two problems were, perhaps, less insuperable. Because of its appalling public transport service, Bracknell's population is more highly motorised than many towns. This makes the project viable, but none the less a significant proportion find access difficult, if not impossible. Financially, the centre has suffered from developing at a time of rapid inflation, and public spending cut-backs, but as yet this has only slowed the development not maimed it. In our first full year of operation (1975/6) we had a budgeted expenditure of £180,000 towards which we received grants of £37,000 from the District Council,

£30,000 from the Arts Council, £17,000 from the Town Council and £5,400 from the Southern Arts Association. We therefore had an earned income target (taking net figures for all catering operations) of over £90,000, and it is the pressures which this target has generated which most seriously affected the realisation of our aims.

Despite these difficulties, South Hill Park has enjoyed several advantages of which support from the key members and officers of all three contributing authorities has been, and is, the most important. For although advice has been available, the staff have been left to develop the Centre without interference. This level of trust in a predominantly young and inexperienced staff will, if the project succeeds, be the main single reason for its success. In addition, for all the disadvantages of the house mentioned previously, it is also true that it has acted as a magnet: it is warm, it is 'lived in' and has a 'history'. There is an intangible atmosphere which I have never found in a new building. Besides, the first visit to 'the Park' is so much easier because it *is* a local 'stately home'. What reason is there for a first visit to a 'theatre' or a new 'arts centre' other than an interest in 'theatre' or 'art'?

Finally, because of the design of the house (and the unplanned, but fortuitous extensions to the building programme) we have been able to open in stages. Opening a large theatre, you face the problem of selling all the seats from the day you open. You will be judged by one product and have very little option but to direct your advertising to the audience most likely to attend – the established arts audience. Needless to say, once that audience is in your building, they begin to define its atmosphere, and it is extremely difficult to reach out to a new audience or break from a known, financially successful, formula. In our case the earliest users were prepared to put up with cold, dirt and the confusion of building works to use our facilities. They have been able to watch the growth of the project from the inside – 'I remember when' is common – instant nostalgia and a sense of belonging. Admittedly these early users were the already converted, but they have given the building an active rather than a passive feel. There is no embarrassment in walking through the hall, the bar or corridor, and mixing with a classical recital audience in the clothes you've been painting in.

Our staffing policy was an integral part of the centre's

124

design. Commitment to the aims of the centre, energy, administrative ability and social skills were vital, but these had to be allied with a commitment to, knowledge of and flair for, a particular art form. Given the diversity of our programme, there was no way in which that programme could be devised by one person. Equally the levels of commitment and energy necessary could only be sustained by total responsibility for a particular activity – you are working for your own ideas and no one else's. In consequence, the structure is 'horizontal': eight department heads running our music, theatre, visual arts, cinema and film-making, crafts, recording studio and electronics, print and design, and youth-work programmes, within policy guide lines and budgets agreed with the director in advance at a series of monthly and weekly meetings. They are supported by finance, publicity and management departments which also report independently to the director, whose role becomes one of co-ordination and occasional stimulation. There is a full-time staff of eighteen and a part-time staff of twenty-two, excluding all catering operations. The average age is twenty-eight.

The creative department heads are the centre's front line. They have all established informal contact with local people interested in their 'art' form, but they are not answerable to them other than through the director's responsibility to the local councillors on the board. This independence is vital, as it enables us to reach out for new audiences, or participants, without being identified with existing local societies (which we try to support in other ways). We had to create a new and exciting identity for people participating in creative leisure activities if we were to bring in people who had not become involved in the town's amateur society life in the past, for whatever reason. It is my intention that in the future there will be more local involvement in our programming, but for the 'leap forward' independence was a prerequisite.

The Park is a public facility. There is a membership scheme which gives regular mailings and reductions for events and courses, but this is available rather than being pushed. We stress that you do not have to be a member, and that there is no admission charge, but it is only since our year-long 'There's a Pub in the Park' campaign that this has begun to be generally believed. Because one of the bars (and the coffee bar) open onto the lawn,

part of which is licensed as a pub garden, we can operate throughout the summer months as a real family centre – the perfect excuse for a first visit to, and then regular use of, the centre. It is my belief that once this pattern of regular use has been established, a visit to the cinema or involvement in a new hobby becomes so much more possible.

The grounds of the house are an attraction in themselves. To them we have added a permanent sculpture exhibition and, through the local Natural History Society, a nature trail. In the summers we capitalise on this natural resource by mounting large-scale events which the size of our indoor spaces prohibit. These events have included inflatables; kite-flying weekends; displays of hot rods, model aircraft, boats and trains; a Victorian crafts fair; free rock concerts; a three-day national folk festival (*The Handsome Mouldiwarp*) and two week-long theatre shows with casts of over thirty drawn from professionals, staff, local amateurs and our own youth theatre (one, on and around the lake – *Moby Dick* – which featured an inflatable whale and played to 1,500 people, the other *Bartlemy Fair*, set in a fairground with roast pig and real ale throughout the performance). In addition there has been a nine-day 2,000 seat marquee project in which we presented a different show each night: Rod Hull and Emu, Matt Monro, Micki and Griff, Johnnie Walker, Greenslade; and in the Bracknell Jazz Festival the Mike Westbrook Big Band, George Melly, George Chisholm, Alex Welsh, Barbara Thompson, Stan Tracey, Clark Terry and Wild Bill Davison. The summer concluded with a mammoth firework display organised by the Bracknell Round Table attended by over 10,000 people.

As far as publicity is concerned, the centre prints and designs all its own publicity material: functional, inexpensive, colourful, neither glossy nor 'arty'. The centre has a local feel, and we have tried to rely heavily on word of mouth recommendation. With the help of some of our committed members (and the convenient layout of the town) we have recently set up a mass distribution scheme which gets some of our publicity into over two-thirds of the houses in Bracknell every month.

Given that in almost every area of our work we were operating in unknown and virgin territory, our programming has been consciously eclectic. By trial and many errors we have had to find what our public would come to, pay for and enjoy; be it in shows

126

or courses. After the paying attendance had been consolidated we would then, and only then, begin to experiment so that that interest could be developed, deepened and extended. The final goal is where the demand outstrips the supply, and then begins to define quantitatively and qualitatively what the future supply should be.

In order to give a general indication of the centre's day-to-day operation, I am concluding with a list of the events, performances, courses and other activities during a typical week in the autumn of 1975.

Senior Courses (6–20 students per course). 6 silversmithing, woodcarving, 2 spinning and weaving, 2 creative embroidery, church embroidery, winemaking, corn dollies, crochet and macramé, bobbin lace, enamelling, lapidary, advanced recording techniques, model aircraft construction, introduction to bridge, basic and advanced photography, synthesiser, mathematical pastimes, 2 yoga, ballet, beginners' painting, plant painting and drawing, mothers' workshop.

Junior Courses Adventure workshop, movement, sound studio workshop, model aircraft, 2 lapidary, 2 painting, bobbin lace, weaving, silversmithing, ballet, theatre workshop.

Workshops (individual use of facilities without tuition). Dark room (3–4 hirings), music rooms (10 hirings), rock rehearsal room (7 hirings), film workshop (3 meetings to make Super 8mm community newsreel for cinema), silversmithing and enamelling (20 hirings), lapidary (15 hirings), weaving (5 hirings), poetry and mixed-media workshops.

Local Groups & Societies (hiring rooms), Age Concern, District Council, Angling Club, Golf Club, Railway Society, Model Aircraft Club, South Hill Park Big Band, Thames Voyces, Jazz Workshops, Natural History Society, Bracknell Lions, German Club, Breakaways (variety group), parties and wedding receptions, eight bookings of recording studio.

Cinema Monday to Sunday early evening *Last Detail* and
 Easy Rider
 Friday and Saturday late night *The Birds*
 Sunday late night *Alphaville*
 Saturday and Sunday lunchtime children's matinees.

Theatre. Our own five-handed version of *The Taming of the Shrew*. Monday to Saturday and one school's matinee.

Main Gallery. Double Exposure – two photographer's personal views of Bracknell.

Long Gallery. Exhibition of local artists around our theme of 'The Skies'.

Recitals. A recital by a local pianist (part of a series covering all Beethoven's piano sonatas).

Cellar Bar.		
	Monday	Disco
	Tuesday	Modern Jazz – Lennie Best Quartet & Don Rendell.
	Wednesday	Trad Jazz – San Jacinto Band.
	Thursday	Pub Quiz
	Friday	Golden Oldies Disco
	Saturday	Folk Club with Threadbare Consort.
	Sunday	Rock & Blues – Oppo

Miscellaneous. Playgroup and crêche weekday mornings and afternoons respectively. School visit to galleries and courses for local College of Further Education ROSLA project with local school. Video course at adventure playground. Work with local drama club. The restaurant, shop, coffee bar and terrace bar open continuously.

The centre is open every day of the week from the early morning to midnight. An average attendance would be between 4,000 and 5,000 visits per week: over half of those visiting the centre are residents of Bracknell New Town and 80% are from within an eight-mile radius.

Although a majority of people in the town will have visited us, it is probably true to say that we are still viewed as 'Not for us' and 'Perhaps too arty'. Conditioning against 'art' goes very deep and the Park is a long-term project. Equally although this essay may give the impression of a well-thought out plan operating fairly smoothly, the mistakes have been, and still are, numerous. Some of these could be eliminated by more funds, but funds will only come if we can show that the arts have a vital and socially important role to play in developing or reviving our communities as well as inspiring the individual. To prove it we need the funds. Chicken or Egg?

F SERVING A RURAL AREA

The Beaford Centre by Harland Walshaw

Born in York, Harland Walshaw read English at Cambridge before joining the staff of the Beaford Centre in 1967. In 1972 he was appointed first Director of one of the two area arts associations in England, Fylde Arts, based on Blackpool. He returned to Beaford as its Director in 1975.

In the early days of the Beaford Centre, every television crew who came to visit it began their film with a shot of grass growing in the middle of the lane which leads up the steep hill from the river Torridge to the small village which perches at the top. It is necessary to understand the rural nature of the area, for every aspect of the Centre's work is an exploration of the role of an arts centre in the country.

North Devon lies between Dartmoor to the south, Exmoor to the north, and the Atlantic ocean to the west. Its 1000 square miles contain only 120,000 people, living in villages, small market towns and on farms. These are scattered communities, linked by a network of narrow high-banked lanes, with almost no public transport. When Beaford opened there was little industry, but the Dartington Hall Trust which established the Centre, also set up a glass factory in the nearby town of Torrington. This pointer to the way in which the area could solve its problem of finding work for young people and combatting depopulation was enthusiastically followed by local councils, and several small industries have opened here in the last ten years. But North Devon remains one of the most untouched rural parts of England, with its small farms and tiny communities.

The Beaford Centre is housed in a chunky Victorian house standing next to the church in a village which is roughly in the middle of the large area it serves. It opened in the mid-1960s and perhaps its early contribution to people's lives owed something to the philosophy of Arnold Wesker's Centre 42. Its belief was that the arts had a central role to play in the life of any town or area, because they spoke to the emotions, and feelings as well as the intelligence, and because in their social form they brought about that sharing of community identity which was one of the most

129

serious losses that the decline of village life was causing.

The professional performing arts were seldom, if ever, seen in North Devon in those days. Beaford's first achievement was to establish a programme of events all over the area, in towns and villages, which has continued ever since. Dennis Matthews came to Hartland, Ravi Shankar to Barnstaple, Mike Westbrook's Jazz Band to a cafe by the sea in Instow, A.L. Lloyd and Ewan MacColl to Beaford's own village hall. There were string quartets in country houses, puppets in school halls, poets in pubs, happenings on the beach. Pop groups and dance companies, mime artists and flamenco guitarists, cabaret singers and sopranos: suddenly North Devon was alive with some of the best performers available. Two festivals were mounted in the first three years, the second one entirely devoted to the arts of the twentieth century and presenting sixty-six events. At the end of five years these events were being promoted at the rate of three a week, and perhaps the most noticeable feature was their variety. Such a programme was not only remarkable in North Devon, it was remarkable anywhere outside the major cities in those days. What is now the common fare of any major arts centre's programme was then a bold commitment to the untried belief that there was a need for such events in any part of this country, however remote.

The nature of the area dictated one major policy decision. Beaford would take its performances to people's communities, rather than expecting them to come to the Centre. It was the only way to serve so large an area. Some of the local councils, appreciating this, went into partnership with the Centre to provide a programme of events for their districts. Beaford was the base, but the performance it was promoting might be taking place some thirty miles away, in a church on the Atlantic coast or in a village hall on the edge of Dartmoor. The peripatetic nature of the Centre was established, and this is one way in which Beaford is different from all the others mentioned in this book.

The limitations of such a programme of performances soon became apparent. All the performers came from outside North Devon. Nothing that was being promoted was about or for the people of this particular area. Serious consideration was given to the possibility of establishing a film unit to make films about people and their lives in North Devon. Before that plan came to

130

fruition a different kind of opportunity presented itself. In 1968 a group of acting students from the E.15 school spent their summer holidays at Ilfracombe and presented a variety of plays and entertainments: music hall, *America Hurrah*, children's theatre on the beach, John Arden. It was conceived as a pilot scheme for a new professional company. Beaford saw it as an opportunity to establish a group of actors resident in the area who could achieve a permanent relationship with their audiences. Drama had been a weak spot in the programme. John Arden and his wife, Margeretta D'Arcy, had been commissioned to write a play for the opening of the Centre, and had written *The Royal Pardon* for which they gathered a company of students from LAMDA and directed and acted in it themselves for the first performances at Beaford. But after that, apart from visits by one or two companies like Portable Theatre, professional theatre was scarce. The last line of *Serjeant Musgrave's Dance*, the Arden play which, appropriately, the E15 students were performing, is 'D'you reckon we can start an Orchard?' In 1969 the Orchard Theatre was born, the first of the peripatetic companies attached to an arts centre, with a brief to tour their productions in a particular area. They take their own raised seating with them, so that any village or town hall is transformed into a theatre. The policy they established in their first season has remained constant: to present established plays to a high standard, and to commission plays about North Devon. These local shows have included a one-man show about an Exmoor pedlar/poet who was a well-known character in the first quarter of the century, and an entertainment about the coming of the M5 to Devon, which attracted the largest aggregate audience the Orchard has had. The more traditional repertoire has ranged from *Mother Goose* to *Mother Courage*, including such authors as Brighouse, Pinter, Beckett, Goldsmith, Terson, Shakespeare, etc. In the face of continuing struggles for adequate finance, the Orchard can point to impressive achievements: a large and varied output; a consistently high professional standard; and a body of specially-commissioned local plays which have proved once again the deep-rooted interest that people have in their own area.

Almost as soon as the Orchard was founded Beaford was considering other ways in which it could contribute to people's creative needs in North Devon. It had always been part of its faith

131

that everybody needed to take part in an activity, and that they should have the facilities and encouragement to do so. From the very start craft classes had been an integral part of the programme. The Centre boasted the best pottery facilities in the area, and in addition there were painting studios and workshops. Local activities such as lace-making, beekeeping and folk dancing featured amongst the weekly activities, as well as classes in pop culture, play reading, music making, choral singing, literature, and talks on various aspects of Devon life. Throughout the day and every evening the workshops in the outhouses and the rooms in the Centre itself hummed with activity, like the hives which the beekeepers had established in the Centre's large garden.

However, accommodation was limited, classes over-subscribed, and the facilities only available for those prepared to travel. Long before the phrase 'community arts' was common currency, Beaford was devising a scheme to encourage and initiate creative activity amongst groups of people in their own community. If, as Beaford believed, people had a personal and social need for such activity, the greatest contribution would be to establish circumstances in which it could take place. The Beaford Community Project would seek to involve those who would never come to the more formal and traditional events, for whom the word 'arts' represented something elitist and highbrow. There would be a team of workers, activists, who would go into the communities, attempt to discover the kinds of activities that people would enjoy taking part in, and respond to local initiatives. In the event it took some years to establish. It had been much easier to raise money for a theatre company, performing a traditional art form and generating an income. When the Community Project did start there was only the money for one organiser instead of the team of five or six that had been envisaged. However, there were other people at the Centre who could sometimes contribute, and there was no shortage of projects. Carnival, pageants, talent contests, play-schemes, barn dances, discos, amateur drama, a brass band festival: over various parts of North Devon the Community Project has helped with or initiated occasions for people who would never be seen at a Beaford concert or an Orchard play, and has involved them as the participants, the workers, the creators.

The recent Appledore Festival might serve as an example of the

Project in action. At this little seaside town a week-long festival was organised with people from the town itself. Central to the week was an exhibition of Old Appledore: old photographs and objects collected around Appledore, plus a group of photos of Appledore today taken by Beaford's resident photographer. There was a concert on the theme of bells, with performances by Appledore Town Band and a group of handbell ringers. There was an evening of slides given by a local man, another of sea shanties, a firework display laid on by the local shipyard. Appledore hope to make the festival an annual event, which they can now continue to organise on their own. Most of the early projects took place in villages, the chief type of settlement in North Devon. However, the development of Bideford and Barnstaple has meant a large increase in population in these towns, and when money became available for a second Community Project worker, it was decided to place her on one of the new estates in Barnstaple, where she could concentrate on a particular area, get to know it in depth, and try to build up community activities where there is currently no provision for them, over a long period.

The other major project that takes place at Beaford is the Residential Courses. The Centre can accommodate twenty-eight people, and under an arrangement with Devon County Education Committee, groups of schoolchildren come to stay at the Centre continuously throughout the academic year. These courses were developed to give Devon children an opportunity to come into contact with a working arts centre. In an atmosphere far removed from that of the school, they can spend a week of concentrated music-making, or work in the pottery and painting studios. The teachers enjoy the opportunity for a period of concentrated work on a particular project, and for many children it is their first experience of living away from home. 'We can achieve more in a week at the Centre than in a whole term at school,' teachers have told us.

Beaford attaches great importance to its artists-in-residence. An arts centre should act as a middleman between the arts and the community, bringing them together in an age when the social function of the arts has in many ways been forgotten. If artists are not creating anything relevant to an area, then it is the job of an arts centre to ask them to do so. No playwright will write about the coming of the M5 or the siege of Torrington unless the

Orchard commissions a play. Who will write a work for the children of North Devon to sing unless it is one of our resident composers? At present Beaford has three artists-in-residence: a photographer and two composers who are on a Gulbenkian bursary. The concept of a resident photographer has been developed at Beaford over four years. He photographs life in the area today and mounts exhibitions, as well as putting prints in hospitals, waiting-rooms etc. He also collects old photographs which form the basis of the Beaford Archive. They go to make other exhibitions and slide-shows in village halls, and will be used as postcards and booklets. A community is brought face to face with its past in a way it understands and enjoys. Recordings of old people talking about life in their youth is another part of this archive. The task of the resident composers is not so straightforward. They can write music for Orchard shows, but finding local musicians to perform their works in North Devon is not easy. One wrote a piece for two brass bands and handbell ringers, which is where the amateur music-making of North Devon finds some of its most popular expressions, but the bands were frightened by the unconventional nature of the work. However, choral pieces for children, a register of local musicians, a group formed to play old-fashioned tunes at tea parties and old people's homes, have shown various ways in which musicians can contribute to the music-making of people in an area.

It is the nature of the area which has all along determined the role that Beaford can play. In a rural area with a small population what audience is there for contemporary music, for instance, or for anything which in a city would attract its own specialist audience? Beaford has had its successes in this field, such as a legendary and exciting performance by The Fires of London which attracted over 300 people to the Queen's Hall in Barnstaple, a full house for The Composer's Quartet playing two works by Elliot Carter, large audiences for Samuel Beckett and *Ubu Roi* in French. But an arts centre in North Devon is never going to have the most extensive programme of modern jazz, for instance, although once again it is surprising how successful a well-prepared concert can be. Beaford's task is to find things relevant to all the kinds of people who live in North Devon, to the farmers and the retired 'voreigners', to the factory workers and boarding-house keepers, the old, the middle-aged and the young.

It is the stimulus provided by the area itself which has encouraged the most exciting and original developments at Beaford: the Orchard, the Community Project, the Archive. These are the fruits of years of working in North Devon and attempting to respond to people's creative needs.

Perhaps Beaford's major resource is the people who work there, a staff of twenty plus the theatre company which sometimes brings it up to thirty or more: administrators, actors, musicians, a photographer, community workers, a technician, domestic staff. They will step outside their role to provide a mumming play or a group of carol singers, they will work together on projects that provide a cross-fertilisation of the areas of the Centre's activities. Beaford is not one organisation, but various different (but related) projects based under one roof.

How does such a large enterprise come to exist in one of the poorest and least-populated parts of England? It was founded by the Dartington Hall Trust, who continue to give grant aid. Local councils, after a slow start, now recognise that its purposes are something they should support. On a current annual turnover of £80,000 $27^1/_2\%$ is provided by grants from the regional arts association, South West Arts, 15% by grants from Local Authorities, 10% by grants from private trusts and industry, and $27^1/_2\%$ is earned at the box office or by sales.

The increasing support from the local authorities is one sign of the general acceptance of the Centre's role in North Devon. It is an acceptance that has been hard-won, for Beaford had to prove itself to an initially sceptical public. If the local papers no longer receive letters about wasting money on the arts, it is because the policy Beaford has pursued has been more and more relevant to the needs of its particular area. If it seems a large operation amongst so few people, that merely proves that people's needs are much greater than might generally be assumed. If North Devon can support an organisation of this size and nature, then other parts of England must need something similar. Dartington's experiments are designed to serve as an example of what is possible. The growth, success and acceptance of Beaford, so original and such a risk ten years ago, has already spawned its imitators: there are now several peripatetic theatre companies, for example. Beaford takes its character from North Devon; but its principles are relevant anywhere.

135

G PROVISION ON A COMPREHENSIVE SCALE

The Arts in Swindon, by Denys Hodson

After studies at Marlborough and Oxford, Denys Hodson worked in business for nineteen years before being appointed as the first Controller, Arts and Recreation, for Swindon Borough Council. At that time, in 1970, there were less than ten similar posts in the country. He is now director, Arts and Recreation, for its successor Borough of Thamesdown, with responsibilities for 'parks, lakes, playing fields, bowling greens, country parks, forestry, horticulture, nature conservation, swimming pools, sports centres and weirdly enough, two cemeteries and a crematorium!' He is also Chairman of the Southern Arts Association, a member of the regional committee of the Arts Council and a Governor of the British Film Institute.

Local authority and the arts make strange bedfellows. The traditions and practice of local authority stand deeply founded in the poor laws, road building and drains. Yet with the course of time, step by bureaucratic step, we have come to see it as reasonable and acceptable, particularly in the large towns, for the local authority to play a role in promoting the arts. Because of its history, because of the particular nature of its legal powers and because of the political checks and balances which affect its decisions, a local authority is likely to show quite a different arts face to the public than the single arts centre, yet there may be something of value to consider even in its less glamorous aspects.

Swindon is an industrial and commercial town now forming part of the new Borough of Thamesdown. This has a population of 145,000, of whom about 110,000 live in the urban area. The nearest sizable towns are Reading, Oxford, Cheltenham, Gloucester and Bath – all over thirty miles away. The surrounding country is deeply rural and traditional; fine manor houses abound; glossy horses and hand-made guns still play a strong part in the culture; most people vote Conservative and the crest of the Wiltshire County Council is a Bustard, defined in the dictionary as 'an extinct game bird'. Against this cosy background, Swindon stands out as brash, raw, ugly, and

industrial. Yet it is Swindon which has pioneered local authority involvement in the arts as indeed in other fields, for its very nature generates both the demand and resources for a better life.

So what do we do? How do we come to be in this book?

Our first arts centre goes back to 1946, and although it has fallen away from the mainstream of modern arts centres, it is still heavily used. It is now housed in an ex-chapel, ex-dance-hall. It has an auditorium with raked seating for 220, a twenty-way lighting board, film projectors, and rather a good Bluthner; it has a large and a small meeting room and a clubroom with a sink. The centre is used in the main by the many flourishing amateur drama societies and the Thamesdown arts societies. These arts societies – the 'arts' bit is generously interpreted – are affiliated to the Arts and Recreation Committee of the Borough Council. They get the privilege of free meeting rooms and some secretarial help. In turn, their constitution has to be approved by the Council and a member and an Officer of the Council are appointed to their committees. The aim of this is *not* to interfere with the societies' affairs but to keep in touch with their thinking and to give them a direct link into the power system. The societies, about two dozen at the moment, cover a wide range. The Philosophical Society discusses Logical Positivism, and gets Professor Ayer to explain it to them; the Jazz Society does what you would expect; and the Wine-Making Society has a reputation for great conviviality.

We also use the arts centre for some direct promotion, especially a winter season of classical concerts, and occasional professional drama. Recently we have been trying to re-think the policies, and the first fruits of this are the planning of further uses of the clubroom for folk music, and as a gallery space for artists and craftsmen. It was always argued by Harold Jolliffe who set it up, that societies have a life, like people: birth, youth, middle age, and so on, up to death. It is certainly true that many arts activities are initiated by people who age with their own activity, until it becomes necessary to start a new society which will meet the needs of other generations. Possibly the most healthy state is one of sustained but Fabian revolution. In the current year, 1975, the centre had a staff of two to cover the hours, with cleaners extra. The total cost including support to the arts societies was about £13,500 including £950 of loan charges. There were 638 bookings during the year.

If much of the arts tradition has been built round the old arts centre, there is a direct link across to the museums and art gallery, not only because they come within the same department, but because two or three local societies are involved in them. To say we have four museums sounds a little grand, and they are not, with the exception of the GWR Museum, at all earth-shaking, but because of our philosophy we believe that museums have a positive part to play. So we have longish opening hours, 100,000 visitors a year and, we hope, a cheerful extroversion in our attitudes to the service. Apart from being *the birthplace*, the Richard Jeffries Museum is only notable for having escaped the destructive passions of the fifties − we hope to do more by conserving Coate Water, the lake he loved and wrote about, and its wild life, than we can do by way of dusty exhibits. The GWR Museum has fine shining engines, and endless bits and pieces, well displayed, to remind us of our heritage. We have recently put in a coin-operated electric GWR train layout − not purist but very popular. Lydiard Park, a Georgian mansion about five miles from town, has had its state rooms lovingly restored, its St John family portraits brought together again, and some decent furniture cadged, borrowed or bought to make our own municipal stately home, set in a pleasantly wooded park through which runs a new nature trail. Lastly, the town museum tries to reflect a purely local tradition − ammonites from our towns, flints from our fields, Victorian pop bottles from Swindon bottlers. Every decent exhibit we can't show because of limited space is at work in the 120 school-loan collections, and every day we deal with a steady stream of enquiries. On Saturdays our own Junior Museum Club meets, and a flourishing group of Friends give invaluable help − some of it very skilled − in our efforts to make the money go a bit further.

The art gallery, attached to the town museum, is one of our elitist surprises. From an astonishingly generous gift from Mr James Bomford of about twenty modern British paintings, we have since the war built up a really remarkable little permanent collection. Starting with Steer and a fine little Robert Bevan, we have good Bloomsbury pictures, Alfred Wallis, Kit Wood, Wadsworth, the Nashes, a magnificent Ben Nicholson, Henry Moore, loan groups of Passmore and Kenneth Martin, graphics by, among others, Denny, Paolozzi, Hockney, and works recently

bought by Hodgkin, Richard Smith, Tom Phillips, Michael Craig Martin and Richard Long. Since we only have one gallery, we have to limit the time our own pictures are on show because we think it is vital to provide occasional space to our local amateurs and visiting exhibitions, which range from Max Ernst to Victorian dolls.

Newest physical addition to our arts facilities is the Wyvern Theatre and arts centre which opened in 1971. This is a 650-seat theatre with a fly-tower and full equipment, a small studio theatre, a clubroom and three extra general-purpose rooms. Although the Council provides almost seven-eighths of the cash to run the Wyvern, it has, with typical magnanimity, put the management of it in the hands of an independent Trust, on which it is represented but which it cannot, by constitution, control. Used largely for professional events, the Wyvern operates mostly as a theatre but doubles also as a Regional Film Theatre, and as a concert hall, both for the Bournemouth Symphony Orchestra and for The Scaffold. The Trust policy is one of broad appeal – the size and nature of the local population could not at the moment support a very intellectual approach. We have been accused of being too popular in our programme planning, particularly by some members of the arts establishment. Setting aside the lingering doubt whether popularity should be fair grounds for indictment, it is worth wondering what particular canon of taste sanctifies, say, Marivaux and Feydeau but rejects Alan Ayckbourn.

The Trust, however, hedges its bets in its operation of the Jolliffe studio theatre. Seating about 100, this little theatre on the top floor is embarking on its third season with a very small resident company. Up to now the company has specialised in modern classics and has attracted a very loyal following from a wide area. There are regular actor-audience discussions, and the cast generally join the audience for a drink in the studio bar after the performance. The Jolliffe is not only used for drama. Poetry evenings take place there regularly and there are both jazz and chamber music concerts including performances of new work.

Local amateur use of the Wyvern is largely confined to the bigger societies specialising in musicals and opera. Musicals, light opera and concerts promoted by local bands and choirs are generally very successful and are good box office at normal theatre prices. Grand opera presents a rather special problem. It is

not possible in a 600-seat theatre – we lose fifty seats when the orchestra pit is in use – to fund professional opera, and therefore there are special reasons to encourage the local amateur society. Like many local societies throughout the country, many of the members have professional training, and, by union rules at the Wyvern, the orchestra is professional. The Trust sees special merit in trying to ensure the prosperity and quality of the opera society since it is the only way local people will ever see grand opera in Swindon.

All in all over 500 main stage performances take place every year with nearly 200 in the studio on top of that and possibly another 100 arts events and meetings. It is expensive – £95,000 a year plus loan charges – but at least the Wyvern is well used.

Visual arts are not so well covered at the Wyvern but there are regular exhibitions of work at the main bar and we are trying to plan a regular series of lectures by artists running on the same lines as the poetry evenings.

One thing the Wyvern is *not* is a participating arts centre for the artist-craftsman. This is still an unmet need in the district although it is important to remember the part played by Further Education which offers an excellent basic service in this as in many other fields. We are looking at our somewhat moribund town hall to see whether one of its main rooms can be used in this capacity. If it is to work, it will have to be run and serviced by the users; we can only provide shelter, warmth, light and encouragement. We believe it can and will work and that an under-used part of a building will play a fuller part as a result.

So much for the hardware of the service. The most interesting recent development has been the evolution since 1974 of the Council's own community arts project. The Arts Officer, responsible for the old arts centre, the town hall, and some concerts, has created, on the narrow base of a £300 grant, a complete network of activities, which has already involved within a year nearly 1,000 people in working, helping, or performing in them. The principle is a simple one. If you want to spend money, first you must raise it but raising it should be fun for someone. Pop and folk concerts in parks, pony racing on a big football field, are not only fun themselves but can show a profit. This profit can, in turn, be used for street theatre, municipal busking or wall painting. We set up stalls in our shopping centre where artists and

craftsmen can sell their work – and pass on a percentage to the project. A junk sculpture contest is judged by the Mayor! There is an exhibition of art and craft work from the old railway works. A school orchestra plays outside Sainsbury's, a brass band in a park. On the blank end wall of a small terrace of old shops a rather free version of Ucello's *St George and the Dragon*, twenty feet high, is the subject of considerable local pride – and particularly and surprisingly popular with older people.

What haven't we got? We do not have a South Hill Park, a Fun Art Bus, the Bristol Old Vic, the Leeds' Henry Moores, the Cardiff French Impressionists, the Hallé Orchestra, the Free Trade Hall, the Norwich or York Museums, a Bath Festival, or even a Princes Street or Chester Row. Most of these things we can never reasonably expect to have. What we have sets the ratepayers back about £250,000 – outside grants from all sources amount to £27,500. So much for the theory that local authorities don't pull their weight.

To decide to spend money in support of the arts, and to spend it as we do in Swindon, presupposes a set of political and social value-judgments. Perhaps it should be made clear that it is not only the arts that attract local authority support. The Arts and Recreation committee is concerned with a very broad range of events, activities and facilities, such as bowling greens and barbecue sites, parks and pools, flower beds and fishing. It is not our philosophy that the local authority should provide all, only that it should supplement and balance the total provision in the district to give a fair and equal opportunity to the individual of a reasonable choice of things to enjoy. We don't run dance halls, because they exist and we have taken pains to ensure that they do. If a madrigal group can live without us we are delighted. One element, however, does inform our thinking. Minorities have rights, and pure head-counting may be a quick way to extensive deprivation. After all, we are all members of minorities and society has long accepted the duty to provide for some of their needs. We do believe that support for the arts is every bit as justifiable as support for football. So here is a bit of statistical sophistry to work on. A new football pitch in an urban fringe area bought, drained, levelled and with a share of parking and changing-room services, will cost not less than £5,000 and it could be as much as £30,000. It will be used by forty-four people

141

– mostly young men – per week for an average of half the year. It will need cutting, rolling, mowing, marking and annual reinstatement. Pleasure for pleasure and pound for pound, doesn't that make some art centres look cheap?

The difficulty often met with local authority involvement in the arts is the stultifying effect of the councillor and the bureaucrat as judges of aesthetics or managers of artistic enterprise. The councillors' role may be strongly defended since he represents the view of the man in the street. However, his work is more valuable if, like the Thamesdown councillor, he sets out to concern himself with matters of policy rather than detailed management, and believes that in day-to-day matters he should guide rather than command the paid officers. It is harder to defend the bureaucrat who is open to all the temptations of his office – notably conceit, pomposity and procrastination. The role of the *animateurs* is just as crucial to local authority work as to any other arts activities and the same combination of wisdom and luck goes to finding and retaining them. Somehow or other the bureaucracy has to find the heart and will to support the *animateur*. If this can be done, there is no reason why, in a figurative as well as a literal sense, the town hall should not become an arts centre.

Since this was written, the town hall has become a participatory arts centre run by its own users.

APPENDIX I

INFORMATION

National Association of Arts Centres
The National Association of Arts Centres, a self-help agency for the arts-centre movement as a whole, was launched in March 1975. The Association's constituted aims are (1) to work, both singly and in conjunction with others, to re-examine current cultural policies, to help generate a coherent national policy for the arts, and to stimulate a significant increase in the financial support for the arts from national and local government so that current provision in this field can be strengthened and a fairer and broader service developed throughout the country; (2) to co-operate with other bodies, both statutory and voluntary, concerned with furthering the development of the arts in the community; (3) to proffer advice to statutory and voluntary bodies on matters of concern to members; (4) to ensure that there is an efficient clearing house for information received from and relevant to its members and to facilitate the distribution of such information.

In conjunction with the Arts Council the Association has published an illustrated *Directory of Arts Centres in England, Scotland and Wales* (1976) which contains information about the histories, policies, finance and staffiing of 133 arts centres in Britain. It complements this book and is the most comprehensive guide to arts centres yet published. It is available from the Arts Council.

Further information may be obtained from Christine Gregory, Llanover Hall Arts Centre, Romilly Road, Cardiff, South Glamorgan.

The Arts Council and the Regional Arts Association
The Arts Council of Great Britain, 105 Piccadilly, London WIV OAU, will provide the addresses of the Regional Arts

Associations, a list of arts centres in England and Wales, an arts-centre bibliography and much more information on request. Anyone considering the setting up of an arts centre should get in touch with the Arts Council for advice.

The Scottish Arts Council, 19 Charlotte Square, Edinburgh, EH2 4DF. *The Welsh Arts Council*, Holst House, Museum Place, Cardiff CF1 3NX.

APPENDIX 2

BIBLIOGRAPHY

Plans for an arts centre published by Lund Humphries for the Arts Council of Great Britain, 1945

Setting up an arts centre compiled and edited by Robert Cobbing, London Council of Social Service, 1960

Arts Centres in England and Wales compiled by Bettie Miller, National Council of Social Service, 1967

Arts Centre Adventure by Harold Jolliffe, Swindon Borough Council, 1968

A Place for the Arts edited by Alexander Schouvaloff, North West Arts Association, Seel House Press, 1970

Symposium on Socio-Cultural Equipment, Report III. This report was prepared by Bouwcentrum, Rotterdam, on behalf of the Netherlands Ministry of Culture, Recreation and Social Welfare, for the Symposium organised by the Council of Europe's Council for Cultural Co-operation, 5–9 October 1970

Socio-Cultural Facilities at the Urban Level, a study of fifteen integrated socio-cultural centres in Western Europe by various authors. Chalmers, University of Technology, Department of Architecture, Gothenburg, Sweden, 1973. Unfortunately the translation is so poor that this book is almost unreadable. The chapter on the most appropriate scale of a cultural centre is, however, valuable

Arts Centres for the North: A Call for Action by David Dougan, Northern Arts, 1972, contains details of five arts centres – Sunderland, Stockton, Kendal, Wallsend and the Peoples' Theatre in Newcastle

The Educational Function of an Arts Centre with Reference to Oxford City by Madeleine Aitken 1973

The Economics of Arts Centres published by the South East Section of the Chartered Institute of Public Finance and

Accountancy, 1975. Copies available from R. L. Harboard, Finance Department, Town Hall, New Broadway, Ealing, London E5

A Directory of Arts Centres in England, Scotland and Wales published by the Arts Council in association with the National Association of Arts Centres, 1976 (see page 143).

Three Arts Centres published by the Arts Council, 1977. A fascinating report on research at South Hill Park, the Gardner Centre and Chapter, Cardiff.

The authors of this useful pamphlet are concerned with most aspects of the planning and establishing of an arts centre – there are brief sections on type of provision, legal considerations, political considerations, setting up a trust, size of catchment area, selection and design of the building, staffing, catering, financial aspects of operation etc.

Other useful pamphlets and handbooks
Local Government and the Arts by A. H. Marshall, Institute of Local Government Studies, University of Birmingham, 1974. A short guide to local-authority responsibility for the arts with valuable advice about local-authority nominees on boards, control of artistic enterprises, regional arts association, approaching local authorities for help etc
Converting a Bus Anthony Kendall, 1974
Basic Video and Community Work Andi Biren, 1975
Bringing Books to People Glenn Thompson, 1975
Charitable Status Andrew Phillips, 1975
Print: How You Can Do It Yourself Jonathan Zeitlyn, 1975
Community Newspapers John Rety, 1975
Excellent manuals for people wanting to improve the services in their local communities. Obtainable from Inter-Action, 14 Talacre Road, London NW5 4PE
Community Festivals Handbook John Hoyland, Young Volunteer Force Foundation, 1973. A useful guide to running a community festival: the role of the festival co-ordinator, organisation and planning, money and resources, legal problems, publicity etc., obtainable from Young Volunteer Force Foundation, 7 Leonard Street, London EC2

NOTES

PREFACE
1 The figure 150 is based on information supplied by the Arts Council of
 Great Britain, who issued a list of all the arts centres in England and Wales
 in October 1975. (see page 149). A much higher number is quoted in a
 document *Report on the Arts*, issued from the office of the Minister for the
 Arts in July 1974: 'One of the most interesting and valuable recent
 developments has been the creation of arts centres which provide
 opportunities for enjoyment and participation in the arts to a wide number
 of people. There are now probably more than 400 all over the country and
 the number is growing'.
2 A description by Lord Redcliffe-Maud in *Future Support for the Arts in
 England and Wales*, Calouste Gulbenkian Foundation, 1976.
3 No satisfactory 'definition' of an arts centre has yet been written but the
 criteria to be found on page 149, are generally acknowledged as the most
 satisfactory working definition.
4 As above.
5 *Americans and the Arts*, Associated Councils of the Arts, 1975. Research
 revealed that the public has a higher level of interest in a wide range of
 artistic and cultural activities than has generally been assumed. For
 example 43% of the adult population reported that they engaged in
 creative activities such as photography, painting, weaving, etc. while 37%
 attend musical performances such as rock, jazz, folk, symphony or
 chamber music concerts. Participation in arts and cultural activity in the
 UK is covered by rather fewer sources than other sources of leisure. An
 (unpublished) *General Household Survey*, HMSO 1973, revealed that
 theatres were visited by 39% and concerts 21% of the adult population on
 average on three occasions a year.

1 HISTORY
1 Rabrindranath Tagore: from a conversation of January 1925 remembered
 by Leonard Elmhirst.
2 Henry James (1876).
3 *Plans for an Arts Centre*, published by Lund Humphries, not only contains
 plans, drawings and photographs of a model arts centre but illustrates
 examples from Canada, Sweden and the States.
4 Harold Jolliffe: *Arts Centre Adventure — an experiment in municipal
 patronage*, published by Swindon Borough Council, 1968.
5 *Arts Centres in England and Wales*, compiled and published by the
 National Council of Social Service, 1967.

147

6 Harold Jolliffe: *idem*, *Arts Centre Adventure*.

7 From an article 'The Midlands Arts Centre for young people – experiment in socio-cultural education', in *A Place for the Arts*, the Seel House Press, 1970.

8 Arnold Wesker: 'The Allio Brief', published in *Fears of Fragmentation*, Jonathan Cape, 1970.

9 Lord Goodman: in evidence to the House of Commons Estimates Committee published in *Grants for the Arts*, HMSO, 1968.

10 Alexander Dunbar: 'The Arts' from *Leisure Research and Policy*, a series of essays edited by Ian Appleton, Scottish Academic Press, 1974.

11 *A Policy for the Arts: the First Steps*, HMSO, 1965.

12 Further information about the size and location of arts centres can be found in *A Place for the Arts*, the Seel House Press, 1970.

13 Further information about the Maisons is available in *Some Aspects of French Cultural Policy*, 'Unesco', 1970. The writers observe that 'Maisons de la Culture ... are plants intended to be permanent focal points of attraction to culture, stripping it of its mask of austere erudition and breaking down the sociological barriers excluding the masses. The Maisons de la Culture should be multi-purpose and their productions should be of the highest quality, inducing the general public, under a single roof, to share in all the forms of artistic expression – theatre, music, ballet, arts, films, etc. – so as to demonstrate the essential unity of all the artistic idioms. In a word, each plant is a living whole, and not an accumulation of unconnected programmes.'

14 Jean Dubuffet: a collection of articles *Prospectus aux amateurs de tout genre*, 1946.

15 From a conversation between Roger Planchon and Michael Kustow: 'Creating a Theatre of Real Life', printed in *Theatre Quarterly* Vol. II, No. 5, 1972.

16 Arts Council of Great Britain: *Annual Report*, 1972.

17 Ivan Illich: *Tools for Conviviality*, Calder & Boyars and Harper & Row, 1973.

18 *Animation – Implications of a Policy of Socio-cultural Community Development*, Etienne Grosjean and Henri Ingberg; Committee for Out-of-School Education and Cultural Development of the Council of Europe, 1974. For those with a taste for socio-cultural jargon the Council of Europe's reports make interesting reading.

19 Charles Reich: *The Greening of America*, Pelican and Random House, 1973.

20 D. H. Lawrence: *Education of the People: Phoenix 1*, 1936.

21 *Arts Labs Newsletter*, August 1971, BIT. The same newsletter reports the establishment of the Ceolfrith Arts Centre, Sunderland.

22 Jim Haynes: *Arts Labs Newsletter* Issue No. 1, October 1969; BIT information service.

23 Quoted from a conversation in *Symposium Socio-Cultural Equipment Report III*, published by the Council for Cultural Co-operation of the Council of Europe, 1970.

24 From a letter addressed to Neil Duncan, January 1974.

148

25 Lord Redcliffe-Maud: *Support for the Arts in England and Wales*, Calouste Gulbenkian Foundation, 1976.

26 From an article 'The arts on a shoestring' about Llanover Hall, *Western Mail*, October 1974.

27 From a conversation between Chris Kinsey of Chapter and Robert Hutchison, 1975.

28 From an article on Salisbury arts centre by Jane Whittle in *Southern Arts*, June 1975. The magazine has published a series of essays on arts centres in the Southern Arts Region.

29 *Support for the Arts in England and Wales*, Calouste Gulbenkian Foundation, 1976.

30 The exact number of arts centres in the UK has only recently been established because the difficulty of finding an acceptable all-embracing definition has never been solved. In 1970 David Pease compiled a list of 77. Three years later a directory of English centres compiled by the Cockpit Youth Arts Workshop listed 60, a more recent survey (by the Arts Council in April 1975) lists 137. According to the Welsh Arts Council ten centres are operating in Wales. The Scottish Arts Council records another sixteen.

In October 1975 Robert Hutchison at the Arts Council of Great Britain compiled another list with the help of regional and area arts associations, totalling 118 centres in England and a further 10 in Wales. This list includes only those centres which are not subsidised as theatres and which meet the following criteria:

 (a) there is a programme and a policy for more than one art form.

 (b) more than one space is used for arts activities.

 (c) there is some professional input (artistic or managerial).

 (d) there is substantial usage which is not part of formal education (or adult education) provision.

A very few centres are included which do not meet all four criteria but at which there is an exceptional range and amount of activity. More comprehensive leisure centres are only included if the arts activities play a very substantial part in the life of the building. Civic halls are excluded. See page 152.

Accordingly, 37 of the centres listed in the earlier, April 1975 list, were deleted. These included Bath Arts Workshop (because of its lack of a coherent arts dominated cluster of buildings); Interplay in Armley, Leeds; the Key Theatre in Peterborough; and Rosehill, Whitehaven (because they are both subsidised as Theatres). At the time of writing there were therefore 144 different arts centres in Britain — a figure which excludes the peripatetic theatre companies, related community projects and numerous projected projects, too uncertain to count. The Arts Council's list is revised every six months.

A further list giving details of 133 centres (16 of which are in Scotland, 9 in Wales, 108 in England) is available in *A Directory of Arts Centres* published jointly by the National Association of Arts Centres and the Arts Council in 1976. Like the earlier Doomsday record, the National Council for Social Service report published in 1967, *A Directory of Arts Centres*, is the most comprehensive record of British arts centres in print.

According to information received from the National Endowment for the Arts the number of arts centres in the United States is smaller than in this country. There are fifty in the Colleges and Universities and another fifty outside the academic community devoted primarily and specifically to the arts.

2 ACTIVITY

1 André Gide: *Journal* (April 1943) Secker & Warburg, 1951.
2 Lord Redcliffe-Maud: *Support for the Arts in England and Wales*, Calouste Gulbenkian Foundation, 1976.
3 From a conversation with Ted Hughes about the Arvon Foundation, 1975.
4 Peter Stark in conversation with Robert Hutchison, 1975.
5 Jeremy Rees in conversation with the author, 1975.
6 Chris Carrell in conversation with the author, 1975.
7 Harland Walshaw in conversation with the author, 1975.
8 Publicity material published by the Combination at the Albany.
9 Quoted by Albert Hunt in *The Problems and Practice of Rural Community Theatre*. Council of Europe, 1975.
10 Closely based on suggestions made by J. Janne in his introductory address to the Rotterdam Symposium *Facilities for Cultural Democracy*, published by the Council for Cultural Co-operation, Council of Europe, 1971.
11 Alec Davison in conversation with the author, 1975.
12 Harland Walshaw in conversation with the author, 1975.
13 Alec Davison in conversation with the author, 1975.
14 Bill Harpe in correspondence with the author.
15 From the Annual Report of York Arts Centre, 1973–74.
16 John English in conversation with the author, 1975.
17 Alec Davison in conversation with the author, 1975.
18 Peter Stark in conversation with the author, 1975.
19 A description by Peter Newsam of the Cockpit in an article 'Creative Education' in a booklet *The Creative Arts in the Secondary School*, published by the ILEA, 1974.
20 Chris Carrell in conversation with the author, 1975.
21 Robert Atkins in conversation with the author, 1975.
22 Ivan Illich: *Tools for Conviviality*, Calder & Boyars and Harper & Row, 1973.
23 Publicity material published by the Combination at the Albany.
24 Ian Fletcher: *Islington Bus Company*, It's Childs Play, November 1975.
25 Charles Silberman: *Crisis in the Classroom.*
26 Malcolm Ross: Report to the Schools Council Curriculum Study, *Arts and the Adolescent*, 1975.
27 Alec Davison in conversation with the author, 1975.
28 From a paper prepared by Alec Davison 'The Concept of an Arts Centre in Education'.
29 From 'The Arts on a Shoestring' in the *Western Mail*, October 1974.
30 John English in conversation with the author, 1975.
31 An address by Walter Eysselinck at a two-day arts administration trainee course symposium, October 1968. Reprinted as *Arts in Focus.*

32 Chris Kinsey in conversation with Robert Hutchison, February 1975.

3 OPERATION
1 Peter Stark in conversation with Robert Hutchison, 1975.
2 *Socio-cultural facilities at the Urban level*, Chalmers University of Technology Dept. of Architecture, Gothenburg, Sweden, 1973.
3 Chris Carrell in conversation with the author, 1975.
4 A. H. Marshall: *Local Government and the Arts*, Institute of Local Government Studies, University of Birmingham, 1974.
5 Chris Carrell in conversation with the author, 1975.
6 Lord Redcliffe-Maud: *Support for the Arts in England and Wales*, Calouste Gulbenkian Foundation, 1976.

4 MEANING
1 Theodore Roszak: *Where the Wasteland Ends*, Faber, 1973.
2 Erich Fromm: *The Sane Society*, Routledge and Kegan Paul, 1956, and Holt Rinehart.
3 William Morris: *The Decorative Arts*, 1878.
4 William Morris: *Hopes and Fears for Art*, 1882.

5 THE LONG PERSPECTIVE
1 George Sturt: *Change in the Village*, Duckworth, 1912.
2 Peter Berger: *The Human Shape of Work*, Macmillan, 1964.
3 Quoted in *Working for Ford*, by Huw Beynon, Penguin Education, 1973.
4 *Work: Twenty Personal Accounts*, edited by R. Fraser: Penguin Books in association with New Left Review, 1968–69.
5 Polly Toynbee: *A Working Life*, Hodder and Stoughton, 1970.
6 D. H. Lawrence: *Return to Bestwood*, Phoenix II, 1968.
7 John Cowper Powys: *The Meaning of Culture*, W. W. Norton Inc., 1929.
8 Robert Atkins in conversation with the author, 1975.

ARTS CENTRES IN ENGLAND, SCOTLAND AND WALES

The following list, re-printed for convenience, is a revised version of the one given in *A Directory of Arts Centres in England, Scotland and Wales* which was published by the Arts Council in November, 1976. It contains the names and addresses of 170 centres, 42 of which have been opened since the beginning of 1977.

This list omits many projects such as Interplay in Leeds, and the Telford Community Arts project, which are not building-based. Yet are they not arts centres? If so, this list of arts centres based in buildings could be several times its present length.

ENGLAND

ABINGDON: Old Gaol Arts & Sports Centre, Bridge Street, Abingdon, Oxfordshire.

ALDEBURGH: Snape Maltings, Aldeburgh, Suffolk.

ALDERSHOT: West End, Queens Road, Aldershot, Hants.

ALFRETON: Alfreton & District Arts Association, Alfreton Hall, Alfreton, Derbyshire.

BAMPTON: Bampton Arts Centre, Town Hall, Bampton, Oxon.

BANBURY: Spiceball Arts & Community Association, The Mill, Spiceball Park, Banbury, Oxon.

BASILDON: The Towngate Theatre and Arts Centre, Towngate, Basildon, Essex.

BASINGSTOKE: Central Studio, Queen Mary's College, Cuddesden Road, Basingstoke.

BATH: Bath Arts Workshop Ltd., 146 Walcot Street, Bath.

BEAFORD: The Beaford Centre, Beaford, Winkleigh, North Devon.

BINGLEY: Bingley Arts Centre, Main Street, Bingley, West Yorkshire.

BIRKENHEAD: The Arts Centre, Wirral College of Art & Design and Adult Studies, Whetstone Lane, Birkenhead, Merseyside.

BIRMINGHAM:	Aston University Centre for the Arts, University of Aston, Gosta Green, Birmingham.
BIRMINGHAM:	Birmingham Arts Laboratory, Holt Street, Birmingham.
BIRMINGHAM:	Midlands Arts Centre for Young People, Cannon Hill Park, Birmingham.
BOGNOR REGIS:	The Old School House, 114 Seltham Road, Seltham, Bognor Regis.
BOSTON:	Blackfriars, Spain Lane, Boston, Lincs.
BRACKNELL:	South Hill Park, Bracknell, Berks.
BRENTWOOD:	Old House Arts and Community Centre, Shenfield Road, Brentwood, Essex.
BRIDGNORTH:	Bridgnorth Sports & Leisure Centre, Northgate, Bridgnorth, Salop.
BRIDGWATER:	Bridgwater Arts Centre, 11 Castle Street, Bridgwater, Somerset.
BRIGHTON:	Gardner Centre for the Arts, University of Sussex, Falmer, Brighton.
BRISTOL:	Arnolfini, Narrow Quay, Bristol.
BRISTOL:	Bristol Arts Centre, 4/5 King Square, Bristol.
BRISTOL:	The Ink Works, 20–22 Hepburn Road, St. Pauls, Bristol 2.
CHELMSFORD:	Little Baddow Hall Arts Centre, Church Road, Little Baddow, Chelmsford, Essex.
CHELTENHAM:	The Young Arts Centre, The Old Bakery, Chester Walk, Cheltenham.
CHESTER:	Chester Arts & Recreation Trust, The Centre, Market Square, Chester, Cheshire.
CHESTERFIELD:	The Arts Centre, College of Art & Design, Sheffield Road, Chesterfield, Derbyshire.
CHESTERFIELD:	Zone, Church Street, Brimington, Chesterfield, Derbys.
COVENTRY:	University of Warwick Arts Centre, Coventry, West Midlands.
CRAWLEY:	Crawley Arts Workshop, Barnfield Road, Northgate, Crawley, Sussex.
DURHAM:	Durham Light Infantry Museum and Arts Centre, Aykley Heads, Durham.
ELLESMERE:	Ellesmere College Arts Centre, Ellesmere, Salop.
FALMOUTH:	Falmouth Arts Centre, Church Street, Falmouth, Cornwall.

153

FARNHAM:	Farnham Maltings Association Ltd., Bridge Square, Farnham, Surrey.
FOLKESTONE:	Folkestone Arts Centre, New Metropole, The Leas, Folkestone, Kent.
FROME:	Merlin Theatre & Arts Centre, Bath Road, Frome, Somerset.
GLOUCESTER:	Courtyard Arts Trust, 1 Berkeley Street, Gloucester, and Barge Semington, Victoria Basin, Gloucester Docks.
HARLOW:	The Playhouse, Coates Street, The High, Harlow, Essex.
HASTINGS:	The Stables Theatre, High Street, Hastings, Sussex.
HEBDEN BRIDGE:	Arvon Foundation, Lumb Bank, Hebden Bridge, Yorkshire.
HEMEL HEMPSTEAD:	Hemel Hempstead Arts Centre for Young People, Boxmoor Hall, St. John's Road, Hemel Hempstead, Herts.
HORSHAM:	Arts Centre, Christ's Hospital, Horsham, Sussex.
HULL:	Humberside Theatre, Hull Arts Centre, Spring Street, Hull.
ILMINSTER:	Dillington Arts Centre, Dillington House, Ilminster, Somerset.
IPSWICH:	Corn Exchange, King Street, Ipswich, Suffolk.
KENDAL:	Brewery Community Arts Centre, 122A Highgate, Kendal, Westmorland.
KIDDERMINSTER:	Old Schools Arts & Recreation Centre, Market Street, Kidderminster.
KINGS LYNN:	Fermoy Centre, King Street, Kings Lynn, Norfolk.
LANCASTER:	New Planet City, Back Cable Street, Lancaster.
LANCASTER:	Nuffield Theatre Studio, University of Lancaster, Bailrigg, Lancaster.
LICHFIELD:	Lichfield Arts Centre, Bird Street, Lichfield, Staffs.
LIVERPOOL:	Bluecoat Society of Arts, Bluecoat Chambers, School Lane, Liverpool.
LIVERPOOL:	Great Georges Community Arts Project, Great Georges Street, Liverpool 1.

LONDON:	The Albany, Creek Road, Deptford, London SE8.
LONDON:	Battersea Arts Centre, Battersea Town Hall, Lavender Hill, London SW11.
LONDON:	Brycbox Youth Arts Workshop, Cocks Crescent, New Malden, Surrey.
LONDON:	Camden Arts Centre, Arkwright Road, London NW3.
LONDON:	Centerprise, 136 Kingsland High Street, London E8.
LONDON:	The Cockpit Arts Workshop, Gateforth Street, Marylebone, London NW8.
LONDON:	The Drill Hall, 16 Cherries Street, London WC1.
LONDON:	Fairfield Halls, Park Lane, Croydon, Surrey.
LONDON:	Fairkytes Arts Centre, 51 Billet Lane, Hornchurch, Essex.
LONDON:	Fulham Arts Centre, Dawes Road, London SW6.
LONDON:	Haringey Arts Centre, Redvers Road, London N22.
LONDON:	Hoxton Hall, 128a Hoxton Street, London N1.
LONDON:	Institute of Contemporary Arts, Nash House, 12 Carlton House Terrace, London SW1.
LONDON:	Interaction Community Resource Centre, 14 Talacre Road, Kentish Town, London NW5.
LONDON:	The Keskidee Centre, Gifford Street, Islington, London N1.
LONDON:	Marble Factory Project, 34 Camberwell Road, London SE5.
LONDON:	Merton Youth Arts Centre, Garth High School, Llanthony Road, Morden, Surrey.
LONDON:	Moonshine Community Arts Workshop, Victor Road, Harrow Road, London NW10.
LONDON:	Morley College, 61 Westminster Bridge Road, London SE1.
LONDON:	Oval House, 52/54 Kennington Oval, London SE11.
LONDON:	Ripley Arts Centre, 24 Sundridge Avenue and Denmark Villas Arts Centre, 1/3 Denmark Road, Bromley, Kent.

LONDON:	Riverside Studios, Crisp Road, London W6.
LONDON:	Salisbury House Arts Centre, Bury Street West, London N9.
LONDON:	Southlands Arts Centre, The Green, West Drayton, Middlesex.
LONDON:	Stage One Arts Workshop, 15–17 Deanery Road, Newham, London E15.
LONDON:	Warehouse Theatre/Waterside Workshops, 99 Rotherhithe Street, London SE16.
LOWESTOFT:	Lowestoft Theatre Centre, Morton Road, Lowestoft, Suffolk.
LYMINGTON:	Lymington Community Centre, New Street, Lymington, Hants.
MANCHESTER:	The Forum, Civic Centre Complex, Wythenshawe, Manchester 22.
MANCHESTER:	Royal Northern College of Music, 124 Oxford Road, Manchester.
MARGATE:	International Arts Centre, Northdown House, Northdown Park, Cliftonville, Margate.
NEWARK:	The Palace, Appletongate, Newark, Notts.
NEWCASTLE:	Bath House, Shipley Rise, Byker, Newcastle-upon-Tyne.
NEWCASTLE:	People's Theatre Arts Centre, Stephenson Road, Newcastle-upon-Tyne.
NEWCASTLE:	Spectro Arts Workshop, Bells Court, Pilgrim Street, Newcastle-upon-Tyne 1.
NORTHAMPTON:	NCFE Creative Arts Centre, Northampton College of Further Education, St. Gregory's Road, Booth Lane South, Northampton.
NORWICH:	Premises, 21/23 St. Benedict's Street, Norwich, Norfolk.
NOTTINGHAM:	Midland Group Nottingham, Carlton Street, Nottingham.
NUNEATON:	Nuneaton Arts Centre, 139 Weddington Road, Nuneaton.
OLDHAM:	Grange Arts Centre, Rochdale Road, Oldham, Greater Manchester.
OXFORD:	Old Fire Station Arts Centre, 40 George Street, Oxford.
PENZANCE:	West Cornwall Arts Centre, Parade Street, Penzance, Cornwall.

156

PLYMOUTH:	Plymouth Arts Centre, 38 Looe Street, Plymouth, Devon.
POOLE:	Poole Arts Centre, Kingland Road, Poole, Dorset.
PRESTON:	Preston Polytechnic Arts Centre, St. Peter's Square, Off Fylde Road, Preston PR1 7BA.
ROTHERHAM:	The Arts Centre, Frederick Street, Rotherham, South Yorkshire.
ST. AUSTELL:	St. Austell Arts Club & Theatre, 87 Truro Road, St. Austell, Cornwall.
SALISBURY:	St. Edmunds Arts Trust, Bedwin Street, Salisbury, Wilts.
SHAFTESBURY:	Shaftesbury Arts Centre, Bell Street, Shaftesbury, Dorset.
SHEEPWASH:	Arvon Foundation, Totleigh Barton, Sheepwash, Near Beaworthy, North Devon.
SHEFFIELD:	Hay's Gallery, Hay's Buildings, 101 Norfolk Street, Sheffield.
SHEFFIELD:	Hurlfield Arts, East Bank Road, Sheffield.
SHOREHAM:	Shoreham Youth Workshop, The Barn, St. Julian's Lane, Shoreham by Sea, Sussex.
SHREWSBURY:	Shrewsbury & District Arts Association, College Hill House, 13 College Hill, Shrewsbury, Salop.
SKEGNESS:	The Arcadia Centre, (East Lincolnshire Arts Centre), Drummond Road, Skegness, Lincs.
SOUTHPORT:	Southport Arts Centre, Lord Street, Southport, Merseyside.
SPALDING:	South Holland Arts Centre, Market Place, Spalding, Lincs.
STAMFORD:	Stamford Arts Centre, St. Mary's Street, Stamford, Lincs.
STEVENAGE:	Stevenage Leisure Centre, Lytton Way, Stevenage, Herts.
STOCKTON:	Dovecot Arts Centre, Dovecot Street, Stockton-on-Tees, Cleveland.
SUNDERLAND:	Sunderland Arts Centre, 17 Grange Terrace, Stockton Road, Sunderland, Tyne & Wear.
SWINDON:	Wyvern Theatre & Arts Centre, Swindon, Wilts.
SWINDON:	The Arts Centre, Devizes Road, Swindon, Wilts.

TAMWORTH:	Tamworth Arts Centre, Church Street, Tamworth, Staffs.
TAUNTON:	Brewhouse Theatre & Arts Centre, Coal Orchard, Taunton, Somerset.
TEWKESBURY:	The Roses Theatre, Sun Street, Tewkesbury, Glos.
TIVERTON:	East Devon College Arts Centre, Chapel Street, Tiverton, Devon.
TORRINGTON:	The Plough, Fore Street, Torrington, North Devon.
TOTNES:	Dartington Arts Society, Dartington Hall, Totnes, Devon.
ULVERSTON:	Renaissance Theatre Trust, The Centre, 17 Fountain Street, Ulverston, Cumbria.
WALLINGFORD:	Wallingford Arts Centre, The Kinecroft, Wallingford, Oxfordshire.
WALLSEND:	Wallsend Arts Centre, 67 Charlotte Street, Wallsend, Tyne & Wear.
WARMINSTER:	Warminster Arts and Civic Society, Athenaeum Arts Centre, High Street, Warminster, Wilts.
WASHINGTON:	Biddick Farm Arts Centre, Biddick Lane, Fatfield, District 7, Washington, Tyne & Wear.
WATFORD:	Pump House Theatre & Arts Centre, Local Board Road, Lower High Street, Watford, Herts.
WELWYN:	Digswell Arts Trust, Digswell House, Welwyn Garden City, Herts.
WEYMOUTH:	Weymouth & South Dorset Art Centre, Commercial Road, Weymouth, Dorset.
WINCHESTER:	Tower Arts Centre, Romsey Road, Winchester, Hants.
WORKINGTON:	Carnegie Theatre & Arts Centre, Finkle Street, Workington, Cumbria.
YORK:	Arts Centre York, Micklegate, York.

SCOTLAND

ABERDEEN:	Aberdeen Arts Centre, King Street, Aberdeen.
AIRDRIE:	Airdrie Arts Centre, Anderson Street, Airdrie, Lanarkshire.

BEARSDEN:	Bearsden and Milngavie Arts Guild, Kilmardinny House Arts Centre, Kilmardinny Avenue, Bearsden, Glasgow.
CRAIGMILLAR:	Craigmillar Festival Society Arts Centre, St. Andrews Church, Newcraighall Road, Craigmillar.
DALKEITH:	Dalkeith Arts Centre, White Hart Street, Dalkeith, Midlothian.
DUNBAR/NORTH BERWICK:	North Berwick Community Arts and Crafts Centre, Law Road, East Lothian.
DUNDEE:	Dudhope Arts Centre, St. Mary Place, Dundee.
EDINBURGH:	Theatre Workshop Edinburgh, 34 Hamilton Place, Edinburgh.
EDINBURGH:	Calton Studios, 24 Calton Road, Edinburgh.
GLASGOW:	Dolphin Arts Centre, 7 James Street, Bridgeton, Glasgow.
GLASGOW:	Glasgow Arts Centre, 12 Washington Street, Glasgow.
GLASGOW:	Third Eye Centre, 350 Sauchiehall Street, Glasgow G2.
GREENOCK:	Greenock Arts Guild, Campbell Street, Greenock.
HADDINGTON:	Lamp of Lothian Collegiate Centre, Haddington House, Haddington, East Lothian.
INVERNESS:	Eden Court Theatre, Bishops Road, Inverness.
INVERNESS:	Farraline Park Arts Centre, (Inverness Arts Guild), 26 Church Street, Inverness.
IRVINE:	Harbour Arts Centre, Harbour Street, Irvine, Ayrshire.
KILMARNOCK:	Kilmarnock and District Arts Guild, 9 Green Street, Kilmarnock.
KIRKCALDY:	Adam Smith Centre, Bennochy Road, Kirkcaldy, Fife.
KIRKINTILLOCH:	Solsgirth Theatre and Arts Club, Solsgirth, Kirkintilloch, Dunbartonshire.
LIVINGSTON:	Howden Park Centre, Livingston, West Lothian.
LOCHGELLY:	The Lochgelly Centre, Lochgelly, Fife.
LYTH:	Lyth Arts Centre, near Wick.

159

NEWPORT-ON-TAY:	Forgan Arts Centre, Newport-on-Tay, Fife.
STIRLING:	MacRobert Arts Centre, University of Stirling, Stirling.

WALES

ABERYSTWYTH:	Aberystwyth Arts Centre, Penglais, Aberystwyth, Dyfed.
BANGOR:	Theatr Gwynedd, Bangor, Gwynedd.
BRIDGEND:	Berwyn Centre, Nantymoel, Bridgend, Mid Glamorgan.
CARDIFF:	Chapter Arts Centre, Cardiff's Workshop & Centre for the Arts, Market Road, Canton, Cardiff.
CARDIFF:	Llanover Hall Arts Centre, Romilly Road, Canton, Cardiff.
CARDIFF:	Sherman Theatre, University College Cardiff, Senghennydd Road, Cardiff.
HARLECH:	Coleg Harlech Arts Centre, Harlech, Gwynedd.
LAMPETER:	Felinfach Arts Centre, Felinfach, Lampeter, Dyfed.
LLANTWIT MAJOR:	St. Donat's Arts Centre, Llantwit Major, South Glamorgan.
MILFORD HAVEN:	The Torch Theatre, Milford Haven Education and Arts Centre, St. Peters Road, Milford Haven, Dyfed.
MOLD:	Theatr Clwyd, Mold, Clwyd.